THE ENCYCLOPEDIA OF WATERCOLOUR TECHNIQUES

LIBRARY LAUDER COLLEGE

THE ENCYCLOPEDIA OF WATERCOLOUR TECHNIQUES

HAZEL HARRISON

A QUARTO BOOK

This edition published in Great Britain in 2004 by
Search Press Ltd
Wellwood
North Farm Road
Tunbridge Wells
Kent TNR 3DR
United Kingdom

First published in paperback in Great Britain in 1999 by Headline Book Publishing plc

Copyright © 1990, 2004 Quarto Publishing plc

All rights reserved.

No part of this publication may be reproduced, stored in a retrieval system or transmitted in any form or by any means without the prior permission in writing of the Publisher, nor be otherwise circulated in any form or by any means without the prior permission in writing of the Publisher, nor be otherwise circulated in any form of binding or cover other than that in which it is published and without a similar condition imposed on the subsequent purchaser.

ISBN 1 844480 364

QUAR.EWT-N

This book was designed and produced by Quarto Publishing plc The Old Brewery 6 Blundell Street London N7 9BH

Senior Editor Diana Craig Managing Art Editor Francis Cawley Designer Claudia Meissner

Picture Researcher Angela Gair Picture Manager Joanna Wiese

Art Director Moira Clinch

Manufactured in Hong Kong by Regent Publishing Services Ltd. Printed in China by SNP Leefung Printers Limited

CONTENTS

PART ONE TECHNIQUES 8

BACKRUNS • BLENDING • BLOTS • BODY COLOUR • BROKEN COLOUR BRUSH DRAWING • BRUSHMARKS • BUILDING UP • COLOUR CHANGES CORRECTIONS • DRAWING • DRY BRUSH • GLAZING • GUM ARABIC HARD AND SOFT EDGES • HIGHLIGHTS • LIFTING OUT • LINE AND WASH MASKING • MIXED MEDIA • SCRAPING BACK • SCUMBLING • SPATTERING SPONGE PAINTING • SQUARING UP • STIPPLING • STRETCHING PAPER TEXTURES • TONED GROUND • UNDERPAINTING • WASH • WASH-OFF WAX RESIST • WET-IN-WET • WET-ON-DRY

PART TWO THEMES 72

THE ANIMAL WORLD • 74

BUILDINGS • 86

THE FIGURE • 104

FLOWERS • 118

LANDSCAPE • 132

SKIES • 150

STILL LIFE • 160

WATER • 174

INDEX • 188

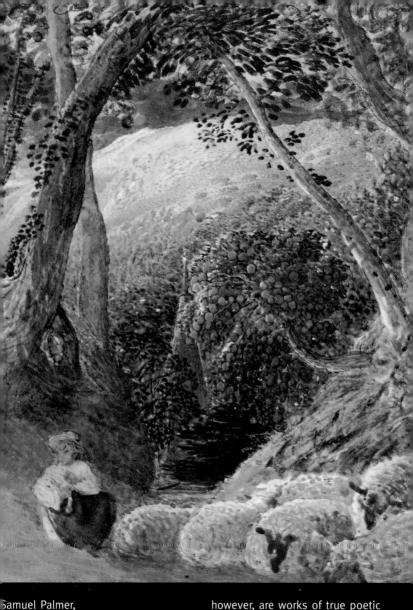

The Magic Apple Tree,
34 9 × 27 3 cm (133/, × 103/, in),
VATERCOLOUR AND PEN AND INK

The main body of Palmer's work was n oil, and was efficient but uninspired. His early watercolours however, are works of true poetic imagination, owing much to the example of William Blake, whom he met in 1824. Works such as this one, painted in 1830, are highly personal visions, and his desire to express his ideas led him to an inventive and original use of watercolour techniques.

INTRODUCTION

Watercolour is an enormously popular painting medium and has been since the nineteenth century. Ironically, however, its very popularity gave it something of a bad name at one time. Because so many amateur painters used it in Victorian times, the phrase 'painting in watercolour' conjured up a mental picture of neatly dressed ladies sitting at easels in the countryside producing small, rather timid landscapes in pale, delicate colours. This image has not been entirely dispelled even today – among the non-painting public there is still a tendency to regard watercolour painting as a pleasant pastime on a level with flower arranging. Artists, however, do not see it in this way, and an increasing number are now choosing it in preference to other media, exploiting it in inventive and creative ways for every possible subject.

Another old myth that is fast losing credence is that there is a a 'correct' way of working in watercolour. That is, laying down washes of transparent pigment and allowing the white paper alone to stand as the highlights. This 'classic' technique produces very beautiful results, but there are many other methods. Besides, not all watercolour paints are transparent – gouache and acrylic are also watercolours and, more surprisingly, so are the tempera paints that Michelangelo used to paint the Sistine Chapel ceiling. Today no shame attaches to mixing watercolour with opaque white, combining transparent and opaque paints, and even mixing several media in one painting. All paints and pastels are made pigment and the only real distinction is between the oil-based and the water-based ones.

This book covers the subject of watercolour in the broad sense of the term, suggesting ways of working with gouache and acryllc as well as explaining the time-honoured techniques associated with transparent watercolour. I hope that it will help banish some preconceptions, provide some new ideas, and demonstrate the inspiringly broad range of effects offered by water-based paints.

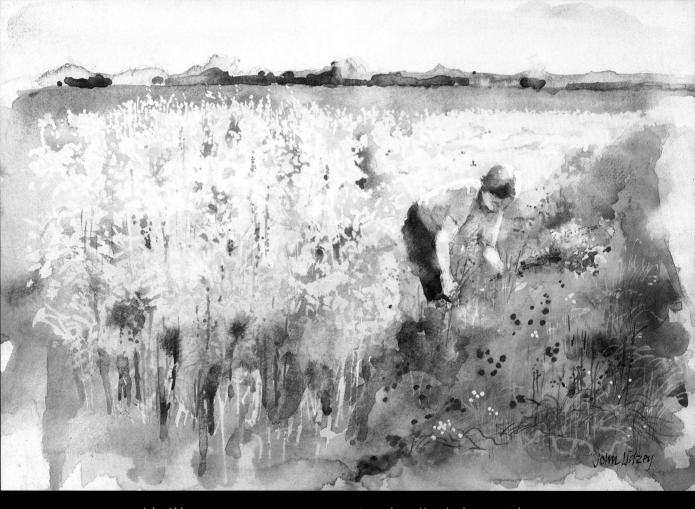

John Lidzey, Figure in a Cornfield, APPROX 34.3 x 50.8 CM (13½ x 20 IN), WATERCOLOUR

Lidzey is an artist who enjoys experimenting with different techniques and combinations of media to obtain effects of light and atmosphere. Here he has created a broad impression of the flowers and grasses by painting the shapes with MASKING fluid and laying washes on top. The fluid is then removed to leave white 'negative' shapes, parts of which have been left white while others have been modified by further pale washes.

PART ONE TECHNIQUES

The nineteenth-century academic obsession with correct technique bred a revolt in the early part of this century, to the extent that teaching students how to apply paint began to be regarded as almost immoral – stifling self-expression and creativity. However, while it is true that no amount of technical knowledge and expertise can be a substitute for vision, there is nothing more frustrating than knowing you have something to say but do not have the means to say it. No art exists in a vacuum – we can always learn from other artists and should never be ashamed to study their methods as well as their subject matter – this is and always has been part of the quest for a personal artistic language.

The aim of this first alphabetical section of the book is to show you not what you should do but what you can do. Even in the relatively narrow field of water-based media there are almost endless different ways of applying paint to paper, and I have tried to show a comprehensive selection of them here. Some of the techniques described may strike a chord, while others may not, but I hope you will try them all out. Learning to understand the capabilities of a medium has a wonderfully liberating effect – it enables you to 'find your own voice' and express your ideas with confidence and vigour. Always remember, though, that technique is not only a tool – the way you paint should never be more important than what you paint.

Backruns

These are both a nuisance and a delight to watercolour painters. If you lay a WASH and apply more colour into it before it is completely dry, the chances are that the new paint will seep into the old, creating strangely shaped blotches with hard, jagged edges sometimes alternatively described as 'cauliflowers'. It does not always happen: the more absorbent or roughtextured papers are less conductive to backruns than smoother, highly sized ones. and with practice it is possible to avoid them completely.

There is no remedy for a backrun except to wash off the entire area and start again. However, many watercolour painters use them deliberately, both in large areas such as skies or water and small ones such as the petals of flowers, since the effects they create are unlike those achieved by conventional brushwork. For example, a realistic approximation of reflections in gently moving water can be achieved by lightly working wet colour or clear water into a still-damp wash. The paint or water will flow outward, giving an area of soft colour with the irregular, jagged outlines so typical of reflections. It takes a little practice to be able to judge how wet or dry the first wash should be, but as a guide, if there is still a sheen on it, it is too wet and the colours will merge together without a backrun, as they do in the WET-IN-WET technique.

1 In this painting, the artist aims to exploit the natural backruns formed by watercolour to suggest the loose, organic shapes of flowers. She begins in the centre of the painting, applying patches of very wet wash and allowing the paint to spread and settle naturally. When the paint is partially dry, she floats in other colours on top. Notice the 'eyes' of unpainted white paper left in the centre of each flower.

2 While the paint is drying, the artist works on other parts of the picture. Here, she adds another flower form, applying a rich blue over a patch of damp red.

3 | By paying careful attention to the relative dryness of different areas. various effects can be achieved. Here, blue has bled into damp yellow to form a patch of green. While the green is still damp, the artist feeds in a further colour - red - on top.

Different drying times of the various washes can lead to such happy accidents as this green 'cauliflower', leaching into the underlying yellow wash. Such pleasing organic shapes, which form the basis of the painting, can then be given definition with deliberately added detail, such as the finely veined leaf seen here.

5 | Yellow washes loosely applied and allowed to settle in their own way form these distinctive, abstract shapes at the bottom of the painting.

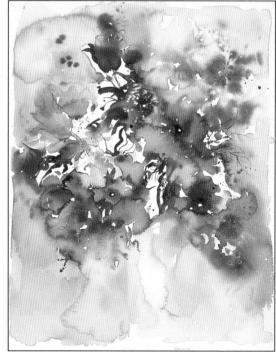

Blending

This means achieving a soft, gradual transition from one colour or tone to another. It is a slightly trickier process with water-based paints than with oil or pastel, because they dry quickly, but there are various methods that can be used.

One of these is to work WETIN-WET, keeping the whole area damp so that the colours flow into one another. This is a lovely method for amorphous shapes such as clouds, but is less suited to precise effects, such as those you might need in portraits, because you cannot control it enough. You can easily find that a shadow intended to define a nose spreads haphazardly.

To avoid the hard edges where a wash ends or meets another wash, brush or sponge the edge lightly with water before it is dry. To convey the roundness of a piece of fruit, use the paint fairly dry, applying it in small strokes rather than broad washes. If unwanted hard edges do form, they can be softened by 'painting' along them using a small sponge or cotton bud dipped in a little water.

The best method for blending acrylics is to keep them fluid by adding retarding medium. This allows very subtle effects, as the paint can be moved around on the paper. Opaque gouache colours can be laid over one another to create soft effects, though the danger is that too much overlaying of wet colour muddies the earlier layers. One way to avoid this is to use the DRY BRUSH technique, applying the paint thickly, with the minimum of water.

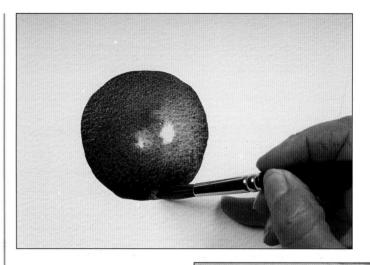

To achieve a softly blended effect, the artist will work wet-in-wet so that the colours can fuse gently into each other. She first applies a wash of raw sienna, leaving patches of white paper for highlights. She then flows in a wash of alizarin crimson. taking it along the right-hand edge of the fruit and over the curved surface on the left to increase the sense of rounded form. Finally, she applies a wash of Payne's grey in the areas of deepest shadow.

When the paint is completely dry, the artist works into the fruit, using a fine brush and the same colours used in the previous step, to build up the tones and increase definition and modelling of the form.

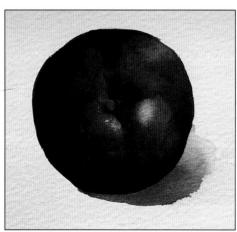

3 As a final touch, the artist adds a wash of Payne's grey for the shadow under the fruit so that it does not appear to float in space. The gradual building up of tone over the initial washes results in an almost tangible fruit.

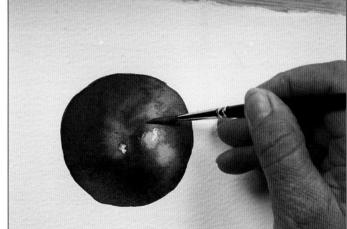

Blots

Blot painting is a technique most often associated with monochrome ink drawing, but since watercolours are available in liquid (ink) form I have included this technique here. The other reason for its inclusion is that it is an excellent way of loosening up technique and providing new visual ideas. Like BACKRUNS. blots are never entirely predictable, and the shapes they make will sometimes suggest a painting or a particular treatment of a subject quite unlike the one

that was planned. Allowing the painting to evolve in this way can have a liberating effect and may suggest a new way of working in the future.

The shapes the blots make depend on the height from which they are dropped, the consistency of the paint or ink

and the angle of the paper. Tilting the board will make the blot run downhill: flicking the paint or ink will give small spatters; wetting the paper will give a diffused, soft-edged blot. A further variation can be provided by dropping a blot onto the paper and then blowing it, which sends tendrils of paint shooting out into various directions. Blots can also be used in a controlled, selective way to suggest the textures of a tree, flowers or pebbles in a particular part of a painting.

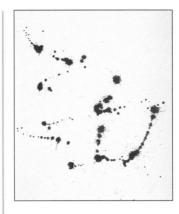

Flicking a loaded brush onto paper produces these random paint blots.

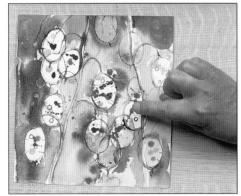

Washes of colour are added where necessary. and additional spots of colour are dabbed on with a finger.

4 In the finished piece, the forms have been sufficiently defined to be read figuratively, yet the painting retains the spontaneity of the technique.

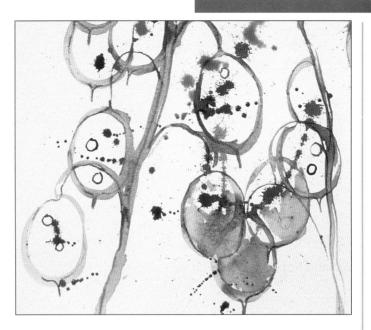

The blots suggest the seeds of Honesty, so the artist builds up the picture by drawing in the paper-thin petals and stems of the plant, using a fine brush.

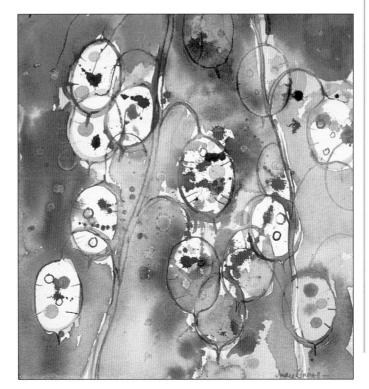

Body colour

This slightly confusing term simply means opaque water-based paint. In the past it was usually applied to the mixture of either Chinese white with transparent watercolour in parts of a painting or used straight out of the tube for highlights. Today, however, it is often used as an alternative term for opaque gouache paint.

Some watercolour painters avoid the use of body colour completely, priding themselves on achieving all the highlights in a painting by reserving areas of white paper. There are good reasons for this, because the lovely translucency of watercolour can be destroyed by the addition of body colour, but opaque watercolour is an attractive medium when used sensitively.

Transparent watercolour mixed with either Chinese white or gouache zinc (not flake) white is particularly well suited to creating subtle weather effects in landscapes, such as mist-shrouded hills. The mixture gives a milky, translucent effect slightly different from that of gouache itself, which has a more chalky, pastel-like quality.

A watercolour that has gone wrong – perhaps become overworked or too bright in one area – can often be saved by overlaying a semi-opaque wash, and untidy highlights can be cleaned up and strengthened in the same way.

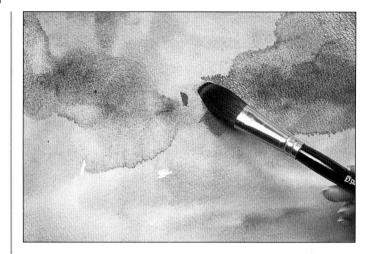

1 First, a TONED GROUND is laid down over the entire surface, using acrylic paint in a pale beige-cream. When this is dry, the building, trees and foreground are painted in with ultramarine, Prussian blue, alizarin crimson and sap green watercolour. Washes of these colours are painted WET-IN-WET, using a large brush and loose brushstrokes. There is little form or definition at this stage of the painting.

When the washes are dry, body colour is used to build up the sky. The artist uses gouache in white, lemon yellow, Indian yellow and neutral grey.

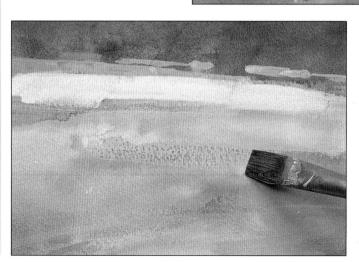

White, saffron green and Indian yellow gouache are applied to the grassy area in the foreground, deliberately echoing the colours of the sky. Patches of especially solid body colour here create the effect of dappled sunlight.

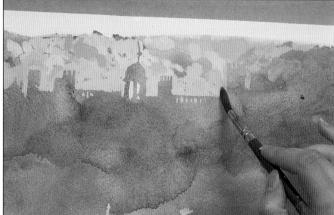

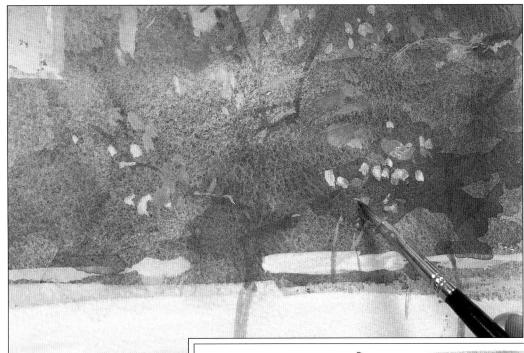

4 | Further details, such as trunks and branches, are added to the trees, using olive green and Prussian blue watercolour. The artist then dabs on touches of pale yellow gouache to highlight some of the leaves on the trees in the foreground.

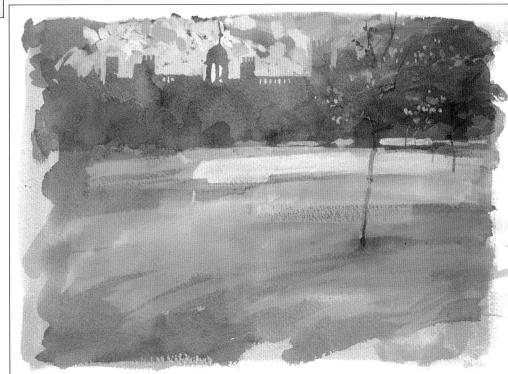

The mixture of misty, bluemauve watercolour and sharp, solid gouache creates a highly atmospheric scene, reminiscent of the colours on a sunny early morning.

Broken colour

It is one of the paradoxes of painting that a large area of flat colour seldom appears as colourful, or as realistic, as one that is textured or broken up in some way. The Impressionists, working mainly in oils, discovered that they could best describe the shimmering effects of light on foliage or grass by placing small dabs of various greens, blues and yellows side by side instead of using just one green for each area. This technique can be adapted very successfully to watercolour, but there are many other ways to break up colour.

If you 'drag' a wash over a textured paper, the paint will sink into the troughs, but will not completely cover the raised tooth of the paper – a broken colour effect much exploited by watercolourists. If you then apply drier paint over the original wash – in a different colour or a darker version of the same one – the effect will be more varied and the painting will have a lively surface texture.

In gouache and acrylic. broken colour effects are best achieved by applying the paint rather dry with a stiff brush (see also DRY BRUSH and SCUMBLING). Acrylic is perfect for this kind of treatment since it dries fast and is immovable once dry, which means that layers can be laid one over the other. This is not true of gouache: although it is opaque, it is also absorbent and so too many new layers will simply disappear into those below.

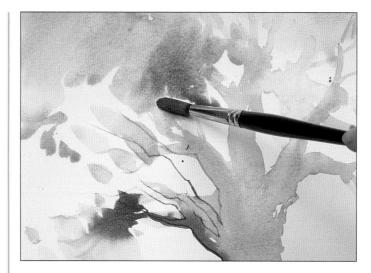

1 The artist begins by painting in the trunk and main branches of the tree with a mixture of cadmium lemon and green-gold watercolour. She then starts to build up the foliage with washes of colour. While the paint is still wet, she draws into it with a twig to create some of the finer branches. The wet paint runs into the grooves formed by the twig.

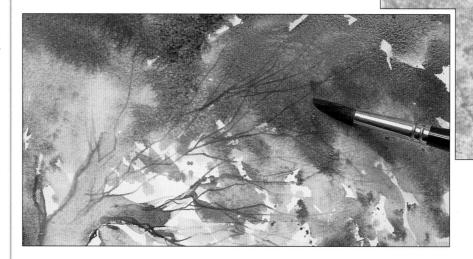

She continues to build up the foliage, using lemon yellow for sunlit areas, and ultramarine, manganese blue and touches of alizarin crimson for the mauve shadows. She applies the colours randomly, working WET-IN-WET so they bleed into each other. This, and the untouched patches of white paper left for the gaps in the foliage, help to create a dappled effect. While the paint is still wet, she draws in additional fine branches with the twig.

To break up the colour further and create a speckled effect, the artist sprinkles a few grains of salt onto areas of wet paint. The

salt absorbs the moisture in

shapes suggestive of leaves.

the paint, leaving crystal

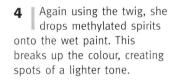

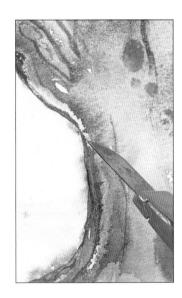

5 A purple wash is applied for the shading on the trunk and lower branches. While this is still damp, the artist uses a blunt craft knife to scratch out a reflected highlight along one edge (a credit card or even a fingernail could be used to achieve the same effect).

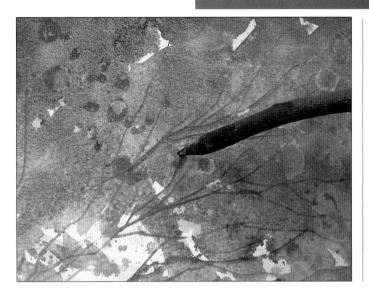

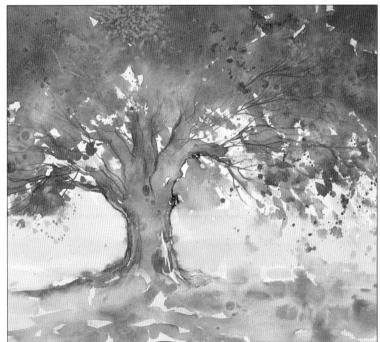

Finally, broad strokes of mauve and blue wash are painted over the dry yellow foreground to suggest dappled light and shadow. Additional colour is lightly spattered onto the dry foliage. Although the tree is seen 'contre jour' (against the light), the techniques used by the artist ensure that it glows with colour and reflected light.

Brush drawing

Drawing freely and directly with a brush is an excellent way to loosen up your technique. Artists over the centuries have made brush sketches, sometimes using pen marks as well, and the Chinese and Japanese made the technique into a fine art.

Opaque paints are not suitable for brush drawing, since the marks and lines must be fluid, flowing easily from brush to paper. You can use ordinary watercolours, watercolour inks or acrylics thinned with water; good, springy brushes are also essential.

Light pressure with the tip of a medium-

sized, pointed brush will give precise. delicate lines. A little more pressure and the line will become thicker, so that it is possible to draw a line that is dark and thick in places and very fine in others. More pressure still, bringing the thick part of the brush into contact with the paper, will give a shaped brushmark rather than a line. Thus, by using only one brush, you can create a variety of effects; and,

The technique can be combined with others in a painting and is particularly useful for conveying a feeling of movement, in figures, animals or even landscape.

if you use several brushes, including broad, flat-ended ones, your repertoire will be

almost endless.

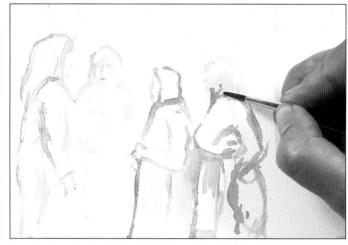

1 Using a fine No. 4 brush and a pale colour, the artist draws in the main outlines of the figures and the background, and indicates some of the main tonal areas.

2 She begins to build up the painting using a medium No. 8 brush and washes of deeper colour.

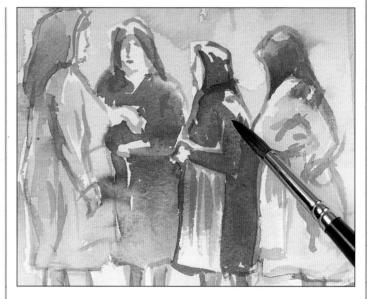

3 She works on the group of women, paying attention to the tonal contrasts that give definition to the individual figures.

4 With the No. 4 brush and a dark colour, she draws in the fine detail – the folds in the dresses, the shadows on the legs and the apron strings on the figure on the far left.

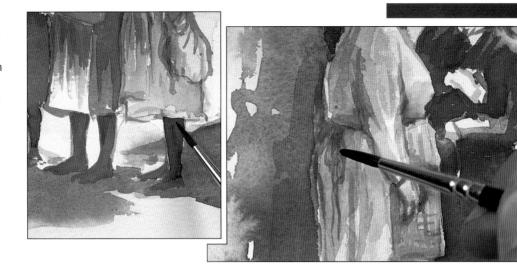

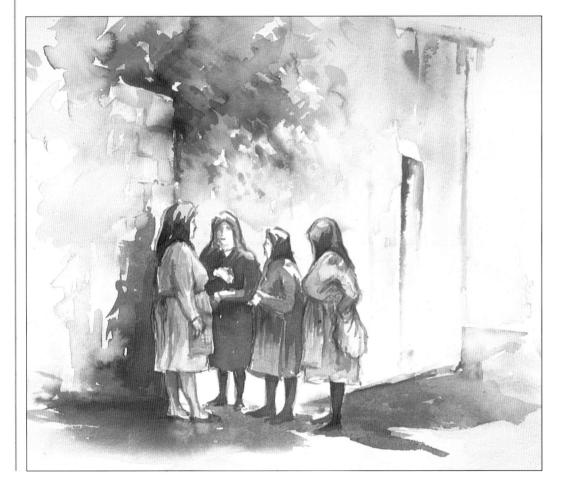

5 The completed painting shows a perfect balance between the detail on the figures and their surroundings, which are conveyed with no more than a few fine lines and the lightest touch of tone. The foliage overhanging the wall reinforces the composition, while the shadows along the ground anchor the whole. Colours have been kept muted and subtle throughout.

Brushmarks

The marks made by the brush as a contributing factor to a finished painting are exploited most fully in the thick, buttery medium of oil paint. This has often led people to ignore the importance of brushmarks in watercolour, but they can play a vital and expressive part in a painting, making all the difference between a lively, dynamic picture and a dull, routine one.

The most obvious example of visible brushmarks in watercolour occurs in the technique of STIPPLING. Then the painting is built up entirely with tiny strokes of a pointed brush. However, it is possible to discern the strokes of the brush in most watercolours to a greater or lesser degree. Some artists use a broad, flat brush, allowing it to follow the direction of a form, while others use a pointed one to create a network of lines in different colours and tones. A popular technique for creating the impression of squalls of rain or swirling mist is to work into a wet wash with a dry bristle brush to 'stroke' paint in a particular direction, while an exciting impression of foliage can be conveyed by dabbing or flicking paint onto paper using short strokes of a small square-ended brush. Another useful technique for foliage – a notoriously tricky subject - is DRY BRUSH, which creates a pleasing, feathery texture because the dry paint only partially covers the paper.

After painting the sky with a pale, flat wash of indigo mixed with raw umber, the artist uses the same wash for the sea. Holding a No. 10 round brush parallel to the paper, she drags the wash across it, leaving some of the textured surface exposed to suggest the sparkling highlights on the water.

While the wash is still only partially dry, she uses a No. 3 rigger to paint bands of colour across the water to suggest waves. The colours used are the same as before except that the wash is tonally stronger, and touches of alizarin are added. By pulling the brush down across the brushstrokes, it is possible to create textural marks as well.

3 | The same wash, this time applied with a No. 1 round brush, is again used to build up the distant shoreline. Applying successive layers of the wash allows a darker tone to be achieved.

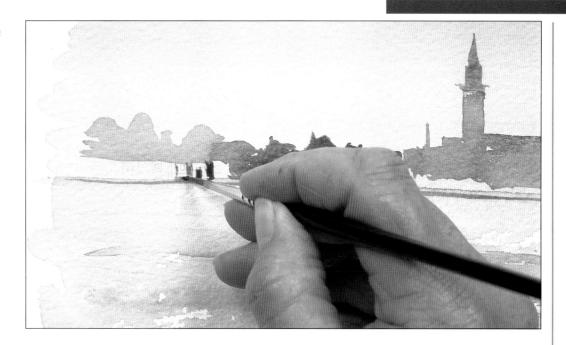

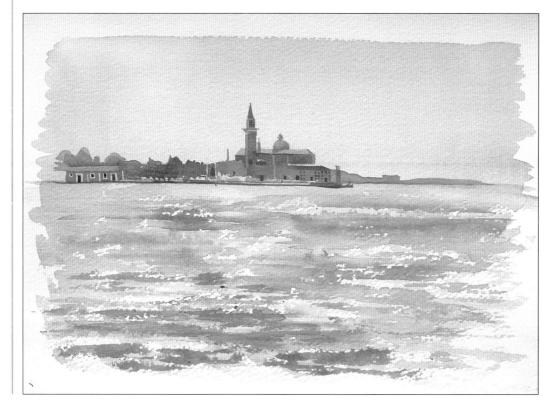

4 | With a palette limited I to just three colours, much of the interest in this painting comes from clever brushwork, which has produced undulating waves and sparkling water in the foreground, delicately worked buildings on the far shoreline and a broad, flat sky.

Building up

Watercolour

Because watercolours are semi-transparent, light colours cannot be laid over dark. Thus, traditional practice is to begin a painting with the lightest shades and build up gradually towards the darker ones by means of successive washes or brushstrokes.

Many, but by no means all, artists start by laying a flat WASH all over the paper. leaving uncovered any areas that are to become pure white highlights (known as reserving). This procedure obviously needs some planning, so it is wise to start with a pencil drawing to establish the exact place and shape of the highlights to be reserved. The shade and colour of the preliminary wash also need to be planned as they must relate to the overall colour key of the finished painting. A deep blue wash laid all over the paper might be the correct colour and intensity for the sky in a landscape, but would not be suitable for a foreground containing pale vellows and ochres. Another variation of the overall wash is to lay one for the sky, allow this to dry, and then put down another one for the land. Both these procedures have the advantage of covering the paper quickly so that you can begin to assess colours and tones without the distraction of pure white paper.

Overpainting

When the first wash or washes are completely dry, the process of intensifying certain areas begins, done by laying

darker washes or individual brushstrokes over the original ones. A watercolour will lose its freshness if there is too much overpainting, so always assess the strength of colour needed for each layer carefully and apply it quickly, with one sweep of the brush, so that it does not disturb the paint below. As each wash is allowed to dry, it will form hard edges, which usually make a positive feature of watercolour, adding clarity and crispness.

Other methods

Some artists find it easier to judge the tone and colour key of the painting if they begin with the darkest area of colour, then go back to the lightest, adding the middle tones last when the two extremes have been established.

Building up a painting in washes is not the only method. Some artists avoid washes altogether, beginning by putting down small brushstrokes of strong colour all over the paper, sometimes modifying them with washes on top to soften or strengthen certain areas.

This landscape clearly shows the progression of building up a painting with watercolour. Starting with the lightest tones and working from the background to the foreground, the artist builds up the image with successive layers of colour, working WET-ON-DRY. She first lays down a wash of ultramarine for the sky, and another of raw umber and sepia for the foreground. These are left to dry completely.

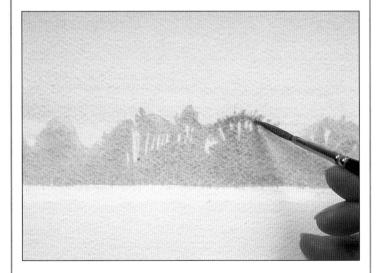

2 Using a mixture of ultramarine and umber, she adds the silhouette of the trees along the horizon, overlaying the dry washes laid down in step 1. She allows the paint to dry before moving on to the next step.

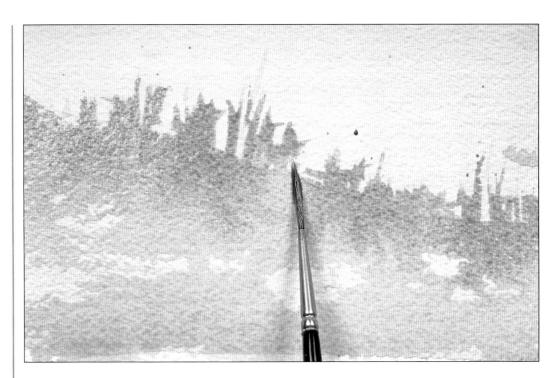

Using stronger washes of ultramarine and umber, she begins to build up the detail in the middle ground and foreground – the trees and the grass, the fence posts and the shadows.

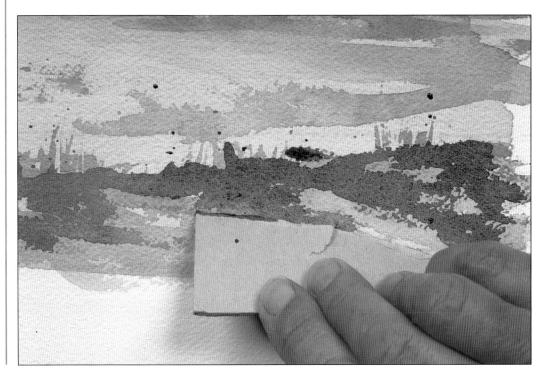

An even stronger blend of the same two colours is used for the details in the foreground. Holding a piece of card on its edge, the artist drags the colour downward to produce a feathery mark.

The same card and colour is used for the strong uprights of the fence posts. Other foreground details are added with a brush.

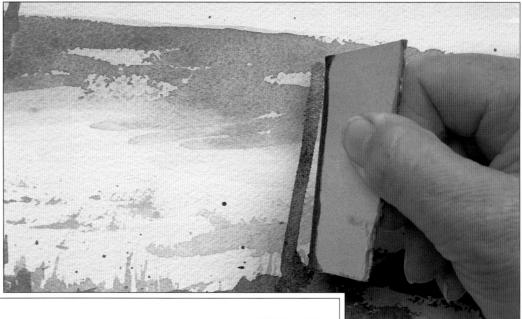

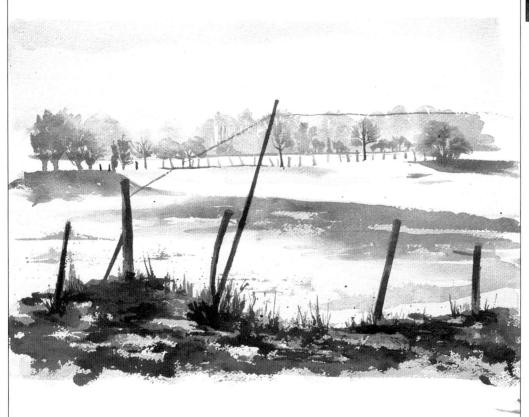

6 The finished painting shows the clear progression from light tones in the background to dark tones and greater detail in the foreground.

Colour changes

Newcomers to watercolour often find it difficult to judge the strength and quality of the first colour to be applied. There are two reasons for this: one is that the paint becomes a great deal lighter when dry; the other is that it is hard to judge a colour against pure white paper – the first wash inevitably looks too dark or too bright.

If you find the first colours are wrong, do not despair. Because watercolours are built up in a series of overlaid washes or brushstrokes, the first colour and tone you put down is by no means final: many further changes can be made on the paper itself. If a pale vellow wash is covered partially or completely - with a blue one, the colour changes to become green, and the tone darkens because there are now two layers of paint. By the same token, a wash that is too pale is very easily darkened by applying a second wash of the same colour or a slightly darker version of it. Although it is often stated in books about watercolour that light colours cannot be laid over dark ones, this only means that they will not become lighter, but colours can be modified in this way, particularly greens. A green that is too 'cool', that is, with too high a proportion of blue, can be changed into a warmer, richer green by laying a strong wash of vellow on top.

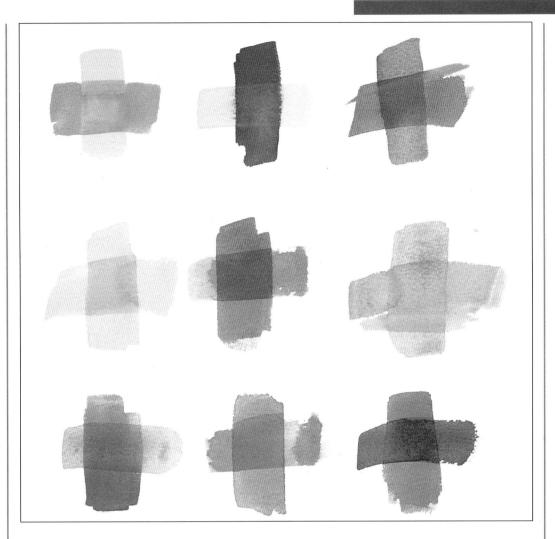

It is surprising how radically even quite a strong colour can be altered by overlaying it with another one. Second and subsequent colours should be applied quickly and surely to avoid stirring up those below. Whether colour is applied WET-IN-WET OR WET-ON-DRY will also have an effect on how the

colours blend. The colours shown here are as follows (left to right). Top row: permanent yellow down, cadmium red across; ultramarine down, permanent yellow across; ultramarine (more diluted) down, crimson across. Middle row: permanent yellow with cadmium red

down, crimson across (all fairly diluted); cadmium red down, viridian across; raw sienna down, cadmium red (diluted) across. Bottom row: olive green down, raw sienna across; olive green down, viridian across; olive green down, ultramarine across.

Corrections

It is a common belief that watercolours cannot be corrected, but, in fact, there are several ways of making changes, correcting or modifying parts of a painting.

If it becomes clear early on that something is badly wrong, simply put the whole thing under cold running water and gently sponge off the paint. For smaller areas, wet a small sponge in clean water and wipe away the offending colour, or, for a very tiny area, use a wet brush.

It must be said, though, that some colours are more permanent than others – sap green, for example, is hard to remove totally – and that some papers hold onto the pigment with grim determination. Arches is one of the latter, but other papers will wash clean very well.

As a painting nears completion, you may find that there are too many hard edges or not enough HIGHLIGHTS. Edges can be softened by the water treatment described above, but here the best implement to use is a dampened cotton bud. Both these and sponges are nearessentials in watercolour painting, as they are ideal for LIFTING OUT areas of paint to create soft highlights. Any small specks of dark paint that may have inadvertently flicked onto a white or light-coloured area can be removed with a craft knife blade, but use the side in a gentle scraping motion, because pressure with the point could easily make holes in the paper.

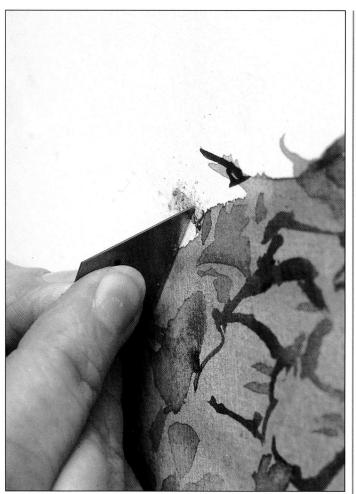

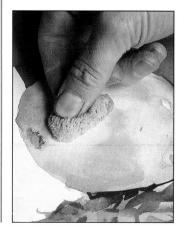

Small blots and blemishes are easily removed by scraping with a knife or razor blade (above). This must be done with care, however, or the blade might tear holes in the paper.

If there is too much colour in one area, some can be lifted out with a damp sponge (left).

If one colour floods into another to create an unwanted effect, the excess can be mopped up with a small sponge or piece of blotting paper (above).

Ragged edges can either be tidied up with a knife, as in the first example, or with opaque white gouache paint, as here (above).

Drawing

Because watercolours cannot be changed radically (except by washing off and beginning again), they need to be planned in advance, so it is usual to begin a painting by drawing the subject directly onto the paper. Some artists dispense with this stage, but this is usually because they are familiar with the subject, have painted it before and have a clear idea of how they want the finished painting to look.

There are certain inherent problems with underdrawings for watercolour. One is that the drawn lines are likely to show through the paint in the paler areas. The lines should, therefore, be kept as light as possible and any shading avoided so that the drawing is nothing more than a guideline to remind you which areas should be reserved as highlights and where the first washes should be laid.

Another problem is that, on certain papers, erasing can scuff the surface, removing parts of the top layer, so that any paint applied to these areas will form unsightly blotches. If you find that you need to erase, use kneadable putty, applying light pressure.

For a simple landscape or seascape, your underdrawing will probably consist of no more than a few lines, but a complex subject, such as buildings or a portrait, will need a more elaborate drawing. Then you may find that the SQUARING UP method is helpful, using either a sketch or photograph of the subject.

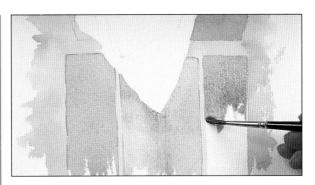

1 Having lightly drawn in the main outlines in pencil, the artist begins filling in areas of colour with pale watercolour washes. The paint is left to dry.

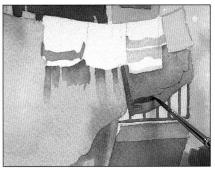

2 The artist then redefines the edges of some of the shapes in pencil, drawing over the dry paint. She paints in the shadows, using a warm grey wash to maintain translucency of tone – shadows are not opaque.

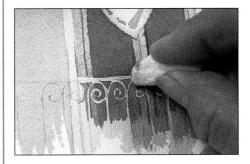

3 Using the pencilled outlines as her guide, she paints in between the railings of the lower balcony. She then erases the pencil lines to leave crisp ironwork highlighted against the darker tones behind.

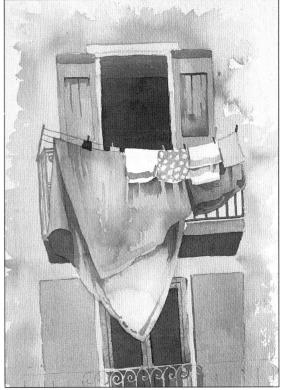

4 The finished painting is a judicious mix of fine detail and loose, suggestive washes.

Dry brush

This technique is just what its name implies – painting with the bare minimum of paint on the brush so that the colour only partially covers the paper. It is one of the most often used ways of creating TEXTURE and BROKEN COLOUR in watercolour, particularly for foliage and grass in a landscape or hair and fur textures in a portrait or animal painting. It needs practice: if there is too little paint, it will not cover the paper at all. but if there is too much, it will simply create a rather blotchy wash.

As a general principle, the technique should not be used all over a painting, since this can look monotonous. Texture-making methods work best in combination with others, such as flat or broken washes.

Opaque gouache and acrylic are also well suited to the dry brush technique. In both cases the paint should be

used with only just enough water to make it malleable – or even none at all – and the best effects are obtained with bristle, not soft sable or synthetic-hair, brushes (these are, in any case, quickly spoiled by such treatment).

Having pressed out excess moisture from the brush, the artist drags greyblue watercolour across the paper for the sea. Since the paint is fairly dry, it does not spread evenly over the paper like a fluid wash, but produces a patchy finish suggestive of sparkling water.

2 While this is drying, she adds washes for the sky and an uneven wash of light ochre for the beach.

When the sea is completely dry, she dry-brushes streaks of indigo mixed with cerulean blue over it. She also paints in the headland, overlaying a wash of grey-blue on top of the semi-dry sky so that the two blend a little to create a softer effect.

Using a flat, broad brush and ochre, she begins to dry-brush the marram grass on the shore.

When the first layer of grass is dry, she builds up subsequent layers in the same way, dry-brushing progessively darker colours over the lighter tones. She also adds a small figure, partially hidden by the grass.

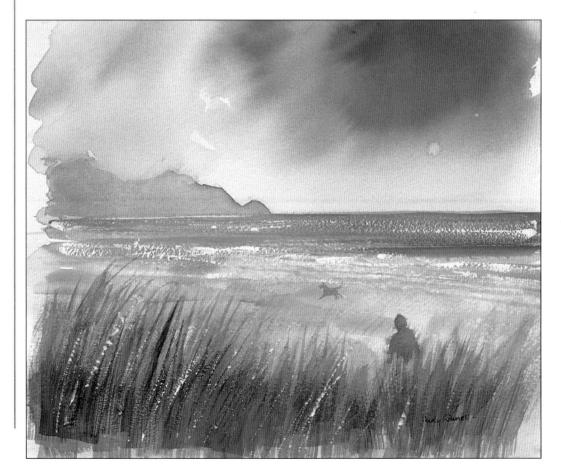

The picture is completed with the addition of a little white gouache for extra highlights on the sea. Highlights are also scratched into the grass with a craft knife, and – as a final touch – the small figure of a dog running along the sand is placed in the middle ground.

Glazing

This is a technique that was perfected by the early painters using oils. They would lay thin skins of transparent pigment one over the other to create colours of incredible richness and luminosity. In watercolour painting, overlaying washes is sometimes described as glazing, but this is misleading because it implies a special technique, whereas in fact it is the normal way of working.

Acrylic paint is perfectly suited to the glazing technique because it dries so fast: each layer must be thoroughly dry before the next one is applied. The effects the technique creates are quite different from those of colour applied opaquely, because light seems to reflect through each layer, almost giving the appearance of being lit from within. The use of a brilliant white ground (acrylic gesso is ideal) on a smooth surface such as masonite or plain illustration board further enhances the luminosity.

Special mediums are sold for acrylic glazing – available in both gloss and matt – and these can be used either alone or in conjunction with water.

A whole painting can be built up layer by layer in this way – as can be seen in some of David Hockney's acrylic paintings – but this is not the only way of using the technique. Thin glazes can also be laid over an area of thick paint (impasto) to great effect. The glaze will tend to slide off the raised areas and sink into the lower ones – a useful technique for suggesting textures, such as that of weathered stones or tree bark.

1 The artist begins with a drawing in waterproof ink. She then reserves some highlights with masking fluid, and applies a wash of orange acrylic, which won't be diluted by subsequent layers of paint.

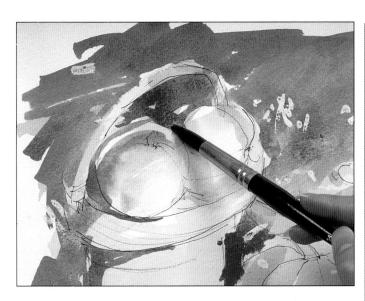

2 When the orange wash is dry, she begins to add various strengths of an ultramarine acrylic wash for the shadows. Some of the masking fluid is removed at this point.

3 Additional colours are built up with watercolour, and finer details are added. The paint is allowed to dry, then any remaining masking fluid is removed.

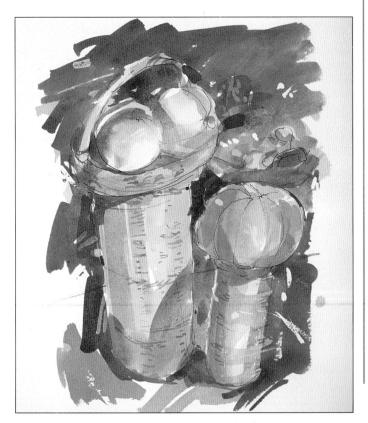

Gum arabic

This is the medium that. together with gelatine, acts as the binder for watercolour pigment (watercolours also contain glycerine to keep them moist).

Gum arabic can be bought in bottled form and is often used as a painting medium. If you add a little gum to your water when mixing paint, it gives it extra body, making it less runny and easier to blend. It is particularly suitable for

the kind of painting that is built up in small, separate brushstrokes, since it prevents them from flowing into one another.

Its other important property is as a varnish. If a dark area of a painting, such as a very deep shadow, has gone dead through too

much overlaying of washes, a light application of gum arabic will revive the colour and give additional richness. It should never be used alone, however, as this could cause cracking.

Experience will teach you how much to dilute it when using it as a painting medium, but a general rule of thumb is that there should be considerably more water than gum (it is sometimes referred to as gum water for this very reason).

The paper is first covered with a pale wash of bluegreen watercolour. When dry, masking fluid is used to mask out the shapes of the fish.

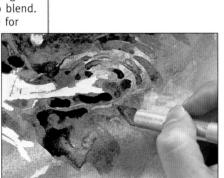

3 Darker washes and highlights are built up in the same way. Additional highlights are lifted out with a craft knife while the ink and gum arabic mixture is damp.

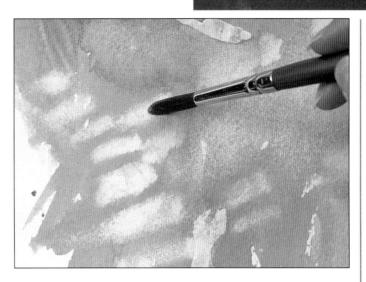

A wash of green and blue ink mixed with gum arabic is painted over the whole surface. While the wash is still damp, a clean, wet brush is pressed into the wash to lift out highlights in the water. The wash is left to dry completely before the masking fluid is removed.

Hard and soft edges

A wet watercolour wash laid on dry paper forms a shallow pool of colour that, if left undisturbed, will form hard edges as it dries, rather like a tidemark. This can be alarming to the novice, but it is one of the characteristics of the medium that can be used to great advantage. By laying smaller, loose washes over previous dry ones, you can build up a fascinating network of fluid, broken lines that not only help to define form but give a sparkling quality to the work. This is an excellent method for building up irregular, natural forms such as clouds, rocks or ripples on water.

You will not necessarily want to use the same technique in every part of the painting. A combination of hard and soft edges describes the subject more successfully and gives more variety.

There are several ways of avoiding hard edges. One is to work wet-in-wet by dampening the paper before laying the first wash and then working subsequent colours into it before it dries so that they blend into one another with subtle transitions. A wash on dry paper can be softened and drawn out at the edges by using a sponge, paintbrush or cotton bud dipped in clean water to remove the excess paint. A wash 'dragged' or 'pulled' over dry paper with either a brush or sponge will also dry without hard edges, since the paint is prevented from forming a pool.

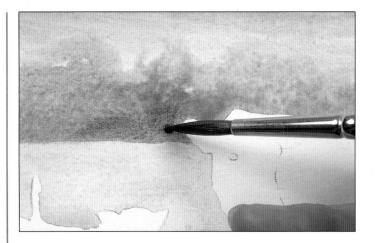

The artist lays a pale wash of cobalt blue to the sky, and a wash of the same blue mixed with yellow to the middle ground. She works WET-ON-DRY, taking care to paint around the outlines of the cows. While the sky is still damp, she works WET-IN-WET, applying a wash of indigo and sepia down to the horizon line and allowing the colours to bleed together naturally.

She paints in the foreground, using a stronger green than in step 1 and leaving some white highlights. She paints in the shadows on the cows, the fence rail and posts and the grass with a wash of indigo and sepia, working WET-ON-DRY so that hard edges form.

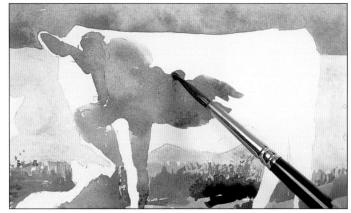

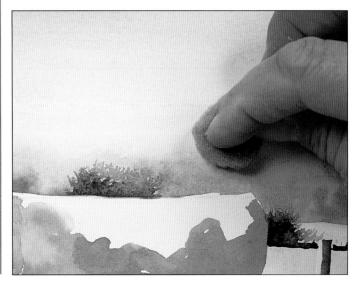

3 She then returns to the background and paints in the trees with a mix of cobalt blue and burnt sienna. Where these dark shapes meet the cow's silhouette, they reinforce the hard, crisp edge. She dabs the sky with a damp sponge to soften the outline of the clouds.

4 | All the paint is left to dry before any further painting is done.

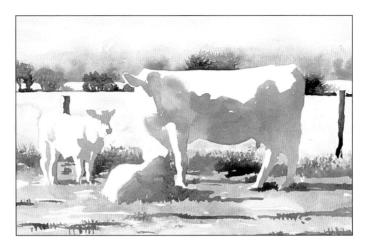

5 She then applies a wash of deep sienna for the patches on the cows, taking it over the underpainted shadows.

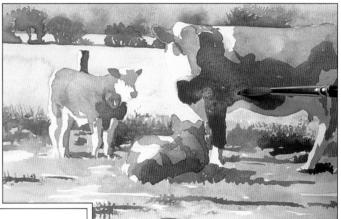

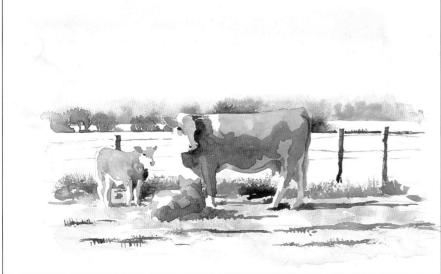

6 ▮ To complete the picture, she uses a deeper mix of indigo and sepia for the shadows around the animals' heads and for their facial features, all of which helps to define the forms further.

Highlights

The light reflecting off white paper is an integral part of a watercolour painting, giving good watercolours their lovely translucent quality. For this reason, the most effective way of creating pure, sparkling highlights is to 'reserve' any areas that are to be white by painting around them. This means that when you begin a painting, you must have a clear idea of where the highlights are to be, so some advance planning is necessary.

Not all highlights, of course, are pure white: in a painting where all the tones are dark, too many whites could be over-emphatic. Thus, before the painting has advanced very far, you will have to decide whether to reserve areas of an initial pale wash or to build up really dark tones around a later, mid-toned one.

When you lay a wash around an area to be reserved for a highlight, it will dry with a hard edge. This can be very effective, but it may not be what you want, for example, on a rounded object such as a piece of fruit. In such cases, you can achieve a gentler transition by softening the edge with a brush, small sponge or cotton bud dipped in water.

Small highlights, such as the points of light in eyes or the tiny sparkles seen on sunlit, rippling water, which are virtually impossible to reserve, can either be achieved by MASKING or added with thick Chinese white or zinc white gouache paint as a final stage. Highlights can also be made by removing paint (see LIFTING OUT and SCRAPING BACK).

1 To ensure that highlights will not be lost when washes are added, the artist applies masking fluid to those parts of the petals that catch the light. She then paints washes of green and yellow on the background, working WET-IN-WET.

While the background is drying, she paints the pots, again working wet-in-wet and leaving white highlights along the rims and the left-hand edge. When all the paint is dry, she begins on the leaves, using a warm green and leaving patches of white paper for highlights.

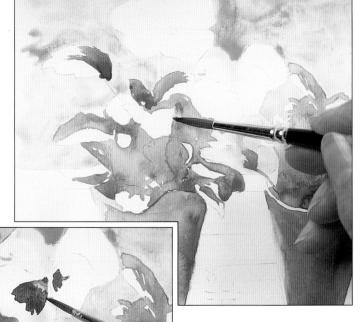

3 She paints the petals in the same way.

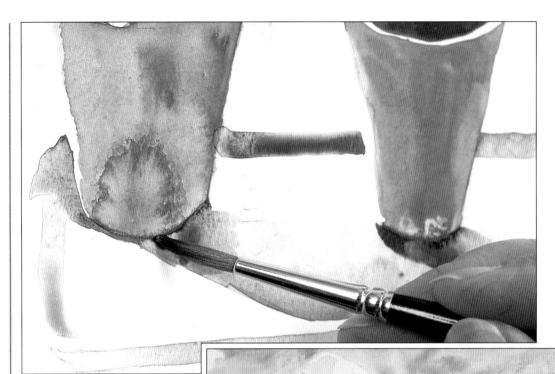

In order to 'attach' the pots to the surface so that they don't appear to float, she paints shadows beneath them, using a mixture of ultramarine and sepia. She uses the same mix for the shadow along the inner edge of the tray.

Lifting out

Removing paint from the paper is not only a correction method, it is a watercolour technique in its own right and can be used to great effect to soften edges, diffuse and modify colour and create those HIGHLIGHTS that cannot be reserved. For instance, the effect of streaked wind clouds in a blue sky is quickly and easily created by laying a blue wash and wiping a dry sponge, paintbrush or paper towel across it while it is still wet. The white tops of cumulus clouds can be suggested by dabbing the wet paint with a sponge or some blotting paper.

Paint can also be lifted out when dry by using a dampened sponge or other such tool, but the success of the method depends both on the colour to be lifted and the type of paper used. Certain colours, such as sap green and phthalocyanine blue, act rather like dyes, staining the paper, while some papers absorb the paint, making it hard to move it around. Bockingford, Saunders and Cotman papers are all excellent for lifting out in this way. Another useful aid to lifting out is GUM ARABIC. Add it in small quantities to the colour you intend to remove partially.

Large areas of dry paint can be lifted with a dampened sponge, but for smaller ones, the most useful tool is a cotton bud, using gentle pressure to prevent the stick poking through and scratching the surface of the paper.

1 First, a loose, uneven wash is laid down for the sky. While the paint is still wet, cloud shapes are lifted out by pressing firmly with paper towel.

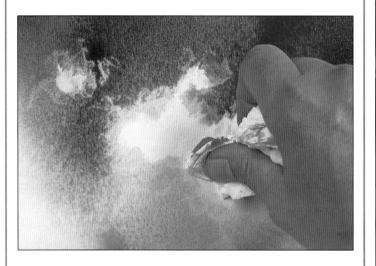

2 By varying the pressure applied, different amounts of colour can be removed. The paper towel can also be rolled to a point to lift out finc detail, as shown here.

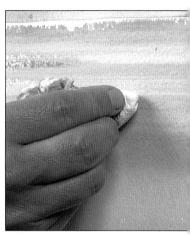

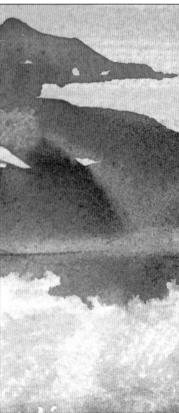

A pale wash is applied for the sea. A piece of paper towel is then dragged across the damp wash to create varying bands of tone and colour. The paint is left to dry.

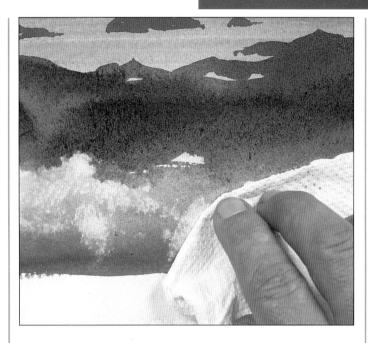

A clean, dry brush is used to lift out colour in the middle distance to suggest a flat area between the hills.

The distant headlands are painted in a grey-blue wash and the hills in the foreground in a deep green. Paper towel is again used to blot up some of the colour in the foreground to suggest forms in the landscape.

Although the palette has been restricted to sombre blues and greens, the finished piece is not lacking in drama, due to the powerful contrasts in tone and texture that the lifting-out technique can produce.

Line and wash

This technique has a long history and is still much used today, particularly for illustrative work. Before the eighteenth century, it had been used mainly to put pale, flat tints over pen drawings, a practice that itself continued the tradition of the pen-and-ink-wash drawings often made by artists as preliminary studies for paintings.

The line and wash technique is particularly well suited to small, delicate subjects, such as plant drawings, or to quick figure studies intended to convey a sense of movement. Rembrandt's sketchbooks are full of monochrome pen and wash drawings, conveying everything he needed to record in a few lines and one or two surely placed tones.

The traditional method is to begin with a pen drawing, leave it to dry, and then lay in fluid, light colour with a brush. One of the difficulties of the technique is to integrate the drawing and the colour in such a way that the washes do not look like a 'colouring in' exercise, so it is often more satisfactory to develop both line and wash at the same time, beginning with some lines and colour and then adding to and strengthening both as necessary. You can also start back to front, as it were, laying down the washes first to establish the main tones and then drawing on top, in which case you will need to begin with a light pencil sketch as a guideline.

To maintain the liveliness of the painting, the artist has deliberately chosen to do the linework in a variety of waterproof and watersoluble felt-tipped pens in different colours, rather than the more usual approach of drawing in a single colour with a single tool. Here, she draws in some of the outlines in green. Other lines are drawn in red or dark blue. (A light pencil underdrawing can be done first, if wished, to provide guidelines for the penwork.)

2 A grey wash is applied to the sky and, in patches, to the boats and foreground, leaving plenty of white space to retain the freshness of the picture. Where the wash has been taken over water-soluble felt-tipped pen, the ink dissolves and bleeds into the damp paper, creating pockets of intense colour.

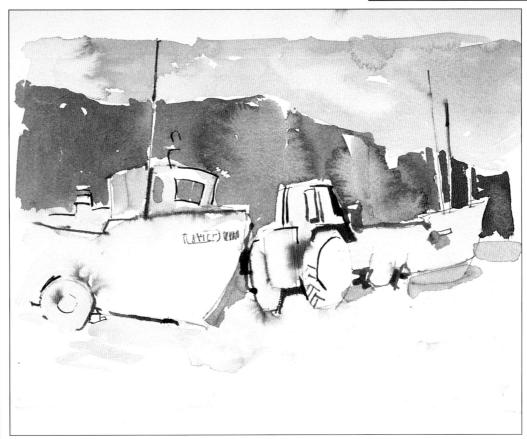

3 To complete the picture, slate-grey and pale crimson washes are applied to the cliffs in the background. When the paint in the foreground is dry, a few small details, such as the name on the boat on the left, are added with felt-tipped pen.

Masking

Some watercolourists feel a certain disdain for masking methods, regarding them as 'cheating', or as being too mechanical. It is true that if they are over-used, they can detract from the spontaneity that we associate with watercolours, but masking is a method that can be used creatively, giving exciting effects that cannot be obtained by using the more classic watercolour techniques.

The two main purposes of masking are to create highlights by reserving certain areas of a painting, and to protect one part of a picture while you work on another. If you have planned a painting that relies for its effect on a series of small, intricate highlights, such as a woodland scene with a pattern of leaves and twigs catching the sunlight, or a seascape where the light creates tiny bright points on choppy water, liquid mask can be the answer.

The liquid is available in two types. One has a slight yellow tint, the other is colourless. Both are applied with a brush and once dry (completely). washes are painted over it. When the painting or the particular area of it is complete, the mask is removed by gently rubbing with a finger or an eraser. Be warned, however: if the paper is too rough or too smooth, it will either be impossible to remove or will spoil the paper - the best surface is a medium one (known as Not).

The beauty of liquid mask is that it is a form of painting in negative – the brushstrokes you use can be as varied in shape as you like, and you can create lovely effects by using thick and thin lines, splodges and little dots. The advantage of the yellow-tinted fluid is that you can see how the brushstrokes look as you apply them, whereas with the white version, it is rather a matter of guesswork. The disadvantage is that the yellow patches are always visible as you paint and tend to give a false idea of the colour values.

Sometimes a painting needs to be approached rather carefully and methodically. dealt with in separate parts, and this is where the second main function of masking comes in. Liquid mask or masking tape (ideal for straight lines) can be used as a temporary stop for certain areas of the painting. Suppose vour subject is a lightcoloured, intricately shaped building set against a stormy sky or dark foliage, and you want to build up the background with several layers of colour. Covering the whole area of the building with liquid mask or putting strips of masking tape along the edges will allow you to paint freely without the constant worry of paint spilling over to spoil the sharp, clean lines. Once the background is finished, the mask can be removed, and the rest of the painting carried out as a separate stage. It may be mechanical, but it is a liberating method for anyone who wishes to have complete control over paint.

1 Using a light pencil outline as a guide, the artist begins painting in the petals of the flowers with washes of blue and purple watercolour. She also washes raw umber and burnt sienna over the stems. Patches of deeper blue are applied for the sky. The paint is left to dry completely.

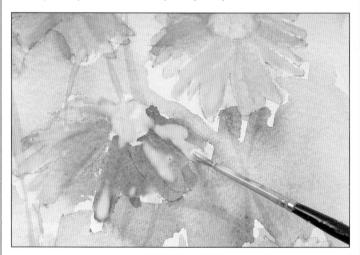

She then masks the flowers and stems with liquid mask and leaves it to dry. Rubbing the paintbrush in wet soap before dipping it in the fluid makes it easier to clean later. The brush should also be cleaned immediately after use. Masking with fluid works best on smoother papers since the fluid can tear the surface of rougher papers when it is rubbed off.

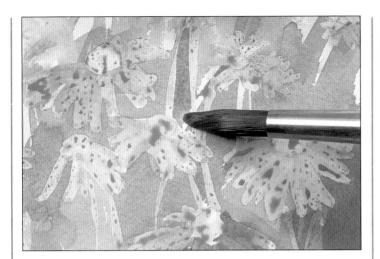

The artist paints a green wash all over the flowers, using directional strokes for the grasses. The paint is left to dry, then a few more stems in the foreground are masked out with fluid.

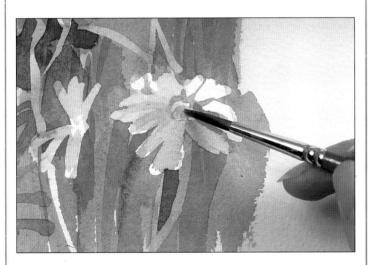

5 Final details, such as the orange hearts of the flowers, are added with a fine brush.

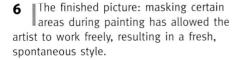

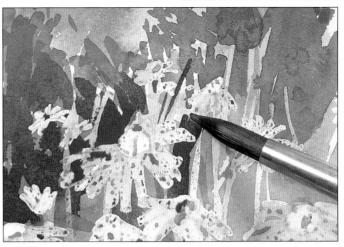

When the liquid mask is dry, she paints darker green over the grasses and on the trees in the background. All the paint is now left to dry fully before the masking fluid is removed.

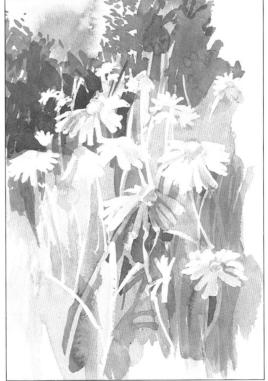

Mixed media

Although many artists know that they can create their best effects with pure watercolour, more and more are breaking away from convention, finding that they can create livelier and more expressive paintings by combining the attributes of several different media.

To some extent, mixing media is a matter of trial and error, and there is now such a diversity of artist's materials that there is no way of prescribing techniques for each one or for each possible combination. However, it can be said that some mixtures are easier to manage than others. Acrylic and watercolour, for example, can be made to blend into one another almost imperceptibly because they have similar characteristics, but two or more physically dissimilar media, such as LINE AND WASH, will automatically set up a contrast. There is nothing wrong with this - it may even be the point of the exercise but it can make it difficult to preserve an overall unity.

The only way to explore the natures of the different materials and find out the most effective means of using them is to try out various combinations. You could use a failed watercolour as a basis – many successful mixed-media paintings are less the result of advance planning than of exploratory reworking.

Watercolour and acrylic Acrylic used thinly, diluted with water but no medium or white,

behaves in more or less the

same way as watercolour. There are two important differences between them. however. One is that acrylic has greater depth of colour so that a first wash can, if desired, be extremely vivid. and the other is that, once dry, the paint cannot be removed. This can be an advantage, as further washes, either in watercolour or acrylic, can be laid over an initial one without disturbing the pigment. The paint need not be applied in thin washes throughout: the combination of shimmering, translucent watercolour and thickly painted areas of acrylic can be very effective, particularly in landscapes with strong foreground interest, where you want to pick out small details like individual flowers or grass heads (very hard to do in watercolour). It is often possible to save an unsuccessful watercolour by turning to acrylic in the later stages.

Watercolour and gouache

These are often used together, and many artists scarcely differentiate between them. However, unless both are used thinly, it can be a more difficult combination to manage, since gouache paint, once mixed with white to make it opaque, has a matt surface, which can make it look dead and dull beside a watercolour wash.

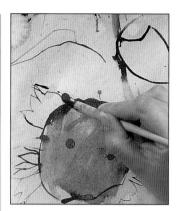

To create a toned ground, cyan acrylic ink is first dripped onto damp paper and spread and rubbed in with paper towel. Using an ink dropper, the artist then draws in some rough outlines with coloured ink. While the ink is still wet, she blocks in areas of darker tone with a paintbrush and ink mixed with gum arabic.

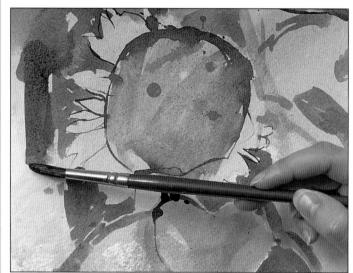

2 She continues to build up the tones, using a mixture of ink and gum arabic.

She paints the sunflower petals in yellow gouache.

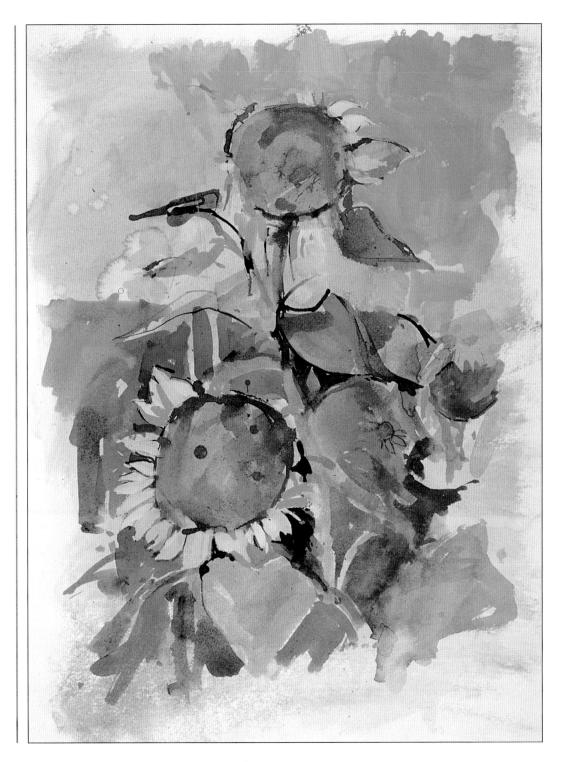

4 The finished picture shows how well the two media complement each other. The patchy, translucent, bluegreen ink washes provide the perfect contrast to the strong, flat, yellow gouache of the flower petals.

Paint and pastel

Soft pastels can be used very successfully with watercolour and provide an excellent means of adding texture and surface interest to a painting.

Sparkling broken colours can be created by overlaying a watercolour wash with light strokes of pastel, particularly on a fairly rough paper.

Oil pastels have a slightly different, but equally interesting, effect. A light layer of oil pastel laid down under a watercolour wash will repel the water to a greater or lesser degree (some oil pastels are oilier than others) so that it sinks only into the troughs of the paper, resulting in a slightly mottled, granular area of colour.

Gouache and pastel

These have been used together since the eighteenth century when pastel was at the height of its popularity as and artist's medium. Some mixed-media techniques are based on the dissimilarity of the elements used, which creates its own kind of tension and dynamism, but these two are natural partners, having a similar matt, chalky quality.

Watercolour crayons

These are, in effect, mixed media in themselves. When dry, they are a drawing medium, but as soon as water is applied to them, they become paint and can be spread with a brush. Very varied effects can be created by using them in a linear manner in some areas of a painting and as paints in others. They can also be combined with traditional watercolours, felt-tipped pens or pen and ink.

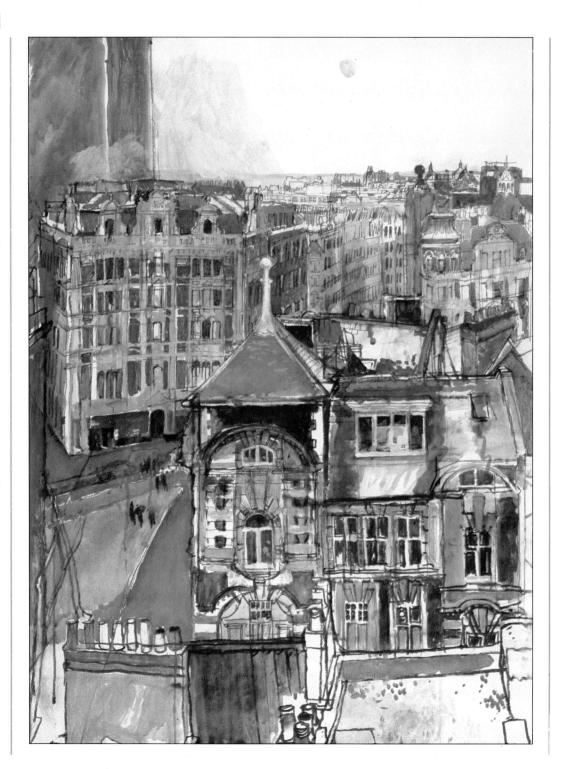

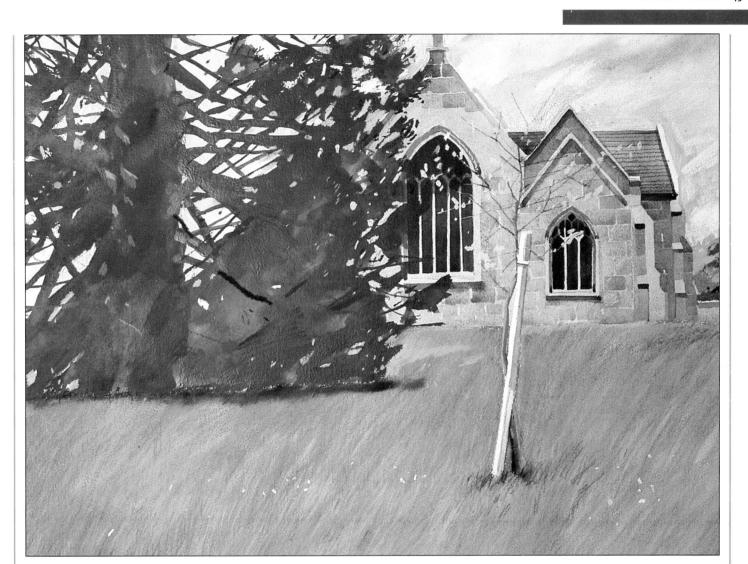

■ Ian Simpson, From St Martins, 84 x 58.5 CM (33 x 23 IN), ACRYLIC, PENCIL AND CHARCOAL

This was painted on the spot (from a window). It began as a charcoal drawing, which was then fixed, and the painting built up with acrylic, pencil and more charcoal. The paint is transparent in places and opaque in others, and large areas of paper have been deliberately left uncovered. ▲ lan Sidaway, Churchyard, 28.6 x 40.6 CM (11½ x 16 IN), WATERCOLOUR, PASTEL AND CONTÉ PENCIL

This combination of media has produced a lively contrast of textures. The building and tree

are pure watercolour, while the sky and grass are pastel worked over an initial watercolour wash. Details have been picked out lightly with conté pencil.

Scraping back

Sometimes called sgraffito, this simply means removing dry paint so that the white paper is revealed. The method is most often used to create the kind of small, fine highlights that cannot be reserved, such as the light catching blades of grass in the foreground of a landscape. It is a more satisfactory method than opaque white applied with a brush, because this tends to look clumsy and, if laid over a dark colour, does not cover it verv well.

Scraping is done with a sharp knife, such as a craft knife, or with a razor blade. For the finest lines, use the point of the knife, but avoid digging it into the paper. A more diffused highlight over a wider area can be made by scraping gently with the side of the knife or with a razor blade, which will remove some of the paint but not all of it.

This technique is not successful unless you use a good-quality, reasonably heavy paper — it should be no lighter than 300 gsm. On a flimsier paper you could easily make holes or spoil the surface.

The same method can be used for gouache and acrylic, but it is essential that the surface is one that can withstand this treatment.

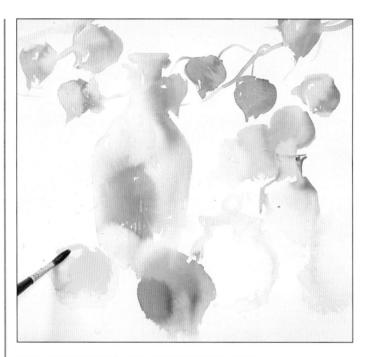

1 For this still life, layers of watercolour wash are first built up in the usual way. The light underpainting will allow for scraping back later.

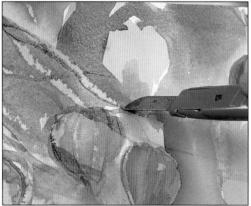

Using a round-bladed craft knife, the artist scrapes away the plant stems. She has chosen to do this while the paint is just damp so that it is easier to remove. Working in this way requires careful judgment. If the paint is loo wel, the colour will simply flow back into the space it previously filled; the paper surface will also be wetter and so more easily torn. If the paint is left to dry completely, however, it can be more difficult to scrape away.

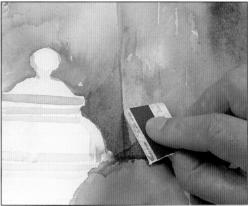

3 Other tools can be used for scraping back. Here, a credit card provides a useful edge for scraping away bands of just-damp colour.

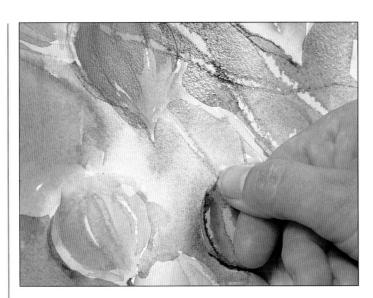

4 A fingernail provides another ready tool for scraping back.

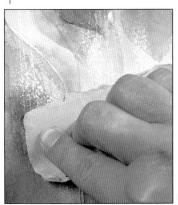

If more highlights are required, the surface may be gently rubbed with sandpaper. This must only be done when the paint is completely dry, or it will rip the surface of the paper. To create shafts of light, the sandpaper can be folded to a knife-edge (below).

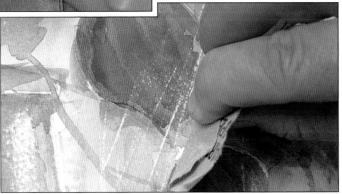

6 Translucent watercolour washes and scraped-back areas give the finished still life a luminous quality.

Scumbling

This is one of the best-known of all techniques for creating texture and BROKEN COLOUR effects, particularly in the opaque media. It involves scrubbing very dry paint unevenly over another layer of dry colour so that the first one shows through, but only partially. It is most frequently used in oil painting, but is in many ways even better suited to acrylic and gouache because they dry so much faster - the oil painter has to wait some time for the first layer to dry.

Scumbling can give amazing richness to colours, creating a lovely glowing effect rather akin to that of a semitransparent fabric with another, solidly coloured one beneath.

There is no standard set of rules for the technique, as it is fundamentally an improvisational one. You can scumble light over dark, dark over light or a vivid colour over a contrasting one, but do not try to use a soft, sable-type brush or the paint will go on too evenly (and you will quickly ruin the brush). A bristle brush is ideal, but other possibilities are stencilling brushes, sponges, crumpled tissue paper or your fingers.

The particular value of the method for gouache is that it allows colours to be overlaid without becoming muddy and dead looking – always a danger with this medium

Scumbling is less well suited to watercolour, but it is possible to adapt the DRY BRUSH method to scumbling, using the paint as thick as possible – even straight from the tube – and working on rough paper.

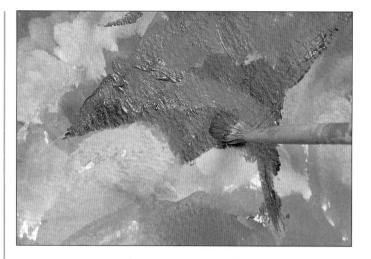

2 She adds in the fine details, such as the nose and mouth and a line for the chin.

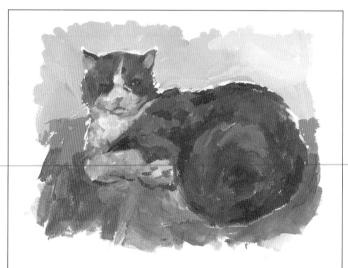

Many 'black' cats are, on closer inspection, really a variety of browns. Scumbling is an ideal technique for conveying the multiplicity of tones that our eyes read as black, as the finished painting clearly shows. Notice, too, how the artist has allowed more of the blue undercoat to show through where she has needed to convey shadow.

Spattering

Spraying or flicking paint onto the paper, once regarded as unorthodox and 'tricksy', is now accepted by most artists as an excellent means of enlivening an area of flat colour or suggesting texture.

Spattering is a somewhat unpredictable method and it takes some practice before you can be sure of the effect it will create, so it is wise to try it out on some spare paper first. Any medium can be used, but the paint must not be too thick or it will cling to the brush. To make a fine spatter, load a toothbrush with fairly thick paint, hold it horizontally above the paper, bristle side down, and run your index finger over the bristles. For a coarser effect, use a bristle brush, loaded with paint of the same consistency, and tap it sharply with the handle of another brush.

The main problem with the method is judging the tone and depth of colour of the spattered paint against that of the colour beneath. If you apply dark paint - and thick watercolour will of necessity be quite dark – over a very pale tint, it may be too obtrusive. The best effects are created when the tonal values are close together. If you are using the technique to suggest the texture of a pebbled or sandy beach, for which it is ideal, you may need to spatter one pale colour over another. In this case the best implement is a mouth diffuser of the kind sold for spraying fixative. The bristle brush method can also be used for watery paint, but will give much larger drops.

The sky is first masked out with a piece of torn paper – a torn, rather than cut, edge gives a more natural line. Low-tack tape can be used to hold the mask in place. The artist then begins spattering greens and yellows onto the paper by running a scalpel over the bristles of a blunt-ended stencilling brush.

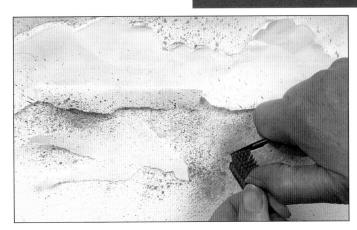

When the first application of paint is dry, she lays more torn paper masks over the surface and begins spattering red paint from a toothbrush. When the masks are lifted, they will leave spattered, red edges suggestive of the drifts of poppies in the field. The artist continues building up the rest of the picture in the same way.

3 When all the paint is dry, she dabs in the larger poppyheads in the foreground with a fine brush. She also paints in the long grasses, the tree trunks, the rooftops and the sky, and adds in shadows where necessary.

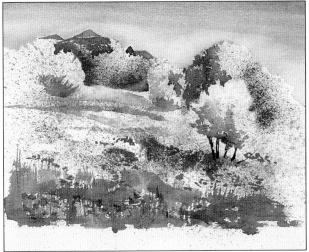

4 Although there are large areas of white in the finished landscape, the almost pointillistic effect of the spattered paint suggests what is not there – and the eye 'fills in' the rest.

Sponge painting

Sponges are an essential part of the artist's tool kit. They are useful for mopping up unwanted paint, cleaning up edges and making corrections, and they can be used for applying paint — either alone or in conjunction with brushes.

Laying a flat wash is just as easy (some claim it is easier) with a sponge as it is with a brush. The only thing it cannot do satisfactorily is take a wash around an intricate edge - for which a brush is best - but if you intend to begin a painting with an overall wash of one colour, a sponge is ideal. For a completely even wash, with no variations, keep the sponge well saturated and squeeze it out gently as you work down the paper. If you want a less regular wash, squeeze some of the paint out so that the sponge is only moistened. This will give a slightly striated effect, which can be effective for skies, seas, the distance in a landscape or a person's hair in a portrait.

Dabbing paint onto paper with a sponge gives an attractive mottled effect, particularly if you use the paint reasonably thick. This method is an excellent way in which to describe texture, and you can suggest form at the same time by applying the paint lightly in some areas and densely in others.

There is no reason why whole paintings should not be worked using this method, but brushes are usually brought into play for the later stages to create fine lines and details.

1 When paint is dabbed on with a sponge, it adheres to the raised parts of the paper. For this reason, the artist has deliberately chosen a rough paper to emphasize the effect. Using a sponge loaded with warm yellow watercolour, she is able to cover large areas quickly, dragging and wiping the colour across the surface.

When the first coat of colour is dry, she dabs on orange watercolour to begin defining the forms.

3 | When the second sponging is dry, she creates more precise areas of shadow using burnt sienna and applying it with a sponge pinched between her fingers to make more exact marks.

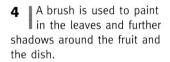

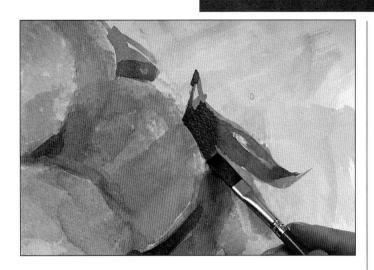

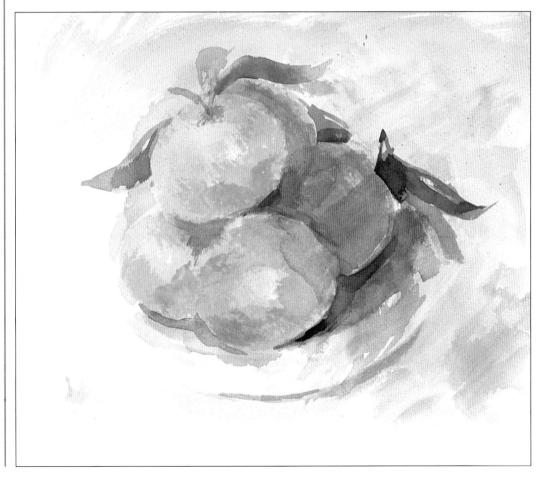

5 The finished painting: the mottled finish that sponging creates is ideal for conveying the pitted surface of fruit such as oranges.

Squaring up

It is not always necessary to begin a painting with a detailed drawing, but some subjects, such as portraits, call for a careful, methodical approach in the early stages.

One way of avoiding too much drawing and erasing on the paper, which can spoil the surface, is to make a smaller study of the subject first and then to transfer it to the watercolour paper by squaring it up to the size desired. A photograph can be used instead of a drawing, but photographs do tend to flatten and distort perspective, and sometimes present an insufficiently clear image, so try to use them only in conjunction with sketches. observation and imagination.

Squaring up is a slightly laborious process, but it is not too difficult and really does pay off when the effect of the painting depends on accuracy.

Using a ruler, draw a measured grid over the study or photograph, then draw another grid on the watercolour paper, using light pencil marks. This must have the same number of squares. but if you want to enlarge the drawing, they must obviously be larger. If you use a 2.5 cm (1 in) grid for your original drawing and a 3.8 cm $(1\frac{1}{2} in)$ one for the painting, it will be one-and-a-half times the size, and so on. When the grid is complete, look carefully at the drawing, note where each line intersects a grid line and transfer the information from one to the other.

The method shown here avoids damaging the original drawing or photograph. A grid is drawn with a felt-tipped pen on a sheet of acetate. The grid is traced from a sheet of graph paper beneath it, which saves time and is very accurate.

The next stage is drawing an enlarged version of the grid on the working paper. A pencil, T-square and ruler are needed for this, and the pencil lines of the transferred grid should be as faint as possible.

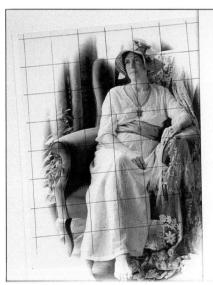

The acetate sheet is then placed over the photograph or working drawing, and the image is transferred to the working paper square by square. This process should not be rushed

and the work should be checked carefully as it progresses, or part of the composition could be placed in the wrong square.

4 Dividing the square up diagonally into triangles breaks the original image up into even smaller segments, thus providing an even more exact grid to work from.

Stippling

This is a method of applying paint in a series of separate, small marks made with the point of the brush, so that the whole image consists of tiny dots of different colours. It was and still is a technique favoured by painters of miniatures, and is seldom used for large paintings for obvious reasons. However, for anyone who enjoys small-scale work and the challenge of a slow and deliberate approach, it is an attractive method and can produce lovely results quite unlike those of any other watercolour technique.

The success of stippled paintings relies on the separateness of each dot: the colours and tones should blend together in the viewer's eve rather than physically on the paper. Like all watercolours they are built up from light to dark, with highlights left white or only lightly covered so that the white ground shows through, while dark areas are built up gradually with increasingly dense brushmarks. However, it is certainly possible to use BODY COLOUR to emphasize the smaller highlights and to establish a larger, darker area of colour by laying a preliminary wash.

The beauty of the technique is that it allows you to use a great variety of colours within one small area – a shadow could consist of a whole spectrum of deep blues, violets, greens and browns. As long as they are all close enough in tone, they will still 'read' as one colour, but a more ambiguous and evocative one than would be produced by a flat wash of dark green.

1 The main areas of colour are first laid down, using flat, background washes.

2 The artist then begins building up the shadows, stippling on tiny dots of blue and blue-grey around the outline of the statuette, to define its shape.

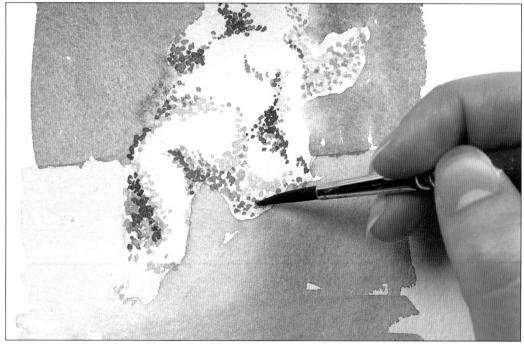

The artist uses the same stippling technique on the background, applying dots of various colours all over this area, and, to a lesser extent, over the foreground. Where the shadows need to be darkest, the dots are heavily worked to become almost a solid tone.

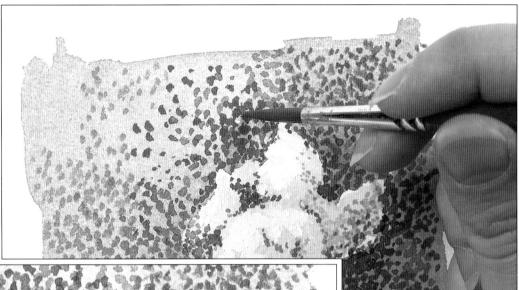

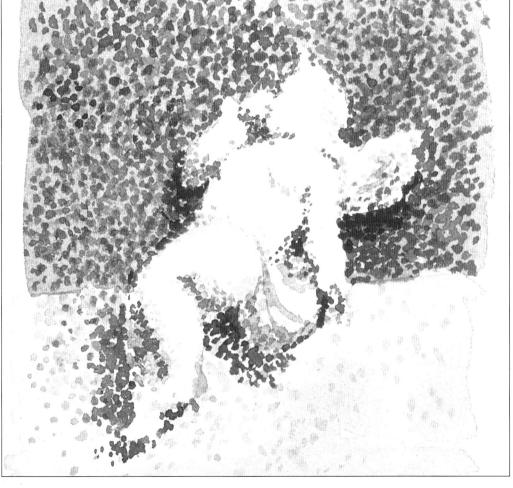

4 | The eye 'mixes' the various colours of the dots in the finished piece and 'reads' them as single colours. However, stippling creates more lively surface interest than if solid colours had been used.

Stretching paper

This is not strictly speaking a technique, but it is included here because so many watercolour techniques depend upon it. Wet paint causes paper to buckle, and lighter papers will remain buckled even when dry. This not only spoils the picture but is a hindrance to the work in progress, because you cannot place a flat wash on an unevenly corrugated surface. Novice painters tend to be daunted by this task, but it is not difficult, nor is it always necessary – heavier papers do not require stretching. As a general rule of thumb, any paper over 400 gsm can be used without this treatment. though even a 400 gsm paper can buckle slightly if you use a lot of water, for example, when working WET-IN-WET.

The only real problem with stretching is that it requires preplanning, since the paper takes a long time to dry, so if you intend to paint in the morning, prepare the paper the night before.

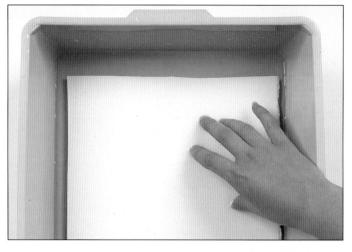

1 The paper is fully immersed in water and left to soak so that it absorbs water on both sides.

The paper is removed and gently shaken to remove any excess water. It is placed on a board and smoothed down, working from the centre, to ensure that no air bubbles are trapped underneath.

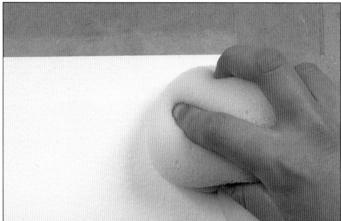

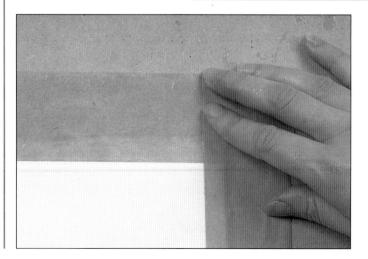

Four lengths of gummed strip are cut to go around all four sides of the paper. Each of these is dampened in turn – ideally they should be the same dampness as the paper for even drying – and then smoothed down along the edges of the paper to secure it to the board. The two long edges should be pasted down first. When all four sides of the paper have been pasted down, the paper should be left to dry naturally.

Textures

There are two main kinds of texture in painting; surface texture, in which the paint itself is built up or manipulated in some way to create what is known as surface interest: and imitative texture, in which a certain technique is employed to provide the pictorial equivalent of a texture seen in nature. These overlap to some extent: surface texture is sometimes seen as an end in itself, but in many cases it is a welcome by-product of the attempt to turn the three-dimensional world into a convincing twodimensional image.

Surface texture

Since watercolours are applied in thin layers, they cannot be built up to form surface texture, but this can be provided instead by the grain of the paper. There are a great many watercolour papers on the market, some of which particularly the handmade varieties – are so rough that they appear almost to be embossed. Rough papers can give exciting effects, because the paint will settle unevenly (and not always predictably). breaking up each area of colour and leaving flecks of white showing through. Reserved highlights on rough paper stand out with great brilliance - because the edges are slightly ragged, the white areas appear to be standing proud of the surrounding colours.

Acrylic paints are ideal for creating surface interest because they can be used both thickly and thinly in the same painting, providing a

lively contrast. You can vary the brushmarks, using fine, delicate strokes in some places and large, sweeping ones in others. You can put on slabs of paint with a knife, and you can even mix the paint with sand or sawdust to give it an intriguing. grainy look.

Imitative texture

Several of the best-known techniques for making paint resemble rocks, tree bark, fabrics and so on are described in other entries (see DRY BRUSH, SCUMBLING, SPATTERING. SPONGE PAINTING, WAX RESIST), but there are some other tricks of the trade. One of these unconventional but effective is to mix watercolour paint with soap. The soap thickens the paint without destroying its translucency. Soapy paint stavs where you put it instead of flowing outward, and allows you to use inventive brushwork to describe both textures and forms.

Intriguingly unpredictable effects can be obtained by a variation of the resist technique. If you lay down some turpentine or paint thinner on the paper and then paint over it, the paint and the oil will separate to give a marbled appearance. A slightly similar effect can be gained by dropping crystals of sea salt into wet paint. Leave it to dry, brush off the salt, and you will see pale, snowflake shapes where the salt has absorbed the surrounding paint. If the crystals are close together, these shapes will run into one another to form a large mottled blob resembling weathered rock.

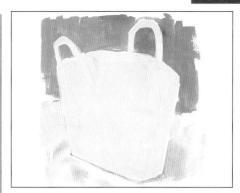

The basket is first drawn in lightly, and then washes are applied to the background. foreground and to the basket itself. The paint is left to dry completely.

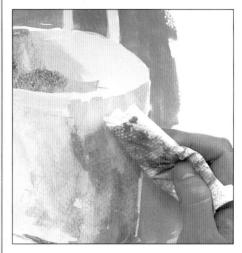

Shadowed areas are painted in, and, while the paint is still wet, the textured side of a piece of paper towel is pressed into it to lift off some of the paint and leave an imprint of the paper behind. The paint is then left to drv.

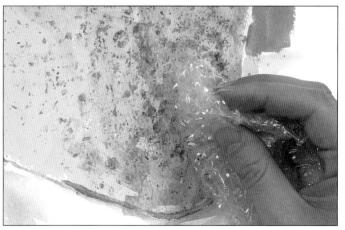

Spots of darker colour are then dabbed onto the basket using bubble wrap, bubble-side out, to suggest the mottled. textured weave of the basket.

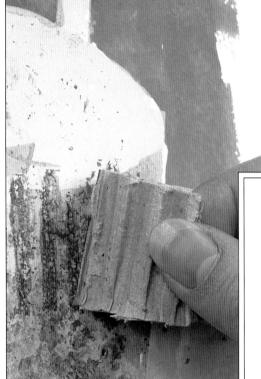

4 When this is dry, a strip of corrugated cardboard is used to apply paint for the woven border along the top edge of the basket.

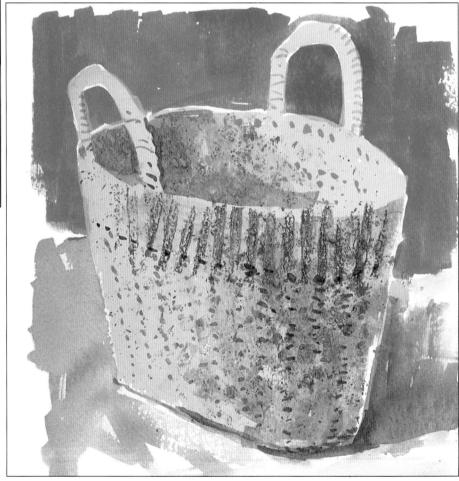

5 An imaginative application of paint, using the kind of scrap materials that most people have in their homes, has resulted in the almost tactile surface texture of this basket.

Toned ground

For a picture that is planned as an exercise in dark, rich tones and colours, it can be an advantage to begin with a pretinted ground. It is possible to buy heavy coloured papers for watercolour work, few of the smaller, less specialist art supply shops stock them.

A quick and simple way to pretint watercolour paper is to lay an overall wash of thinned acrylic (after STRETCHING THE PAPER). The colour, when dry, will be permanent.

The advantages of toned grounds are twofold. First, they help you to achieve unity of colour because the ground shows through the applied colours to some extent, particularly if you leave small patches uncovered. Second, they allow you to build up deep colours with fewer washes, thus avoiding the risk of muddying. They are especially well suited to opaque gouache work where muddying occurs very easily.

The main problem with pretinting is deciding what colour to use. Some artists like to paint a cool picture, such as a snow scene, on a warm, yellow ochre ground so that the blues, blue-whites and greys are heightened by small amounts of yellow showing through. Others prefer cool grounds for cool paintings and warm ground for warm ones. You need to think carefully about the overall colour key of the painting, and you will probably have to try out one or two ground colours.

1 The subject matter is lightly sketched in, and the paper is then tinted with a wash of raw umber acrylic paint. The paint is initially applied with a brush and then rubbed with tissue to create a slightly uneven, patchy finish.

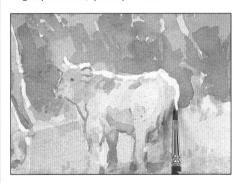

White gouache mixed with watercolour is applied for the highlights on the animals, tree and buttercups.

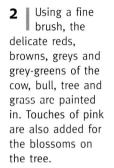

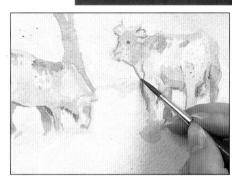

A green wash is applied for the hedge, and a DRY-BRUSH technique is used to emphasize patches of grass.

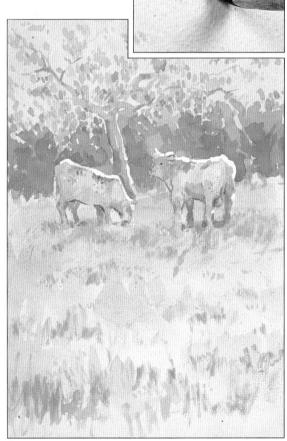

Underpainting

This involves building up a painting over a monochrome tonal foundation. You can see the effects of underpainting if you have ever had to wash down a watercolour by dunking it in a sink. Faint shadows of the original will remain, which can often provide a good basis for the next attempt. This kind of 'accidental' underpainting highlights the value of a deliberately planned one: establishing the tonal balance of a painting is not always easy, and doing this at the outset means you do not have to alter or correct (and possibly overwork) the painting later on.

It is essential to use a pale colour that will not interfere with the colours to be placed on top. In a predominantly green landscape, for instance, blue would be a good choice and, since blues tend to stain the paper, a blue wash is less likely to be disturbed by subsequent washes. The paper should be a fairly absorbent one, such as Arches, which allows the undercolour to sink into it. Any areas to be reserved as bright highlights should, of course, be left uncovered.

An underpainting for acrylic is much less restricted because it will be permanent when dry and the tonal range can be greater because the later colours can be used opaquely to cover the first one. Underpainting also provides a good basis for GLAZING.

The artist has decided to build up this painting entirely in gouache. Using an outline pencil drawing as a guide, she underpaints in blue, blue-green and violet gouache. She reserves areas for the lilies and statues.

2 She paints the statue in mixtures of orange, terracotta and white. She also fills in the green and yellow of the foliage, taking care not to obliterate the underpainting completely so that some of the colour still shows through.

3 The browns of the tree trunk are applied over the violet underpainting. As a finishing touch, the artist dabs in the hearts of the lilies with orange gouache.

Wash

Flat wash

The term 'wash' is a rather confusing one, as it implies a relatively broad area of paint applied flatly, but it is also sometimes used by watercolour painters to describe each brushstroke of fluid paint, however small it may be. Here it refers only to paint laid over an area too large to be covered by one brushstroke.

A flat wash in watercolour. thinned gouache or acrylic can be laid either with a large brush or a sponge (see SPONGE PAINTING), and the paper is usually dampened to allow the paint to spread more easily. although this is not essential. Washes must be applied fast, so mix plenty of paint before beginning - you always need more than you think. Tilt the board slightly so that the brushstrokes flow into each other but do not dribble down the paper. Load the brush with paint, sweep it horizontally across the paper, starting at the top, and immediately lay another line below it, working in the opposite direction. Keep the brush loaded for each stroke and continue working in alternate directions until the area is covered.

Sometimes it is necessary to lay a wash around an intricate shape. In this case the wash must start at the bottom, not at the top, to allow you to paint carefully around the shapes, so you will have to turn the board upside down. If you are dampening the paper first, dampen only up to the edge, because the paint will flow into any wet part of the paper.

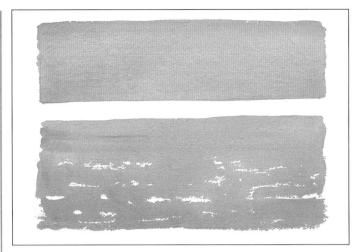

The artist applies a flat wash of blue to the sky and leaves it to dry. She then applies a VARIEGATED WASH (see page 63) to the foreground, painting a band of brownish-crimson above and a wider band of violet below, and allowing the two to blend into each other. Notice how she has exploited the slightly patchy quality of the foreground wash to create white highlights.

When all the paint is dry, she applies a gold wash to the strip of unpainted white paper in the middle, to suggest the distant cornfield.

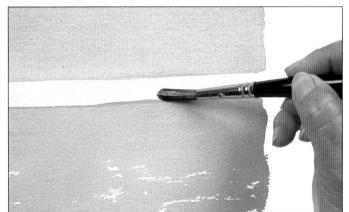

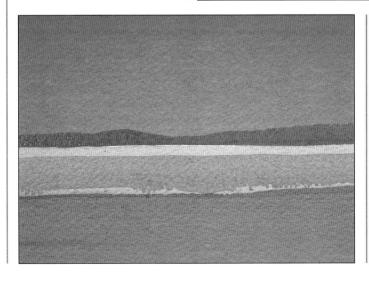

When the gold wash is dry, she overlays it with a band of green. She also paints in the hills in the background with a stronger version of the wash she used for the sky.

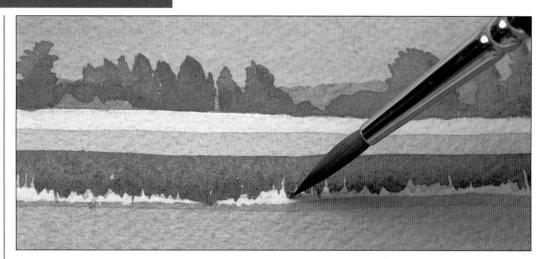

4 ■ Using a stronger version of the green wash in step 3, she paints in the trees. She also paints a band of the same green for the shadow along the front of the cornfield, feathering the lower edge with her brush to suggest the stalks of corn.

■ She paints in foreground detail. Then, having laid a mask over the painting, she spatters on a little paint to create some surface texture.

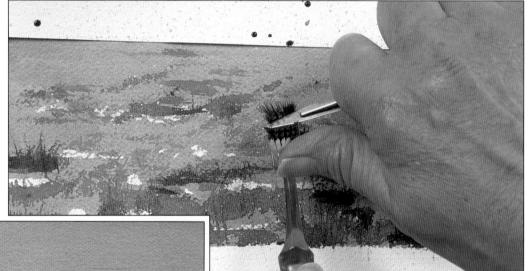

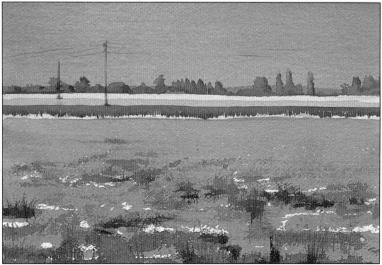

6 ▮ To complete the picture, she paints in the telegraph poles and cables with a fine brush. With the addition of a little extra detail, a landscape with great depth and sense of light has been built up using just three main washes.

Gradated and variegated

Colours in nature are seldom flat and uniform, and it is often necessary to lay a wash that shifts in tone from dark to light or one that contains two or more different colours.

A gradated wash shades from dark to light, and is laid in the same way as a flat wash, the only difference being that more water is added to the pigment for each successive line of paint. It is a little tricky to achieve a really even gradation, because too much water in one line or not enough in another will result in a striped effect. Keep the paint as fluid as possible so that

Keep the paint as fluid as possible so that each brushstroke flows into the one below, and never be tempted to work back into the wash if it does not come out as you wished. You may find a sponge gives better results than a brush, because it is easier to control the amount of water you use.

Variegated washes are those using more than one colour and are much less predictable than flat or gradated ones. However, you can achieve very exciting, if unexpected, results by allowing colours to bleed into one another.

If you intend to paint a sky at sunset, blending from blue at the top to yellows, oranges and reds at the bottom, mix three or four suitable colours on your palette and lay them in strips one under the other on dampened paper so that they blend gently into one another.

1 Starting on the sky, the artist paints a very dilute purple wash down as far as the horizon line.

2 While the paint is still wet, she adds a wash of cobalt blue mixed with sepia to the upper part of the sky, and allows the colours to blend naturally. She leaves the sky to dry.

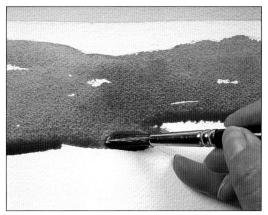

3 She then applies a pale wash of green-gold and sepia to the foreground, leaving areas of white paper for the lakes and the sea. While still wet, she adds a darker wash of cobalt blue and yellow in parts, and allows the two washes to blend and settle naturally.

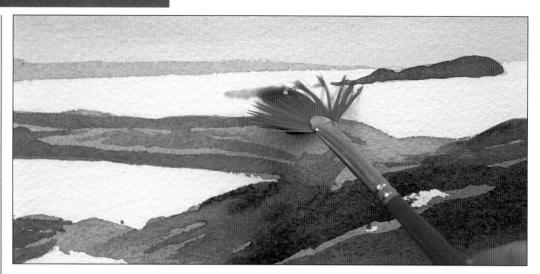

4 ■ The distant hills are painted with a pale purple wash. When this is dry, the artist uses a darker version of the same wash for the closer hills.

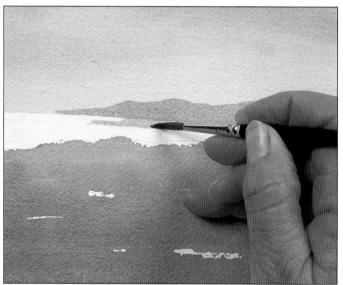

Finally, a paler version of the original wash used for the sky is applied for the reflections on the water.

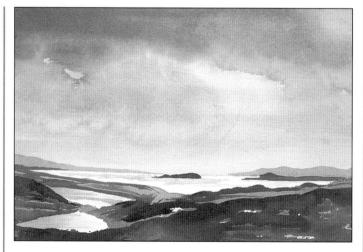

■ The final result: a totally convincing scene of sweeping hills and broad water, stretching as far as the eye can see.

Wash-off

This is an unusual and fascinating technique that exploits the properties of Indian ink and gouache. It is not difficult, but it is slow. involving careful planning and a methodical approach.

Basically, the method involves painting a design with thick gouache paint, covering the whole picture surface with waterproof ink and then holding it under running water. This washes off the soluble paint and the ink that covers it, leaving only the ink in the unpainted areas to form a negative image.

First, the paper must be stretched (see STRETCHING PAPER) - essential, as it has to bear a considerable volume of water. A light wash is then laid over it and left to dry, after which the design is painted on with thick, white gouache paint. White paint must be used. because a colour could stain the paper and destroy the clear, sharp effect. For the same reason, the wash should be as pale as possible: its only purpose is to allow the white paint to show up as you apply it.

Once the paint is thoroughly dry, cover the whole picture surface with waterproof ink (make sure it really is waterproof and is clearly marked as such on the bottle). Allow the ink to dry completely before washing it off.

The 'negative' can either be left as a black-and-white image, or it can be worked into with new colours, using gouache, watercolour or acrylic.

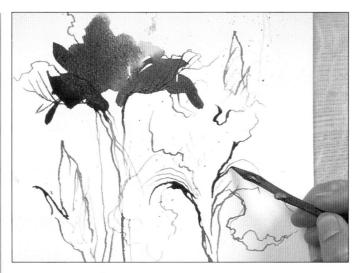

Outlines are drawn with a sharpened twig dipped in watercolour. The twig makes grooves in the paper into which the paint runs and settles. The artist also begins painting in areas of colour, such as the petals of the flowers.

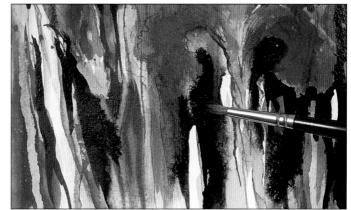

■ When more colour has been added and the paint is semidry to dry, the artist gently trickles water over it, turning the paper around to control the amount of paint washed off, and leaving some areas stained with colour.

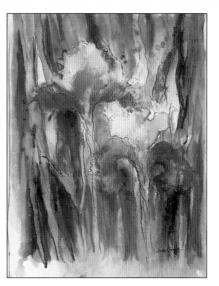

Black ink is added to parts of the painting, for example, between the stems of the flowers. This is left until semi-dry and then carefully washed off as before.

4 The wash-off technique gives an attractive, softly stained quality to the finished flower painting.

Wax resist

This, a valuable addition to the watercolourist's repertoire, is a technique based on the antipathy of oil and water, and involves deliberately repelling paint from certain areas of the paper while allowing it to settle on others.

The idea is simple, but can yield magical results. If you draw over paper with wax and then overlay this with watercolour, the paint will slide off the waxed areas. You can use either an ordinary household candle or inexpensive wax crayons. The British sculptor Henry Moore (1898–1986), also a draftsman of great imagination, used crayons and watercolour for his series of drawings of sleeping figures in the London Underground during World War II.

The wax underdrawing can be as simple or as complex as you like. You can suggest a hint of pattern on wallpaper in a portrait by means of a few lines, dots or blobs made with a candle or make an intricate drawing using crayons, which have good points.

Wax beneath watercolour gives a delightfully unpredictable speckled effect, which varies according to the pressure you apply and the type of paper you use. It is one of the best methods for imitating natural textures, such as those of rocks, cliffs or tree trunks, but like all tricks of the trade, should be reserved for certain areas of the painting only, since textured areas make more of an impact if they are juxtaposed with smooth.

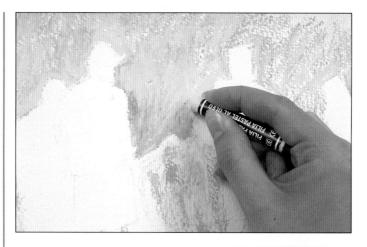

1 Having first lightly pencilled in the outlines of the figures, the artist roughly scribbles over the sunlit background and trees using a white wax candle and green and yellow oil pastels.

Dark shades of watercolour were then flooded over the whole area. The waxy parts reject the watercolour, but where there are tiny gaps in the waxy surface the colour adheres, creating broken shapes and a speckled effect that is characteristic of the wax resist technique.

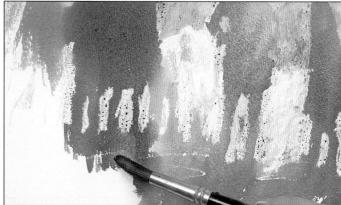

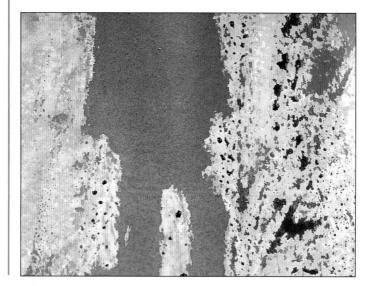

It is difficult to achieve even coverage of the surface using a waxy medium, as seen here in close-up. However, the relative unpredictability of this technique is part of its charm, and adds valuable surface texture to the finished painting.

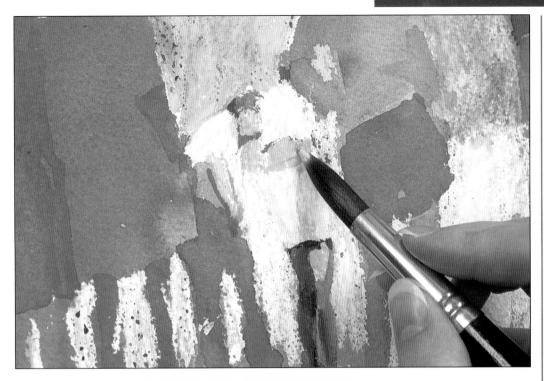

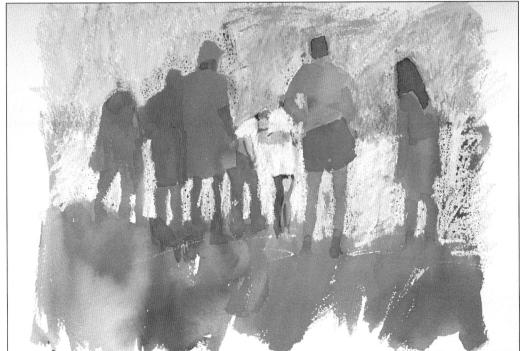

■ The finished piece shows I just how effective the wax resist technique can be. The sunlit background and the shadowy forms in the foreground are suggested with just enough tone and detail in the lightest, most impressionistic way. The trick here, as always, is knowing when to stop, to avoid overworking and ruining the painting. Notice, too, the clever contrast between the bright, acid tones of the background and the cooler, deeper tones of the figures.

Wet-in-wet

This means exactly what its name implies - applying each new colour without waiting for earlier ones to dry, so that they run together with no hard edges or sharp transitions. This is a technique that is only partially controllable, but it is a very enjoyable and challenging one for precisely this reason. Any of the waterbased media can be used, providing no opaque pigment is added, but in the case of acrylic, it is helpful to add retarding medium to the paint to prolong drying time.

The paper must first be well dampened and must not be allowed to dry completely at any time. This means, first, that you must stretch the paper (unless it is a really heavy one of at least 400 gsm) and second, that you must work fast. Paradoxically, when you keep all the colours wet, they will not actually mix. although they will bleed into one another. Placing a loaded brush of wet paint on top of a wet wash of a different colour is a little like dropping a pebble into water; the weight of the water in the new brushstroke causes the first colour to pull away.

The danger with painting a whole picture wet-in-wet is that it may look altogether too formless and undefined. The technique is most effective when it is offset by edges and linear definition, so when you feel you have gone as far as you can, let the painting dry, take a long, hard look at it and decide where you might need to sharpen it up.

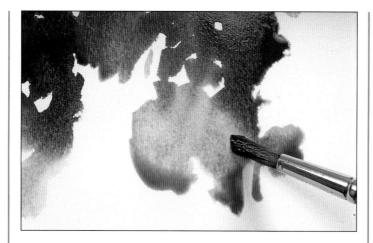

Here, the artist has decided not to dampen a large area of paper first into which the colour would flood, but to rely to a large extent on the wetness of the paint itself. She starts in the middle of the painting, dropping in very wet washes in a fairly random way and allowing the colours to bleed into each other.

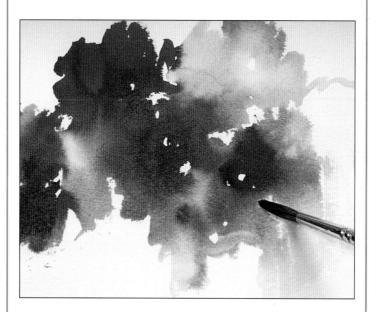

2 Her technique can be seen working here as the crisp edges of the flowers begin to form at the limit of the paint's spread.

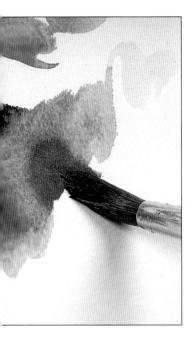

3 ■ Using the same technique as for the flowers, she begins dropping in greens and vellows for the foliage. Notice how the colours flow into each other. It is important to allow them to mix naturally on the paper - interfering in the blending process could result in muddy colors.

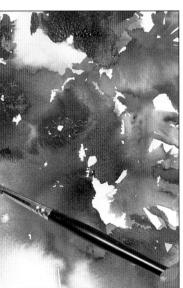

4 | While the paint dries, she watches to see what forms have appeared and, where necessary, drops in a little more colour into patches of still-damp paint. She can then begin the final stage of adding in fine lines and other details where needed.

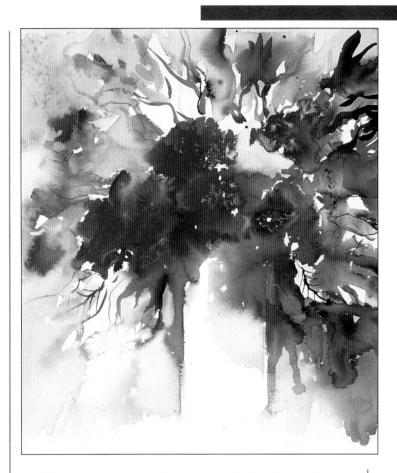

5 The exuberant mass of flowers is perfectly offset by the barely worked form of the straight-sided vase, which has largely been left white.

LIBRARY LAUDER COLLEGE

Wet-on-dry

Laying new (hence wet) washes over earlier ones that have been allowed to dry is the classic method of building up a watercolour. Because it is difficult to achieve great depth of colour with a preliminary wash, the darker and richer areas of a painting are achieved by overlaying colours in successive layers.

One of the more irritating aspects of watercolour work is that of having to wait. sometimes for long periods. for paint to dry before the next colour is added. It is perfectly permissible to use a hairdryer to hasten the process, but avoid using it on really wet paint, because you can find you are blowing a carefully placed wash all over the paper. It is equally permissible, of course, to paint some parts of a picture weton-dry and others wet-in-wet: indeed the most exciting effects are achieved by combining the two methods. The danger with wet-on-dry is that you can allow too many layers to accumulate and muddy the colours, so if you are working mainly in flat washes, always try to make the first one really positive.

In acrylic, wet-on-dry is the most natural way to work, since the paint dries very quickly, but gouache, although also fast-drying, presents more of a problem. To work wet-ondry in gouache, begin by using the paint like watercolour (with water but no white) and gradually build up to thicker layers, One thick layer over another will result in a dull, muddy effect.

The artist lays down washes to establish the main areas of colour on the head, clothing and background. She uses combinations of alizarin crimson, cobalt blue, raw sienna, raw umber, cobalt green and transparent yellow. The washes are allowed to dry completely before any further work is done.

2 She now begins to build up the tones to give form to the portrait. Using clean water and a clean brush, she lightly dampens the area to be worked into. She then applies the paint so that it spreads slightly into the dampened area, avoiding hard edges.

She continues building up the painting, layer by layer. It is important that each layer is dry before the next is added, or the colours will bleed into each other. Notice how the artist varies the brushes she uses, depending on the type of mark she wishes to make.

4 Using a very fine brush, she adds in detail, such as the outline of the lips. If a very crisp line is required, she does not dampen the previous layer of paint, but paints directly onto the dry wash.

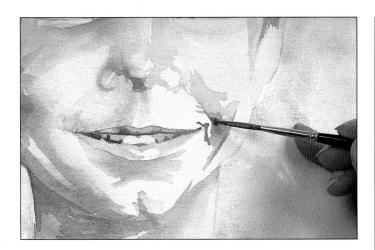

5 She adds further washes to deepen the background tones where the background meets the lighter side of the face.

Note the careful contrasts between light and dark.

The background is darkest where it meets the lightest parts of the face, but lightest against shadowed areas. These contrasts in tone serve to push the background back visually and bring the head forward, creating the illusion that it is a separate, three-dimensional form in space.

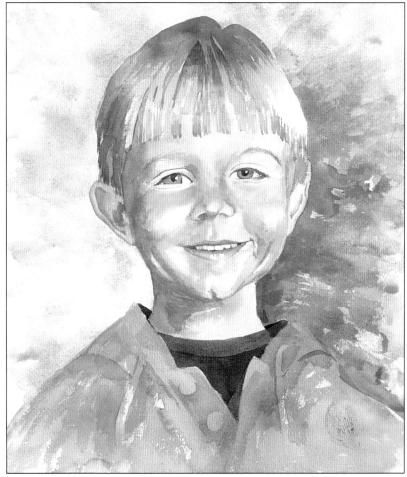

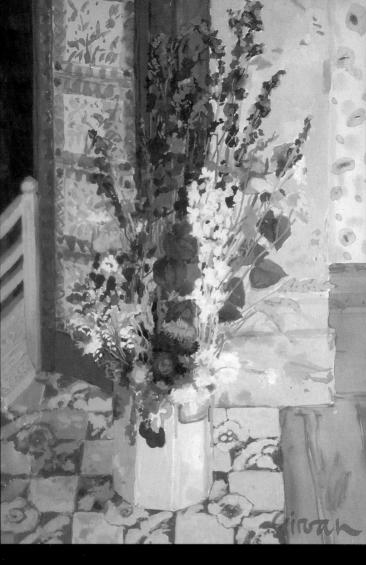

Geraldine Girvan,
Flowers in the Hearth,
271/8 x 191/4 IN (68.9 x 48.9 CM),
GOUACHE

This artist loves colour and pattern, and finds that gouache is the medium best suited to her particular preoccupations.

PART TWO THEMES

In the first part of the book I outlined the techniques most frequently used by watercolour painters as well as introducing some of the more unusual and unconventional ones. I hope that these will provide some food for thought and experiment, but it is important to remember also that painting techniques are no more than vehicles for the expresssion of ideas. My aim in this second part of the book is to show you, by means of step-by-step demonstrations and finished paintings, how other artists have harnessed their technical skills and experience of the medium to their own vision.

I have chosen eight main themes – animals, the human figure, buildings, flowers, landscape, skies, still life and water. A wide variety of techniques and different approaches is shown in each of these subject areas, together with some explanations of the particular difficulties associated with certain subjects. I hope that everyone will find something to inspire them in the selection of paintings – looking at the work of other artists is never time wasted, and analyzing their methods can often suggest a new direction. Someone who has never dared to paint animals or who has consistently failed with skies may see the perfect method for the first time and say, 'so that's how it's done. I could do that too'. You probably can.

The animal world

The animal kingdom presents the most common of all problems to the would-be recorder of its glories: none of its members stay still long enough to be painted. You can usually bribe a friend to sit reasonably still for a portrait, but you cannot expect the same cooperation from a dog, cat or horse. If movement is the essence of a subject, however, why not learn to make a virtue of it?

Observing movement

Watch an animal carefully and you will notice that the movements it makes, although they may be rapid, are not random – they have certain patterns. If you train yourself to make quick sketches whenever possible and take photographs as an aid to understanding, you will find that painting a moving animal is far from impossible – and it is also deeply rewarding.

We in the twentieth century are lucky, because we benefit from the studies and observations of past generations. We know, for instance, that a horse moves its legs in a certain way in each of its four paces - walking, trotting, cantering and galloping – but when Edgar Degas (1834–1917) began to paint his marvellous racing scenes, he did not fully understand these movements. He painted horses galloping with all four legs outstretched, as they had appeared in English sporting prints. It was only when Eadweard Muybridge (1830-1904) published his series of photographs of animals in motion in 1888 that Degas saw his error and was quick to incorporate the newfound knowledge into his paintings. This confirms the value of the camera as a source of reference, but photographs should never be

slavishly copied, because this will result in a static, unconvincing image.

Understanding the basics

Painters and illustrators who specialize in natural history acquire their knowledge in a wide variety of ways. Many take powerful binoculars and cameras into remote parts of the countryside to watch and record birds and animals in their natural habitats, but they also rely on illustrations and photographs or study stuffed creatures in museums. All this research helps them to understand basic structures, such as the way a bird's wing and tail feathers lie or how a horse's or cow's legs are jointed. In the past, artists were taught that a detailed study of anatomy was necessary before they could even begin to draw or paint any living creature. However, for most of us this depth of study is unnecessary.

Sketching from life

Although background knowledge is helpful because it will enable you to paint with more confidence, books and magazines are never a substitute for direct observation. When you are working outdoors, whether in a zoo or on a farm, try to keep your sketches simple, concentrating on the main lines and shapes without worrying about details such as texture and colouring. If the animal moves while you are in mid-sketch, leave it and start another one - several small drawings on the same page can provide a surprising amount of information. You may find it difficult at first, but quick sketches are a knack, and you really will get better with practice, partly because you will be unconsciously teaching yourself to look hard at your subject in a really analytical and selective way.

Laura Wade, Macaws, WATERCOLOUR, GOUACHE AND PENCILS

The artist has made good use of MIXED MEDIA to build up the birds' vivid colours and delicate textures. Like many professional illustrators, she used photographs as well as drawings from life for her reference; this is the original of a printed illustration in a guide brochure.

Birds

Birds are a perennially appealing subject, but they are also a complex one. The fur of a smooth-haired animal does not obscure the structure beneath, but the feathers of a bird do – if you look at a skeleton in a museum you may find it hard to relate it to the living, feathered reality. To portray a bird convincingly, it is important to understand the framework around which it is 'built', and the way the small feathers follow the contours of the body while those of the wing and tail extend beyond it. Never be ashamed to draw on the store of knowledge built up by others: look through natural history books and photographs in wildlife magazines as well as sketching birds whenever you can.

If you are painting birds in their natural habitat, for instance geese on a river or seagulls circling around a cliff top, you will need to concentrate on shape and movement rather than detail. Both the LINE AND WASH and the BRUSH DRAWING methods are well suited to this kind of broad impression, but the two most exciting features of birds, particularly exotic ones, are colour and texture, so many bird painters employ a more precise technique.

You can practise painting feathers and discover ways of building up texture by working initially from a photograph or another artist's work, or even by painting a stuffed bird. If you find that watercolour is hard to control or becomes overworked, you could try gouache, acrylic or one of the many MIXED MEDIA techniques.

Paul Dawson, *Snowy Owl*, 27.9 x 22.2 cm (11 x 8³/₄ IN), WATERCOLOUR AND GOUACHE

Although the paint has been used thickly in places, this is surprisingly not the case on the bird itself, which was protected with LIQUID MASK throughout the process of building up the background and foreground. The artist wanted the white to be that of the paper (in this case a smooth-surfaced one), which stands out far more brilliantly than opaque white paint.

To achieve the depth of tone in the tree, foliage and grass, Dawson began by laying dark watercolour base washes, over which he worked in gouache. The stones in the foreground are watercolour with gouache stippled on with an old brush with splayed bristles – never throw such brushes away, because they may come in handy later.

The feathers of the bird were then built up carefully with small, delicate brushstrokes, with care taken not to destroy the effect of the white against the deep browns and greens.

David Boys, Sketchbook Studies

Boys is a professional wildlife artist, whose studies, such as those shown here, are used by the London Zoo as part of the information labels outside their aviaries and animal cages. The free and spontaneous appearance of his sketches should not blind us

to the fact that they are extremely accurate, and each one is the end-product of several days of careful observation and constant drawing. However, they provide an excellent example of the use of watercolour as a medium for recording rapid impressions.

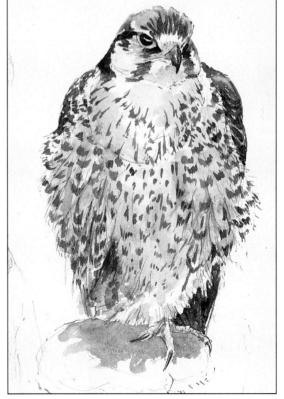

Movement

When we watch an animal in movement, such as a horse galloping, our eyes take in an overall impression of shape and colour without precise details - these become blurred and generalized in direct ratio to the speed of the animal's movement. The best way of capturing the essence of a movement is to choose a technique that in itself suggests it, so try to keep your work free and unfussy, applying the paint fluidly and letting your brush follow the direction of the main lines (see BRUSH DRAWING). Alternatively, you could try watercolour pastels or crayons, which can provide an exciting combination of linear qualities and washes. A sketchy treatment, perhaps with areas of paper left uncovered, will suggest motion much more vividly than a highly finished one - the surest way to 'freeze' a moving animal is to include too much detail. This is exactly what the camera does: a photograph taken at a fast shutter speed gives a false impression because it registers much more than the human eye can. Photographs, though, are enormously useful for helping you to gain an understanding of the way an animal moves, and there is no harm in taking snapshots to use as a 'sketchbook' in combination with observation and on-the-spot studies.

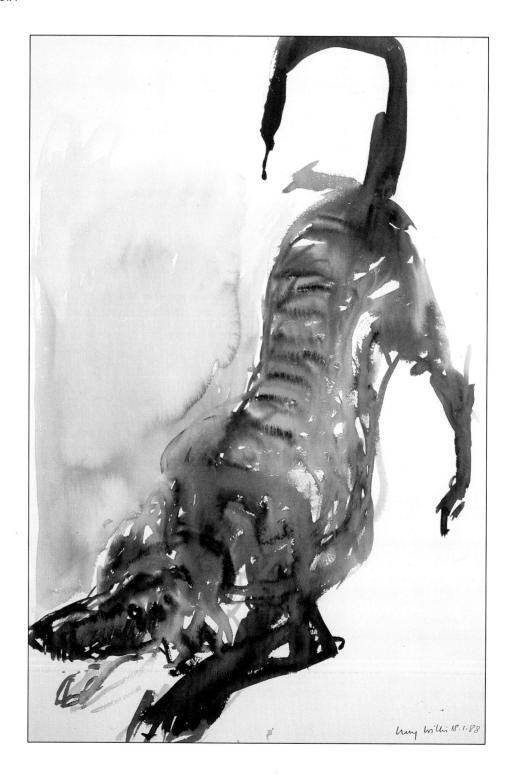

Lucy Willis, Dog with a Stick III, 33.9 x 38.1 CM (22 X 15 IN), WATERCOLOUR

This is a marvellous example of the fluid and vigorous use of paint to convey movement. Willis has painted very rapidly without waiting for washes to dry, so that some brushstrokes on the dog's body have run together. This is particularly effective on the back and shoulders, where small BACKRUNS have been deliberately used to suggest texture. The soft blurring of the paint in these areas is offset by the crisp, linear brushwork on the muzzle and front paws, and a final lively touch is given by the little exclamation mark of paint that has been allowed to run down from the end of the tail.

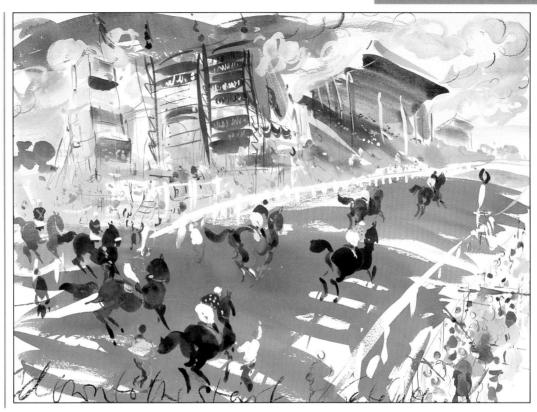

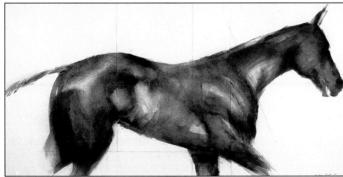

Richard Wills, Bess. 76.2 X 157.5 CM (30 X 62 IN), WATERCOLOUR AND ACRYLIC

This is a studio study of a horse in movement, made after extensive observation and on-the-spot sketches. It is a large painting, necessitating joining paper by splicing it and gluing it to the board, and the joins have become an integral part of the composition. This is a pictorial concept that the artist has taken further in other paintings. The texture on the body has been produced by SPATTERING acrylic paint into wet watercolour.

▲ lake Sutton. Down to the Start, 57.2 X 76.2 CM ($22^{1/2}$ X 30 IN), GOUACHE

Movement forms the main theme of this sparkling picture and is expressed in every area, from the scribbled clouds to the blobs and splashes of paint used for awnings and foreground figures. The artist has avoided any overworking of the paint by painting the horses over the rich green of the turf rather than trying to take the green around the shapes.

Domestic and farm animals

All the best paintings in the history of art are of subjects that the artist is deeply familiar with. Much of John Constable's (1776–1837) artistic output was inspired by his native Suffolk. So if you want to paint animals and have a captive subject, such as your own pet, why not start at home?

One of the great advantages of pets is that they are always around and you can make studies of them sleeping (cats are particularly good for this), running, eating or simply sitting in contemplation. If you live in the country, on or near a farm, sheep, cows and goats are also willing models, since they tend to stand still for long periods when grazing.

One of the most common mistakes in painting an animal is to pay too little attention to its environment, so that it appears to be floating in midair. Always try to integrate the animal with the background and foreground, blurring the edges in places to avoid a cardboard cut-out effect.

The techniques you use are entirely a matter of personal preference and will be dictated by your particular interests, but if you opt for a very precise method, using small brushstrokes to build up the texture of an animal's fur or wool, you must use the same approach throughout the painting or the picture will look disjointed.

Lucy Willis, *Lefteri Milking*, 28.6 x 38.5 cm (11½ x 15½ IN), WATERCOLOUR

Willis works directly from life, using a heavy paper that does not need to be stretched, a limited palette and usually only one brush. She says that her aim is simply to translate to paper a selected chunk of what she sees, but she always spends some time looking at her subject before she starts to paint, in order to impress upon herself exactly what it is she is aiming for. Her most frequent preoccupations are with colour and light. beautifully conveyed here, as in most of her watercolours. Notice the attractive sparkle given by little patches of white paper left uncovered between brushstrokes.

■ Ronald Jesty, Shandie,
27.9 CM (11 IN) DIAMETER,
WATERCOLOUR

Although this is not a particularly small picture, the artist has chosen a circular format reminiscent of a miniature for his delightful dog portrait and has adapted his technique to suit the idea. His usual style, illustrated elsewhere in this book, is a precise vet bold use of WET-ON-DRY, but here, although still working wet-on-dry, he has used very fine, linear brushstrokes to build up the texture of the fur. The buildings behind are treated in equal detail, but with the tones and colours carefully controlled so that they recede into the background.

Richard Wills, White Horse, 76.2 x 50.8 cm (30 x 20 IN), WATERCOLOUR AND ACRYLIC

Wills' control of watercolour is quite breathtaking, and here he has used the most delicate of colours to build up a complex series of forms. Where each pale wash overlaps another, a hard line is formed (see HARD AND SOFT EDGES), and these have been used with absolute precision to define the bony structure of the head and sinewy strength of the neck. This crispness contrasts with the softer areas worked wet-in-wet, with a light SPATTERING of acrylic into wet watercolour blurring the forms and shadows.

Wild animals

Painting wild creatures in their natural habitats is becoming an increasingly specialized branch of art, mainly because it involves so much more than simply painting. Professional wildlife artists devote their lives to watching and studying birds and animals in the field. often using sophisticated equipment such as powerful binoculars and cameras with telephoto lenses. However, this does not mean that wild animals are beyond the reach of the ordinary artist. Wildlife is the bread and butter of these specialist painters, and their patrons often require a high standard of accuracy, but not all animals need be so constrained.

There is no need, either, to choose inaccessible subjects. Deer, for example, are eminently paintable and will often come quite close to the viewer in country parks, while shyer, more exotic creatures can be studied and sketched at zoos. A zoo, of course, is not a true habitat for a lion. tiger, or monkey, so if you want to use such sketches for a finished painting of a tiger in a forest, you may have to resort to books and magazines for a suitable setting. There is nothing wrong with this - after all, not everyone has the opportunity to paint the forests of Asia and Africa from first-hand experience.

John Wilder, *Brown Hare*, 38.1 x 50.8 cm (15 x 20 IN), GOUACHE

It may seem surprising that this lovely, delicate painting was done in gouache, but it provides an excellent demonstration of the versatility of the medium. Although usually associated with bright, bold work, it can be used as effectively for thin. pastel-coloured washes as for vivid, rich impastos. One of its problems is that it dries out very quickly on the palette, but Wilder solves this by using a version of the special palette sold for acrylic, a simple

device consisting of wet blotting paper under a layer of parchment paper. The paints are laid out on the parchment and, if covered between working sessions, will stay moist indefinitely.

He started by transferring the main outlines from a working drawing and then laid several very pale overall base washes before beginning to build up the head and body of the hare. Because he likes to leave the outline vague and the brushwork blurred until the final stages, his working process is one of continual painting, blurring, redefining, overpainting and removing

excess paint by sponging or scraping.

The grass was painted when the hare was almost complete, beginning with barely coloured water and very gradually increasing the strength. The final touch was to wash over the hare once or twice with the background colour, to unify the composition and avoid the cardboard cut-out look seen in many less successful animal paintings.

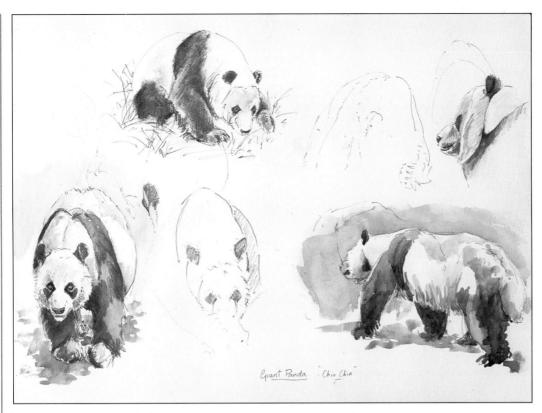

David Boys, Chia-Chia, SKETCHBOOK PAGE, WATERCOLOUR AND PENCIL

These studies of the giant panda Chia-Chia are the work of the London Zoo artist whose bird sketches are shown on page 77. Although he is a professional wildlife artist, drawing and painting primarily to record precise information, he takes an obvious delight in the watercolour medium, which he uses with great fluency. Notice how the colours have run into one another on the legs of the right-hand panda. This is the result of working on highly sized paper, which can produce interesting results.

Sally Michel, Ring-tailed Lemur, WATERCOLOUR AND GOUACHE

Michel trained as an illustrator, but began to exhibit paintings when her book illustration work decreased. She became a wildlife artist more or less by accident and is also well known as a painter of cat and dog portraits. She works in both pastel and watercolour and always from life, although she sometimes takes photographs to record a particular pose.

Textures

The fur of an animal or the feathers of a bird are among their most attractive features, but they do present certain potential problems.

One is that too much attention to texture – the animal's 'outer covering' – can obscure the underlying form and structure, so you must be careful to paint textures in a way that hints at the body beneath. Perspective makes all objects appear smaller as they recede into the distance, and in the same way, the brushstrokes you make to represent fur must vary in size, becoming smaller as the form recedes away from you.

The other problem is the more technical one of how to represent soft fur or stiff, bristly hair with an aqueous medium. Take heart — this is not a real problem at all, but only in the mind, springing from the widely held belief that watercolour can only be used in a broad and fluid manner. In fact, the medium is an extremely versatile one, as can be seen from the illustrations in this book.

Fine, linear brushstrokes are an excellent way of painting fur or feathers and, if necessary, the paint can be thickened with opaque white to give it extra body. Another useful technique is DRY BRUSH. which can be worked over a preliminary wash or straight onto white paper, while the perfect method for highlighting tiny details, such as whiskers catching the light, is SCRAPING BACK with the point of a knife, which gives an infinitely finer line than can be achieved with a brush.

► Mary Ann Rogers, March Hares, 50 x 38 CM (20 x 15 IN), WATERCOLOUR

A huge, pointed brush was the perfect tool for quickly establishing the shape of the two boxing hares – little else was used to capture their fleeting movements. The grainy surface of the rapidly applied washes suggests the velvety texture of the hares' coats.

■ Mary Ann Rogers, Hare, 26 x 20 cm (10½ x 8 IN), WATERCOLOUR

← Mary Ann Rogers, Guinea Fowl.

WATERCOLOUR

45 X 37 CM (18 X 143/4 IN),

The speckled feather patterns

on these guinea fowl provided

the ideal opportunity to try

including SPATTERING masking

fluid and paint, and blowing

all her work, the artist takes

she finds exciting.

an experimental approach – it

is the act of painting itself that

paint onto the birds' heads. In

out some fun techniques,

This bounding hare was the result of a series of experiments, including washing paint away from the initial wash when almost dry.

Look Back. 35 X 50 CM (14 X 20 IN), WATERCOLOUR

Working loosely and freely into an initial wash, the artist has 'sketched' in the feathers even the drips of paint contribute to the effect.

Mary Ann Rogers, Three Tupps, 45 x 35 CM (18 x 14 IN), WATERCOLOUR

A sensitivity to texture and pattern marks the work of

A Mary Ann Rogers, Matador, 45 X 40 CM(18 X 16 IN), WATERCOLOUR

Linear brushstrokes, over pale washes, convey the patterning of this bird's feathers.

Mary Ann Rogers. Here, the contrasting textures of horn and fleece are rendered with a couple of loose initial washes. A few defining marks were added to bring the whole composition together.

Buildings

A lot of people steer clear of painting buildings because they feel they cannot draw well enough or are unable to come to grips with perspective. This is a pity, as buildings form a major part of today's landscape.

Perspective and proportion

If you want to make detailed, accurate and highly finished paintings of complex architectural subjects, such as the great palaces and cathedrals of Europe, a knowledge of perspective is vital, as are sound drawing skills. This is a specialized kind of painting, but most people have humbler aims, and it is perfectly possible to produce a broad impression of such subjects or a convincing portrayal of a rural church, farmhouse or street scene mainly by means of careful observation. Too much worrying about perspective can actually have a negative effect, causing you to overlook far more interesting things, such as a building's character, colour and texture. However, there is one important rule: receding parallel lines meet at a vanishing point on the horizon. The horizon is at your own evelevel, and so is determined by the place you have chosen to paint from. If you are on a hill looking down on your subject, the horizon will be high and the parallels will slope up to it, but if you are sitting directly beneath a tall building, they will slope sharply down to a low horizon. It is vital to remember this when painting on the spot, because if you alter your position, for example, by sitting down when you began the painting standing at an easel, the perspective will change, and this can be disconcerting.

If you intend to paint a 'portrait' of a particular

building, shape and proportion are just as important as they are in a portrait of a person – these give a building its individuality. A common mistake is to misrepresent the size and shape of doors, windows and so on in relation to the wall area, which not only makes it fail as a portrait, but also creates a disturbing impression, as the building looks structurally impossible.

Before you start to draw or paint, look hard at the building and try to assess its particular qualities. Some houses are tall and thin with windows and doors occupying only a small part of each wall, while others seem to be dominated by their windows. In a street scene, there may be several completely different types of building, built at various periods, and all with distinct characters of their own.

Shapes and proportions can be checked by a simple measuring system. Hold a pencil or a small pocket ruler up in front of you and slide your thumb up and down it to work out the height or width of a door or window in relation to those of the main wall. Most professional artists do this; the human eye is surprisingly trustworthy when it comes to architecture.

The straight line problem

Unless you are a trained draftsman or just one of those lucky people, it can be extraordinarily hard to draw and paint straight lines, and a building that tilts to one side or that has outer walls that are not parallel to each other can ruin the impression of solidity as well as looking bizarre. The ruler is useful here, too – there is nothing wrong with using mechanical aids for your preliminary drawing. You can apply colours as freely as you like once you have a good foundation, using the ruled lines as a general guide.

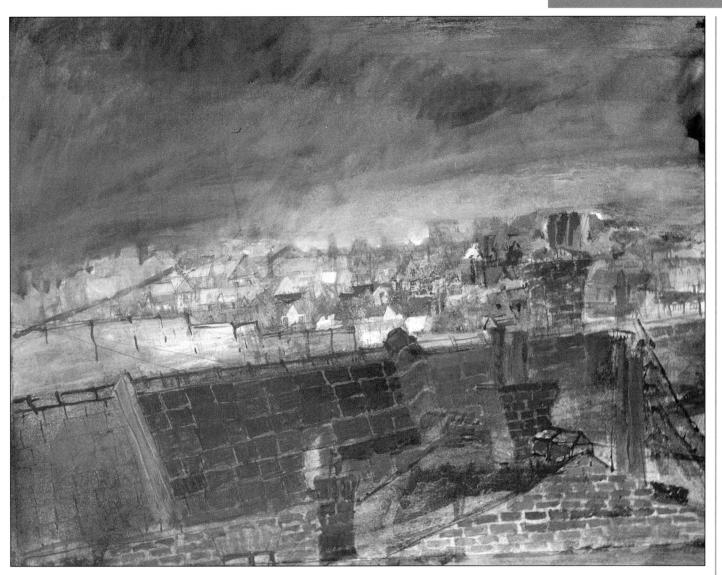

Julia Gurney, *Studio View*, 14 x 18 IN (35.6 x 45.7 cm), WATERCOLOUR, ACRYLIC AND INK

Paintings of buildings do not have to be minutely observed and correct in every detail. Here the artist has taken a broader approach, conveying the atmosphere of the city houses under a stormy sky through her bold and decisive use of MIXED MEDIA. Detail is restricted to the foreground, which she has emphasized by picking out the pattern of the bricks and tiles.

Towns and cityscapes

In industrialized countries, the rural populations are far outnumbered by those of towns and cities, and yet cityscapes do not rank high in popularity as painting subjects. This is perhaps not very surprising. Although most city dwellers can see a wealth of rich subject matter in their surroundings colours, textures, shapes and patterns - the prospect of painting them in a convincing manner seems daunting. There is perspective to contend with, not to mention the straight lines and the complex array of architectural details.

Town houses and streets, however, are marvellous subjects. It is mainly a matter of deciding what interests you and making sure that your technique expresses it. An artist whose obsession is architecture may want to paint panoramic townscapes, using fine, precise brushwork to describe every detail, but another might be concerned exclusively with the interplay of geometric shapes or the quality of light, using a broader, more impressionistic technique.

Start in a small way, perhaps with the view from an upstalrs window, which provides an interesting viewpoint as well as intriguing details you would not see from street level. Practise drawing whenever possible, and avoid tackling over-ambitious projects until you are sure your skills are up to them, because this could lead to frustration and put you off the whole subject.

Sandra Walker, *Grand Street*, 76.2 x 101.6 cm (30 x 40 IN), WATERCOLOUR

The sheer complexity of this New York cityscape, with its multitude of different shapes, colours and forms, would be enough to daunt most watercolourists. But Walker has been equal to the task, producing a busy and lively composition in which, there is no labouring of the paint, although every detail has received loving attention. Sandra Walker, *Brad Street II*, 55.9 x 76.2 cm (22 x 30 IN) WATERCOLOUR

Walker is fascinated by the atmosphere and textures of buildings and has painted a series of large watercolours of London's crumbling East End, of which this is one. Her draftsmanship is superb, and her paintings are remarkable for their accuracy of detail. She has built up texture by a combination of SPATTERING, DRY BRUSH, and scraping with a razor blade.

Martin Taylor, Up the Garden Path, 53 X 39.5 CM (207/8 X 151/2 IN), WATERCOLOUR AND ACRYLIC

Taylor, like Sandra Walker, loves detail and includes every brick, tile, flagstone and blade of grass in his townscapes. He paints slowly, working on one area of the picture at a time, and achieves depth and variety of colour by considerable overlaying of brushstrokes and washes.

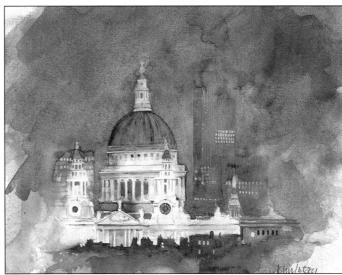

John Lidzey FRSA, St Pauls at Night, 35.6 x 40.6 CM (14 x 16 IN), WATERCOLOUR WITH SOME BODY COLOUR

The freedom of this wonderfully atmospheric painting contrasts strongly with the tighter techniques seen elsewhere on these pages. But it has to be said that the most spontaneousseeming effects in watercolour are usually the result of a thorough knowledge of the medium, and so it is here. The artist began with a careful

drawing, a prerequisite for complex architectural subjects. Having given himself a firm foundation, he was then able to apply the paint freely, with a large, soft mop brush, controlling it on the paper with a piece of damp cotton wool. He proceeded by allowing clean water to flow on freshly painted areas, blotting out as necessary. The details were added wet-on-dry, but softened with damp cotton wool in order to keep the same effect throughout the painting.

Details

A building derives much of its character from the details of its architecture, such as doors, windows, balconies and decorative brick- and stonework, all of which make lovely painting subjects in themselves. An open shutter casting a shadow on a whitewashed wall, for instance, could make an exciting composition, providing a contrast of colours and an interplay of vertical and diagonal lines. This kind of subject can all too easily become static and dull. however, so try to keep your brushwork lively and varied, using a combination of fluid washes and crisp lines. You may find the LINE AND WASH technique adds this kind of extra dimension, or you could make texture the main theme of the painting, using the salt spattering (see TEXTURES) or WAX RESIST methods.

Try to relate the chosen detail to the structure of the building and be careful about the viewpoint you choose. If you paint a window from straight on, you will not be able to suggest the depth of the recess and hence the thickness of the wall, giving it the appearance of being stuck on rather than built in. Another common mistake when painting windows is to make them the same dark tone all over, but window glass takes its colours and tones from the prevailing light, often reflecting colour from the sky or other buildings or showing glimpses from the room behind. If you look carefully, you will see variations.

Paul Millichip, *Scorched Door*, 55.9 x 40.6 cm (22 x 16 IN), WATERCOLOUR

It takes courage to make an entire composition of one object placed centrally on the paper, but this painting succeeds completely. It is more than just a portrait of a door; it is an essay in colour and technique. Working initially WET-IN-WET, Millichip has introduced an astonishing range of colours to the door. echoing the violet-blues in the shadows below and the warm orange-browns in the two small accents of colour on the right and left of the door. He has been equally cunning in terms of composition. The horizontal bar ties the main shape to the sides of the picture, while the diagonals at the bottom prevent a static look that can result from parallel horizontals.

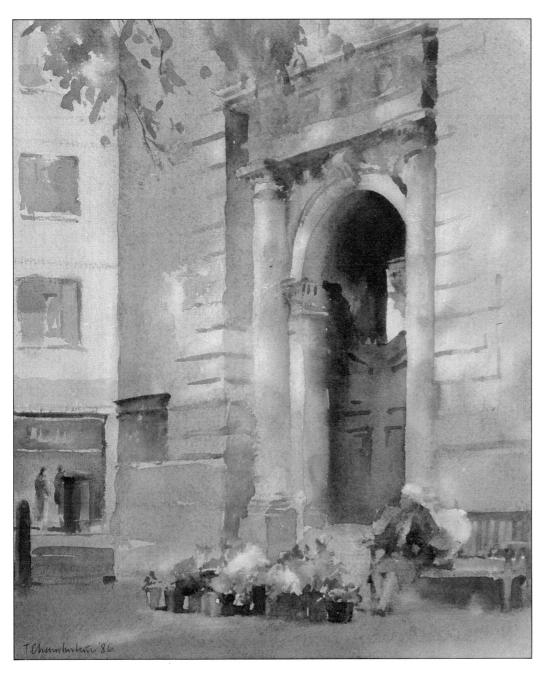

Trevor Chamberlain, The Flower Seller, Bow Church, 26.7 X 22.2 CM ($10^{1/2}$ X $8^{3/4}$ IN), WATERCOLOUR

This is another example of the skilful use of the wet-in-wet technique, and it also provides a lesson on the importance of light in architectural subjects. The artist has clearly been excited by the strong, elegant shapes of the church portico, but the painting is really about the quality of the light he has conveyed through his choice of colours as well as his technique. The colour key is limited, with the same bluegreys and pale yellows repeated throughout the painting to create a gentle and harmonious atmosphere; even the 'red' letter-box and the clumps of flowers are muted versions of their true colours.

Interiors

Interiors are fascinating painting subjects as they provide so many possibilities for experimenting with the effects of light on composition.

Natural interior light is less intense than outdoor light, but it is more varied because the light source is channelled through the relatively small area of a window, creating warm, bright colours in some places and cool, dark ones in others. This also creates interesting patterns. For instance, the light coming in through a window on a sunny day will be partially blocked by the window bars, setting up an interplay of light and dark geometric shapes that can form a strong or dominant element in a painting.

Artificial light also has great potential for pattern and colour. A lamp placed in a dark corner, for example, will throw a strong pool of light below it, and a weaker, more diffused one on the wall behind, breaking up the surfaces into several distinct areas.

These effects of light superimposed on the architectural structure of a room with a framework of verticals and horizontals offers great possibilities. Remember, however, that artificial light is warm and imparts a yellow or orange tinge to colours, so, if you intend to paint a lamp-lit interior, you will find it easier to block out the natural light (or wait until after dark). Natural and artificial light can be mixed, but handling the warm and cool contrasts the mixture provides does require some experience.

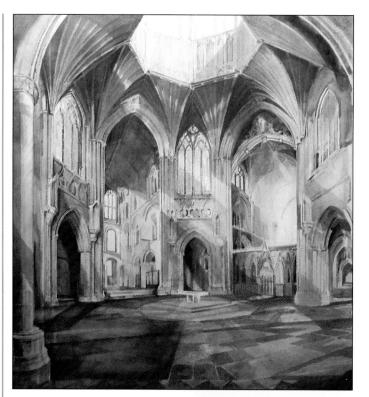

◆ Christopher Baker,Ely Cathedral,66 x 45.7 cm (26 x 18 IN),WATERCOLOUR AND PENCIL

Although we tend to think of painting in terms of colour, it is perfectly possible to 'paint' in monochrome. As can be seen from Baker's sensitive and skilful portraval, it is an effective way of treating complex subjects like this. It is also a good discipline. because it forces you to think about the balance of lights and darks, an important aspect of painting. Baker built up his painting over a careful drawing, working on Hot Pressed (smooth) paper. After carefully modelling the forms, he lightly tinted some areas to provide an overall warmth to the interior.

▶ John Tookey, *London Café*, 21.6 x 29.2 cm (8½ x 11½ IN), WATERCOLOUR WITH SOME GOUACHE

Light coming through a window always creates exciting effects of light and dark, silhouetting some forms and illuminating others, and Tookey has exploited them to the full. Working rapidly on unstretched toned paper, he has boldly blocked in the dark areas, enlivening them with accents of red and yellow. The impressionistic treatment is perfectly suited to the subject.

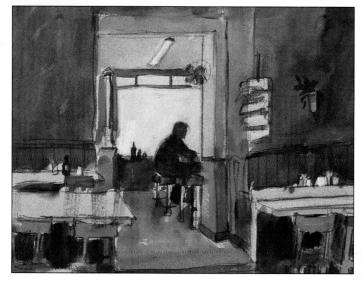

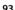

John Lidzey, Interior with Desk and Chair, 66 x 45.7 CM (18 x 24 IN), WATERCOLOUR

Lidzey has achieved a soft, luminous effect by frequently blotting his freely applied paint with damp cotton wool, sometimes completely removing and then reintroducing areas of colour.

This means that there are no obvious brushmarks, and a pleasing, granular texture to the paint. When dry, some areas were wiped with clean water and left again to dry, after which details were reinforced with BODY COLOUR. The houses outside have been 'held back', with the minimum of tonal contrast and detail. to enhance the inside/outside quality and sense of depth.

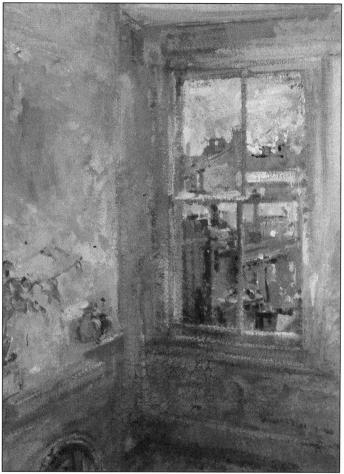

John Martin, Pinda Cottage, 45.7 X 30.5 CM (18 X 12 IN), GOUACHE ON TONED PAPER

In two of the paintings on these pages, the window is the main light source, but here light also appears to be coming into the room from another source on the right, giving a more even illumination with less contrast of tone. The focal point, however, is the window, with its framed view of the buildings outside, towards

which we are led by the diagonals of the left-hand wall. Martin is particularly fond of interior scenes, as he is of the gouache medium, which allows him to build up rich but subtle colour surfaces.

Lighting

Light is the single most important factor in all painting: without it, nothing would exist. It is particularly vital when painting buildings, since it is the play of light and shade on their vertical planes that describes their structure and illuminates their colour and texture. A building seen at noon will tend to look flat and uninteresting because the shadows cast by an overhead sun are minimal, but a low sun, in the morning or evening, throws long, slanting shadows that not only help to describe the features of the building, but also provide exciting contrasts of colour and tone. Light like this makes a building come to life - an ordinary, drab, brick-built row house, for instance, or a view of city rooftops and chimneys, will suddenly present a glowing array of colours, from golden yellows and oranges in the sun-struck areas to purples and blues in the shadows.

It is not always colour or detail that you want to emphasize, however. You may be more concerned with the overall shape and want to suppress minor architectural features. In this case, you could use backlighting to give a dramatic or atmospheric impression, silhouetting the massive bulk of a cathedral or a line of rooftops against an evening sky. For this kind of subject, the paint should be used fluidly, applied in broad washes, with any hard edges restricted to the outlines of buildings against sky.

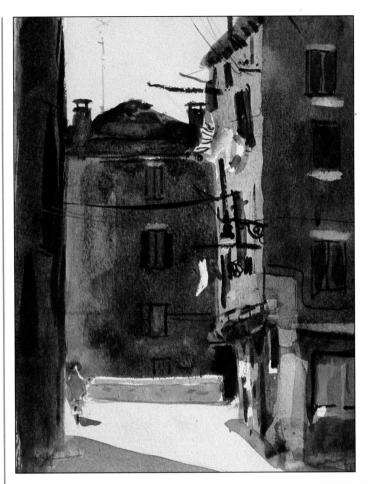

John Tookey,

Venetian Backstreet,

29.2 x 21.6 CM (11½ x 8½ IN),

WATERCOLOUR AND FELT-TIPPED PEN

Imagine what this scene would look like under a flat, grev drizzle - the buildings would hold no interest for an artist because there would be almost no colour or tonal contrast. Tookey has wisely chosen to paint at a time when the sun has turned the right-hand building a rich gold and cast a decisive slanting shadow across the street. His colour scheme is simple but effective: he has enhanced the vellow by using its complementary, blue-violet, repeated in small patches in several places to unify the composition.

Michael Cadman, Gloucester Cathedral III, 35.6 x 48.3 cm (14 x 19 IN), ACRYLIC AND WATERCOLOUR ON TINTED PAPER

A misty, diffused light has allowed the artist to simplify the complex forms of the cathedral. There is a considerable amount of detail on the building, but it is subjugated to shape and colour and the lines have been softened by working into an initial wash which is still damp.

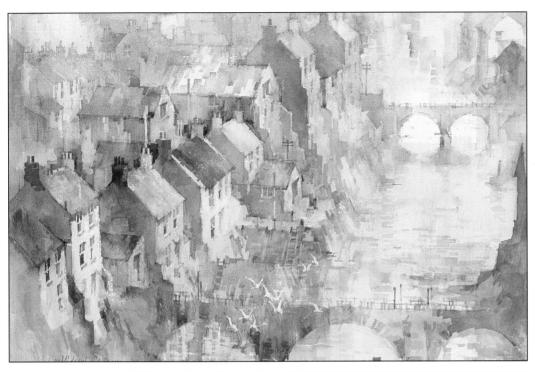

Michael Cadman. A Memory of Whitby, 35.6 x 50.8 cm (14 x 20 IN), ACRYLIC AND WATERCOLOUR

A shaft of sunlight on a misty day has provided both a focal point and a wealth of glowing but subtle colours, which the artist has exploited beautifully. The painting was built up from initial WET-IN-WET washes laid rapidly to cover the white of the paper, and some of the whites and lighter colours were produced by glazing with watercolour over acrylic impasto. The bricklike brushstrokes seen in many of Cadman's paintings are produced by using square-ended brushes (sable and nylon).

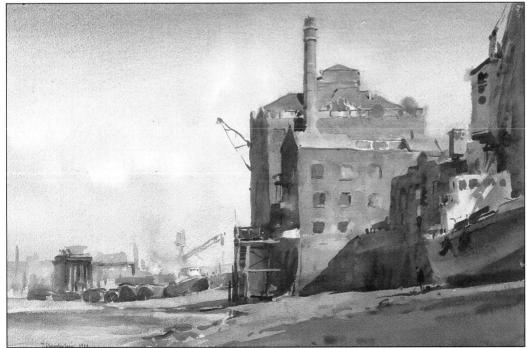

Trevor Chamberlain. Old Wharf at Rotherhithe, 35.6 x 53.3 CM (14 X 21 IN), WATERCOLOUR

A low evening sun is the perfect time for painting buildings, and Chamberlain, whose major interest is the effects of light, has made the most of it. A subject like this one can be quickly spoiled by overworking, and he suits his technique to the subject by working fluidly yet surely with a minimum of overlaid washes.

Viewpoint

The viewpoint you select for an architectural subject needs careful consideration, because it can make all the difference to the composition. This can present you with some problems, however. You might find that sitting on a sidewalk provides an exciting angle for a painting of a city church because the low viewpoint silhouettes it against the sky. but it can be difficult to work in the middle of a busy thoroughfare. It is even more frustrating to find that all the best views are from the middle of a road (they often are because then you are far enough from them to see them in their entirety).

It is a good idea to make one or two preliminary reconnaissances to find the perfect spot. You must be able to see the whole of the building clearly without 'panning' up or down, because as soon as you move, your viewpoint changes — in a small way, but enough to distort the perspective.

Windows are often good vantage points, and painting from the inside looking out has two additional benefits. It shields you from both weather and inquisitive eyes, and the window provides a ready-made frame for your subject.

Angle is important, too. It is difficult to make a building look really solid if you paint it from directly in front, whereas an oblique or corner view provides clearly defined diagonals as well as a more interesting composition.

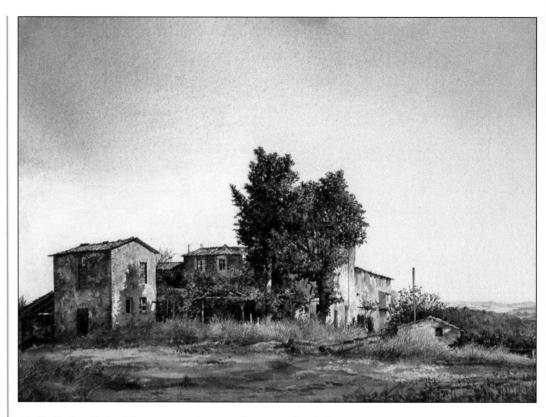

Martin Taylor, *Back of the Castello di Tocchi, Tuscany,* 26 x 35 cm (13³/₄ x 10¹/₄ IN), WATERCOLOUR

Taylor says that he has always been interested in painting the back views of places, partly to avoid the obvious and partly because they are often more interesting. This subject particularly appealed to him because he saw a Corot-like quality in its spaciousness, light and composition. Notice how he has increased the feelings of space by allowing the sky to occupy a large part of the picture area, and has chosen a viewpoint that enables him to convey the solidity of the buildings and make the most of their shapes.

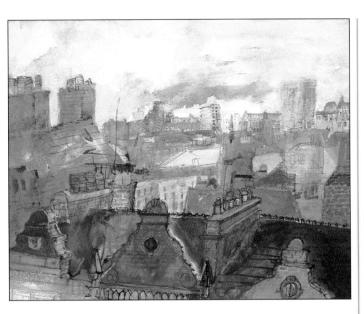

Julia Gurney, From Peter Jones, 35.6 x 43.2 CM (14 X 17 IN), WATERCOLOUR, ACRYLIC AND INK

One of the best viewpoints for buildings is a high one. Not only do the rooftops and chimneys form fascinating patterns, but you also begin to see all sorts of intriguing details not noticeable at eye level, such as the delightfully shaped gable fronts in this painting. Gurney has made expressive use of MIXED MEDIA, drawing with ink on top of watercolour in a vigorous and direct style.

Jill Mirza, Path with Sand Pile, Cycladic Series 45.7 X 30.5 CM (18 X 12 IN), ACRYLIC ON BOARD

Sometimes the viewpoint is not so much the artist's choice as one dictated by the lie of the land, as here, where the buildings are set on a steeply rising hill. The low angle from which we see buildings in hilly towns and villages shows them to good advantage, and the converging parallels sloping downward at a sharp angle encourage dramatic compositions. Mirza has made the most of the intrinsic drama of the subject by strong contrasts of tone, suggesting the texture of the whitewashed walls with a light scumbling of grey-blues and yellows.

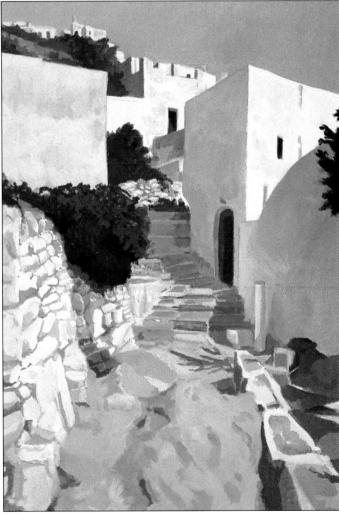

Buildings in landscape

In a town- or cityscape, buildings form the whole subject of the painting — although there may be a 'supporting cast' of people, cars and the occasional tree. A farmhouse, church or group of houses, however, can also be part of a landscape, forming just one of its features in the same way that a bush or outcrop of rocks might.

This is a subject with great potential, because it allows you to exploit the contrast between man-made and natural forms in a way that can enhance the qualities of both. There is, however, a danger that the contrast may be too strong. Most people are familiar with the jarring effect of a new building whose architect has not considered its setting. It looks out of place and unrelated, the very quality you want to avoid in a painting.

Many old buildings look as if they have grown naturally out of the landscape they sit in, often because they are built from local materials and reflect the prevailing colours. So try to achieve a similar unity in your painting, in colour and above all in technique. Because buildings are less easy to draw and paint than fields and hills, it is always a temptation to treat them in a much tighter and more detailed way than the rest of the painting, which is a recipe for failure. If you would naturally paint the landscape wet-in-wet. use the same method for the building, or at least parts of it.

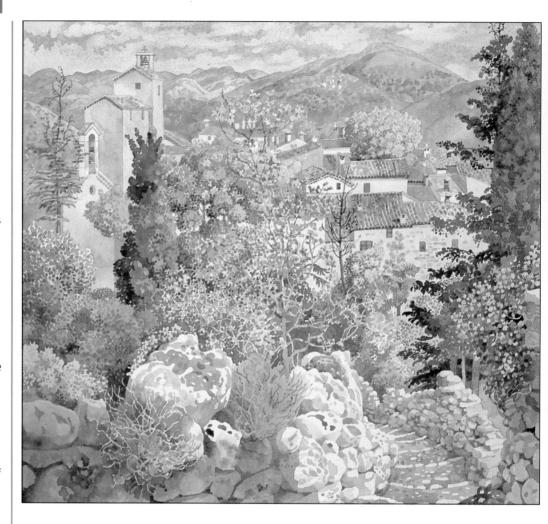

Juliette Palmer, *The Pathway to Molière Cavaillac, Cévennes,* 40.6 x 40.6 cm (16 x 16 IN), WATERCOLOUR

In this delightful painting, the buildings are so well integrated into the landscape that they almost appear to be organic forms like the surrounding rocks and trees. This impression is reinforced by the artist's unusual and

very individual technique, which stresses pattern by means of small, light brushstrokes of different shapes and sizes. Her skill at reserving highlights is amazing: the intricate tangle of tiny twigs on the left and the little white shapes on the steps were created entirely by painting around them — no scratching out techniques or liquid mask were used.

■ Edward Piper, Mellieha, Malta, 55.9 x 76.2 CM (22 x 30 IN), WATERCOLOUR AND PEN

The rose-coloured church, rising up into the deep blue sky, is an important part of the composition, but it is not allowed to dominate. Pattern. colour and movement are the main themes of the painting, expressed through a lively use of the LINE AND WASH technique. Piper does not attempt to outline areas of colour with line, since this usually works to the detriment of both. Instead, he places the colours in an almost random way, so that they sometimes overlap the lines and sometimes end well within them, as on the left side of the church.

David Curtis. Ruined Barracks, Scotland, 38.1 X 55.9 CM (15 X 22 IN), WATERCOLOUR

As in Juliette Palmer's painting opposite, the building looks less like a man-made structure than an integral part of the landscape. Ruins are, of course, a particularly paintable subject because they have weathered and changed shape as parts of the original structure fall away. This painting was done directly from the subject with a fairly limited palette and has all the freshness and immediacy of good on-the-spot paintings.

Pattern and texture

Man-made structures provide as much variety of pattern and texture as the natural world. and it is often these that attract us to a particular building rather than its shape or proportion. Building materials vary hugely - there are houses with wooden boarding, great expanses of shimmering glass on modern office buildings, whitewashed houses, mellowed brick mansion and great stone churches. It would be a great pity to ignore the inventiveness of generations of architects and builders and. in any case, if you paint a wall or roof exactly the same colour and tone all over, it will look like a cardboard cut-out.

Although in general old buildings provide the most surface interest because the materials have become weathered, new ones also have texture or pattern of some kind, so always look for ways of suggesting these qualities.

There are many techniques ideally suited to painting texture. You could try, for example, the WAX RESIST OR SCUMBLING methods or any of those described under the heading TEXTURES in the first part of the book. It is worth experimenting with all these, and you will then evolve your own personal variations.

Jill Mirza, The Old Village of Kardamili, Peloponnese, 81.3 x 81.3 cm (32 x 32 IN), ACRYLIC ON BOARD

The varied colours and irregular shapes of the building stones and the strong shadows and highlights create a lively pattern throughout the painting. Acrylic can be used

in transparent washes just like watercolour, but Mirza uses it very much like opaque gouache, laying light colours over dark and vice versa. The luminous quality of the shadowed walls on the left has been achieved by GLAZING thin paint over underlying colours.

Martin Taylor, Within the Castle Walls, 48 x 36 cm (187/s x 141/s IN), WATERCOLOUR AND ACRYLIC

Taylor has built up the richly textured surface of the old stonework by successive SCUMBLING with a dry watercolour and acrylic mixture over transparent washes. In places he has scuffed the paper with the blade of a knife, applied paint on top, and then repeated the process. Good watercolour paper is surprisingly tough and can withstand a good deal of such treatment.

Moira Huntly uses, watercolour, gouache and pastel pencils for this painting. Having laid loose washes for sky and water, she applies texture by brushing watercolour onto a thick piece of paper and then pressing it firmly onto the working surface. The effect varies according to the texture of the paper and the wetness of the paint.

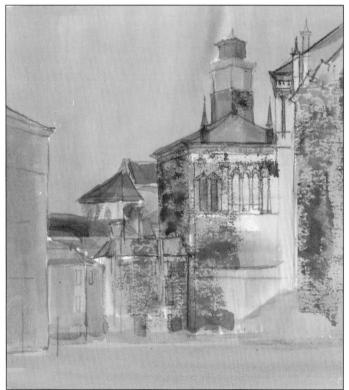

Flat washes of orange and raw sienna (the colours used for the printed texture) and the sky colour are then brushed over the white shapes, in some areas superimposed over the

textures. Detail is introduced by drawing with dark olivegreen and red-brown pastel pencils, with the rough surface of the paper breaking up the line to give a grainy effect.

- Darker shades are painted with watercolour washes of Payne's grey, echoing the sky colour, which is the same grey with a small amount of crimson. Gouache is used to introduce further texture in the lighter-toned areas, again using the printing technique and opaque, creamcoloured paint. This can be seen clearly on the building at the extreme left (see left, below). A few final details are then added with white pastel pencil to complete the picture.
- This shows both the buildup of transparent washes over the printed textures and the textural quality of the pastel line marks.
- Texture on the light areas is created by scumbling opaque gouache over transparent washes. The roof tiles are suggested by drawing with a pale orange pastel pencil over dark washes.

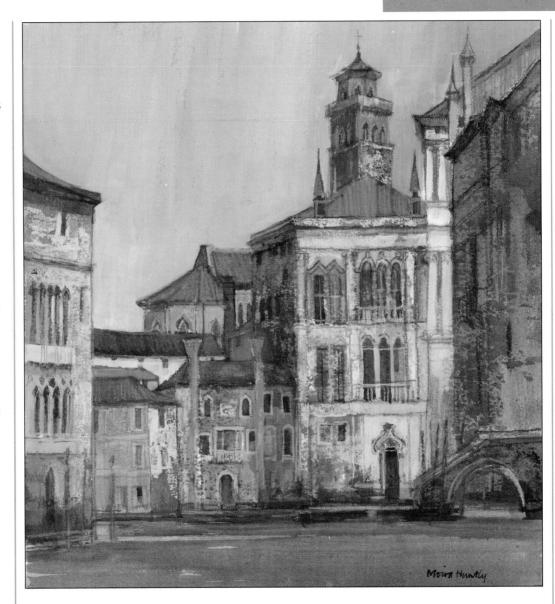

Moira Huntly RI, RSMA, Venice, 30 X 27.5 CM $(11^3/_4$ X $10^3/_4$ IN), WATERCOLOUR, GOUACHE AND PASTEL PENCILS ON STRETCHED PAPER

The figure

Although there is no strong tradition of figure work in watercolour this has nothing to do with any inherent unsuitability of the medium. The reason for the choice of oils is a much simpler one. In the past, most paintings were done for a fee, and artists had to please their patrons. Those who were wealthy enough to commission a portrait or pay a high price for a nude study wanted a large, imposing painting that would withstand the ravages of time, and this meant one in oils.

Today, however, more and more artists are finding that watercolour is a marvellous medium for figure and portrait work, ideal for freer, more impressionistic treatments, and perfectly suited for capturing impressions of light and the delicate living qualities of skin and hair.

Drawing

Because watercolours cannot be reworked and corrected to any great extent, it is vital to start a painting on a good foundation. This means that, before you can paint figures or faces successfully, you must first be able to draw them.

The best way to approach the human figure is to see it as a set of simple forms that fit together – the ovoid of the head joining the cylinder of the neck that, in turn, fits into the broader, flatter planes of the shoulders, and so on. If you intend to tackle the whole figure, map out the whole figure first in broad lines.

Proportion is particularly important, and many promising paintings are spoiled by a too-large head or feet for example. The best way to check proportions is to hold up a pencil to the subject and slide your thumb up and down it to measure

the various elements and check their relative size. Another way to improve your drawing is to look not at the forms themselves, but at the spaces between them. If a model is standing with one arm resting on a hip, there will be a space of a particular shape between these forms. Draw this, not the arm itself, and then move on to any

other 'negative shapes' you can see. This method

is surprisingly accurate.

Composition

It is easy to become so bogged down in the intricacies of the human figure and face that composition is forgotten, but it is every bit as important as in any other branch of painting. Even if you are painting just a head-and-shoulder portrait, always give thought to the placing of the head within the square or rectangle of the paper, the background and the balance of tones.

A plain, light-coloured wall might be the ideal foil for a dark-haired sitter, allowing you to concentrate the drama on the face itself, but you will often find you need more background or foreground interest to balance a subject. Placing your sitter in front of a window, for example, will give an interesting pattern of vertical and horizontal lines in the background as well as a subtle fall of light, while the lines also have pictorial potential.

Figures or groups of figures in an outdoor setting need equally careful preplanning. You will have to think about whether to make them the focal point of the painting, where to place them in relation to the foreground and background and what other elements you should include – or suppress. It is a good idea to make a series of small thumbnail sketches to work out the composition before you begin to paint.

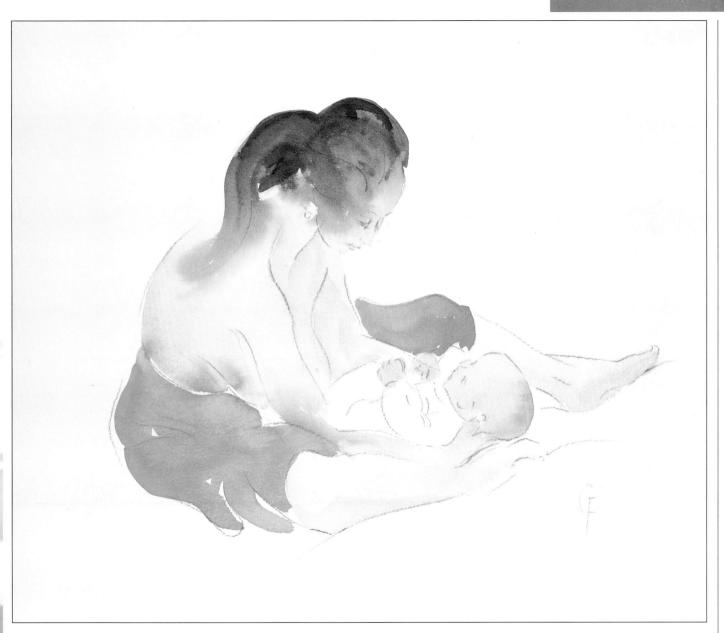

Greta Fenton,

Mother and Child,

50.8 x 66 cm (20 x 26 IN)

WATERCOLOUR AND CONTÉ CRAYON

This lovely, tender group should quickly disabuse us of the notion that the figure cannot be painted in watercolour. In the right hands it is the perfect medium. The artist has painted directly from life, working mainly WET-IN-WET

with a large Chinese brush and adding definition with delicate red crayon lines.

LIBRARY LAUDER COLLEGE

Figure studies

Watercolour is eminently suitable for quick figure studies, whether indoors or out. Making such studies is the best possible way of learning the figure – this is why they are called studies. They are a kind of visual note-taking, and they print impressions on the mind much more effectively than simply looking.

Anyone interested in painting their fellow humans should carry a sketchbook at all times and perhaps a small watercolour box or a few watercolour crayons.

There are countless opportunities to draw and paint unobserved - on buses, in parks and gardens, beside swimming pools and at sports centres. Never attempt a detailed treatment, but try to grasp the essentials as quickly as you can using any method you find you are happy with. Line and wash is much used for this kind of work, as is a combination of pencil and watercolour. You may find it easier to work in monochrome only, drawing with a brush and ink – an expressive and speedy way of conveying movement or blocking areas of tone. If you do use colour, restrict vourself to the minimum and don't bother about mixing the perfect subtle hue. If you want to use your sketches as reference for a later painting, for instance a group of people in a café or a family picnic, write notes about colours on each sketch.

► Jake Sutton, *Circus Cyclist*, 76 x 56 cm (30 x 22½ IN), WATERCOLOUR AND CHARCOAL

Sutton draws with his brush (see BRUSH DRAWING) to convey a marvellous sense of excitement and urgency. The variation in the brushstrokes, some like fine pencil scribbles and others swelling and tapering, seems to increase the momentum of the figure, propelling it forward.

■ Willis, Boy on a Rock,
25.4 x 34.3 CM (10 x 13½ IN),
WATERCOLOUR

This lively and spontaneous study conveys a great deal of information in the most economical way possible. The tension of the boy's pose is described extremely accurately by means of broad washes of no more than two or three colours, and a strong sense of a light and place is conveyed by the shadow and the little touches of paint at the right suggesting the rock.

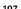

Michael McGuinness ARWS, Sally, 45 X 34 CM (173/4 X 133/8 IN), WATERCOLOUR AND PENCIL

The lightness and delicacy of the artist's technique, and the way he has applied the paint so that it has dripped down the paper, combine to give a powerful impression of immediacy. Nevertheless, this

is a careful and meticulous study, with the shape of the head, the features and the direction and quality of the light described with precision.

Richard Wills, Sir Geraint Evans, 35.6 x 27.9 CM (14 x 11 IN), WATERCOLOUR

In this carefully observed and strongly drawn study, a preliminary sketch for an oil portrait, the artist has explored the structure of the head through directional brushstrokes.

Portraits

There is no doubt that portraiture is a tricky subject there are some people who have the knack of capturing faces and expressions without thinking about it, and they are fortunate, but they are not necessarily good artists. However, the idea that painting portraits is particularly difficult in watercolour should be resisted - it is simply not true, and an increasing number of artists are using its subtle qualities to produce fine and sensitive paintings that are also good likenesses.

No good painting, least of all a portrait, can be built on a shaky foundation, so before you begin to paint a face you must understand its structure and be able to draw it convincingly. A good way of getting to know the basics is to use yourself as a model and start with a self-portrait (there are few artists who have not painted themselves at one time or another). You can also practise by drawing from photographs, but unless they are very good ones, they are not always helpful, since shapes and forms are often obscured by dark shadows and bleached-out highlights. Photographs are more useful in the later stages of a portrait. Most professional portrait painters take them to use as reference for details of clothing and background, but not for the face itself.

► William Bowyer RA, The Artist's Mother, 30.5 x 25.4 cM (12 x 10 IN), WATERCOLOUR AND GOUACHE

This expressive portrait highlights the importance of composition in figure work. By allowing part of the arm and shoulder to go out of the frame on the right and placing the sitter at a three-quarter angle, the artist has avoided a static, over-symmetrical arrangement and has both balanced and stressed the slant of the figure by the dark vertical of the wall behind. It is a surprisingly small picture, and the paint has been used fairly thinly, with delicate, linear drawing on the face and hand. The lower part of the body and the other hand have been treated more sketchily so that they do not steal attention from the face, always the focal point in a portrait.

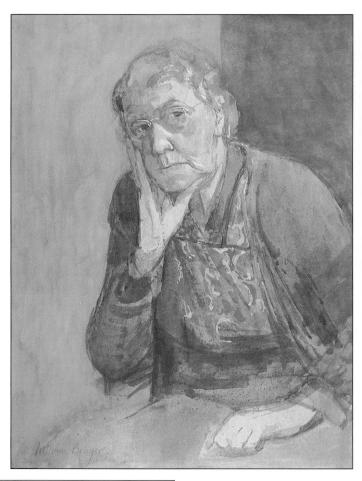

■ Richard Wills,

Old Man with Bucket,

76.2 x 101.6 cm (30 x 40 IN),

WATERCOLOUR AND ACRYLIC

A portrait does not have to be deliberately posed; it can be an informal study of a face seen by chance, as in this studio painting done from location studies. Wills has deliberately created a spontaneous, sketchlike impression by avoiding any background and blurring edges in places to give an impression of movement.

Audrey Macleod, Portrait of Stephen Ebbett, 76.2 X 55.9 CM (30 X 22 IN), WATERCOLOUR WITH A LITTLE GOUACHE

For commissioned portraits, of which this is one. Macleod paints on Hot Pressed watercolour board, which is smooth enough for detailed work, but tough enough to be scraped if corrections are necessary. She begins establishing the overall design rather than worrying about the likeness and then makes small sketches and transfers them to the board by SQUARING UP. She likes to use surrounding objects to create a sense of identity and here expresses the idea of a very young child through scale the high table and windowsill with its teddy-bear sized cat dwarfing the boy's miniature cane-backed chair.

Michael McGuinness ARWS, Bruce. 25 X 19.5 CM (97/8 X 73/4 IN), WATERCOLOUR AND PENCIL WITH SOME BODY COLOUR

McGuinness makes highly effective use of the textures of paint, paper and drawn lines in this taut and finely executed portrait. The brightly lit planes of the face and sharply defined frames of the glasses are thrown into prominence by

the soft blurring at the top of the head and around the chin and neck, achieved by a combination of washing out and applying thin white paint to damp paper.

The figure in context

Because the figure is a complex subject in itself, there is a tendency to lavish all the attention on it and dismiss the setting as unimportant, but few people would think of painting a tree without including the ground from which it grows, and it is just as important to place a person in a specific environment, indoors or out.

Indoor figure paintings have many of the advantages of still life - you can control the lighting, the pose, the background and any other objects, such as furniture, that you may want to include in the composition. Another interesting facet of the subject is that the kind of setting you choose can tell a story about the person. Some of the most successful paintings of figures show people in their place of work or recreation: the marvellous series of ballet dancers by Edgar Degas (1834-1917) are among the best-known examples. So, if you want to paint someone who is fond of reading, think about including books or placing the figure near bookshelves. Degas did this in his portrait of the French writer, Emile Zola.

If you plan a picture of someone who enjoys gardening or some sport, it makes sense to choose an outdoor setting. This is, of course, less controllable, as the light source will change, so you may have to work indoors from sketches made on the spot.

Paul Millichip, *Berber*, 71.1 x 38.1 cm (28 x 15 IN), WATERCOLOUR

Here the figure is completely at one with its background, and the painting, although simple in structure, is full of atmosphere, suggesting a whole culture, climate and way of life. Millichip uses a limited palette consisting of no more than six colours, with no premixed greens, browns, greys or violets. He paints very wet on rough stretched paper, but not WET-IN-WET, waiting for each wash to dry before adding others.

Jacqueline Rizvi, Sarah as Perdita, 88.9 x 61 CM (35 x 24 IN), WATERCOLOUR AND BODY COLOUR

The choice of an outdoor setting at sunset enhances the period flavour of this delightful portrait. She uses watercolour (not gouache) and opaque white, building up layer by layer. This picture, on dark

brown paper, was worked on over a period of two or three months, with the paint applied lightly at first with varying admixtures of white. Although it is a large painting, she used small brushes. In many areas, transparent touches overlay BODY COLOUR so that the underlying colours modify the later ones, as in the GLAZING technique.

Trevor Chamberlain, Armchair Gardener 30.5 X 22.9 CM (12 X 9 IN), WATERCOLOUR

This is a splendid example of a figure painting with an extra dimension. It is a 'slice of life' rather than simply a portrayal of a particular person. Everything about it, from the pose of the sitter to the free, spontaneous paint application, conveys the mood of luxurious and contented relaxation on a sunny afternoon.

◀ Trevor Chamberlain. Marine Blacksmith 17.8 x 25.4 CM (7 x 10 IN), WATERCOLOUR

Chamberlain has concentrated on the light in this scene, creating his soft, diffused effects by working almost entirely wet-in-wet, with a few small details added at the dry stage. The figure, although the main centre of interest, has been treated as broadly as all the other elements, so that the composition has a perfect unity of technique.

▶ George Large RI, Hedgecutters 30.5 X 30.5 CM (12 X 12 IN), WATERCOLOUR AND GOUACHE

This small painting, while stressing abstract and pattern qualities, gives a powerful impression of context. The common activity of the men and the taut shapes of the twisted stems they are working on pull them together as a group, as does the pictorial device of uncovered paper in the outer areas. This is not in fact a toned paper: the flat tint was achieved by laying an overall watercolour wash. Certain areas were then masked (see MASKING) before the gouache was applied.

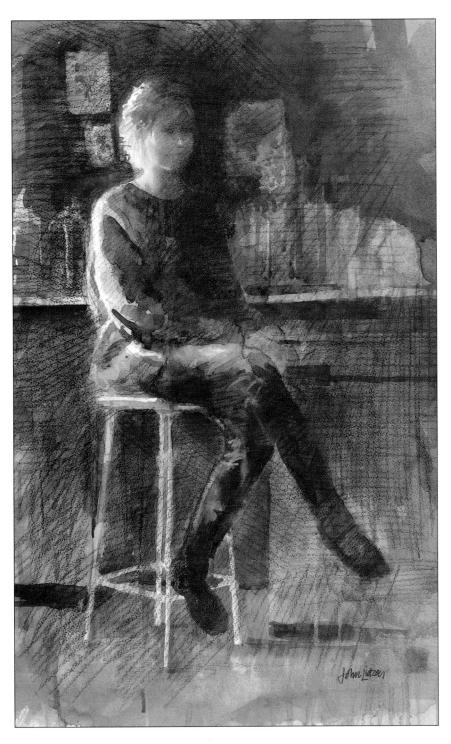

John Lidzey FRSA, Girl on Stool 48.3 x 33 CM (19 x 13 IN), WATERCOLOUR, BODY COLOUR AND CONTÉ CRAYON

Lidzey, like Chamberlain, has been preoccupied with light, but his tonal contrasts are much stronger than in the painting opposite and his range of colours is considerable. He says that the technique he has used here was inspired by that used by French painter Georges Seurat (1859-91) in his magnificent tonal drawings. The underlayer is pure watercolour, used wet, as in most of his paintings. The highlights were reinforced with white gouache, and the picture was built up with successive layers of crosshatching with black conté crayon. The carefully varied crayon lines have been broken up by the grain of the paper to create the effect of a soft veil, which enhances the brilliance and depth of the colours below, as in the SCUMBLING technique. This is an inspiring and completely successful use of MIXED MEDIA, with a satisfying harmony between paint and line.

Groups

Although people are seen more often in groups than singly, particularly outdoors, multiple figure compositions tend to be avoided by all but the most experienced painters. However, groups are not only an exciting and challenging subject, they are in some ways easier than single figures. If you are painting a family picnic or people sunbathing on a beach, for example, you can treat them more broadly than you would a portrait, concentrating on an overall impression of colours and forms. Such paintings, though, usually have to be done from sketches rather than completed on the spot, as people have a way of packing up and going home just as you have got out your paints.

When you come to compose a group painting from sketches of individual figures, you may find that it is not easy to relate them either to each other or to your chosen setting (they may all be drawn to different scales), so try to regard your sketches as the first steps in a planned painting and make them as informative as possible. Avoid drawing figures in isolation. always indicating the foreground and background as well, if only in broad terms. This will provide a frame of reference and help you to avoid the pitfall of inconsistent scale. You could easily find that you have placed a group in front of a building or tree that is disproportionately small or large. Pay attention also to the lighting and the way the shadows fall, and make notes about the colours.

 George Large RI, Finches, 66 x 50.8 cm (26 x 20 IN), WATERCOLOUR

As in his painting on page 112, Large has stylized his group of figures to form a powerful, semi-abstract composition, using a combination of different shapes and textures to give additional movement and interest. The sinuous. flowing lines on the arms of the two main figures on the left and right are counterpointed by the rectangular grids of the bird cages, while the broken colour in the centre, achieved by the WAX RESIST method, contrasts with the flat areas of solid colour. Some areas were blotted with paper towels, and the thin lines were cut with a knife blade or scratched with the point of a pair of compasses.

Francis Bowyer, Changing for a Swim, 38.1 X 38.1 CM (15 X 15 IN), WATERCOLOUR AND BODY COLOUR (GOUACHE WHITE)

Although the treatment of the children is no more detailed than that of the beach, the poses are very carefully observed, and this, together with the suggestion of features on the face of the foreground boy, holds our interest. Bowyer has given a marvellous unity to the composition by repeating versions of the same colours - violet-blues, yellows and warm pinks - throughout the painting.

■ Doreen Osborne, Durrell's Alexandria, 56.5 X 40 CM $(22^{1}/_{4} \times 15^{3}/_{4} \text{ IN})$, GOUACHE AND PEN AND INK

Like Large (opposite), Osborne has stressed the pattern quality of her subject, but in a completely different way. Although she has deliberately flattened the perspective to give a one-dimensional rather than recessive effect, she has treated each figure in detail, with touches of humour. Her painting is a good example of the LINE AND WASH technique used with assurance. The line drawing adds to the lively effect but is never allowed to dominate the colour.

David Curtis works directly from his subject whenever possible, and for a complex subject like this one he makes a series of location sketches and completes the painting in the studio. The secret of working successfully from sketches is to know in advance the kind of visual reference you will need and make sure that your sketches provide it. By using a

combination of quick watercolours made in a small sketchbook and pencil drawings with notes about colour, Curtis has provided himself with an ample store of information. Notice that he never draws or paints figures in isolation; all the sketches are complete notes about the scene he intends to paint.

David Curtis, Bandstand, St James's Park, 38.1 X 55.9 CM (15 X 22 IN), WATERCOLOUR WITH A LITTLE ACRYLIC

Using the sketches shown opposite as the basis, Curtis made a careful preparatory drawing on stretched paper, after which he applied LIQUID MASK to areas such as the awning and poles. He likes to work freely, maintaining the

fresh, translucent quality of the paint, and masking prevents labouring the paint when taking it around small, intricate shapes. Some of the highlight areas in the grass were achieved by mixing a small amount of titanium white acrylic with lemon yellow and phthalocyanine green watercolour, which he finds increases the intensity of colour.

Flowers

Flowers, with their rich and varied array of glowing colours, intricate forms and delicate structures, are an irresistible subject for painters. There are many different approaches to this branch of painting, all suited to the medium of watercolour. Flowers can be painted in their natural habitats or indoors as still-life arrangements, they can be treated singly or in mixed groups, they can be painted in fine detail or broadly and impressionistically.

Flower painting in history

Today flower paintings are hugely popular and avidly collected, and good flower painters can command high prices. This is a relatively recent trend in terms of art history, however. In the Medieval and Renaissance periods, when scientists were busily cataloguing herbs and plants, the main reason for drawing and painting them was to convey information, and a host of illustrated books, called herbals, began to appear, explaining the medicinal properties of various plants and flowers.

The concept of painting flowers for their own sake owes more to the Flemish and Dutch still-life schools than any other. The Netherlandish artists were always more interested in realism and the accurate rendering of everyday subjects than their Italian and French counterparts and, throughout the sixteenth, seventeenth and eighteenth centuries, they vied with one another to produce ever more elaborate flower pieces, with every petal described in minute detail. Although critics in France regarded flower pieces and still life as inferior art forms, even there they had become respectable by the midnineteenth century.

Working methods

Because flowers are so intricate and complex, there is always a temptation to describe every single petal, bud and leaf in minute detail. In some cases there is nothing wrong with this (for anyone intending to make botanical studies, it is the only possible approach), but too much detail can look unnatural and static, and there is also the ever-present danger of overworking the paint and losing the clarity of the colours.

Before you start, make some decisions about which qualities you are interested in. If you are inspired by the glowing colours in a flowerbed, treat the subject broadly, perhaps starting by working WET-IN-WET, adding crisper definition in places to combine HARD AND SOFT EDGES.

Always remember that flowers are living things, fragile and delicate, so don't kill them off in your painting — try to suit the medium to the subject. You can make a fairly detailed study, while still retaining a sense of freedom and movement, by using the LINE AND WASH technique, combining drawn lines (pen or pencil) with fluid washes. Never allow the line to dominate the colour, however, because if you get carried away and start to outline every petal you will destroy the effect. Liquid mask can be helpful if you want to be able to work freely around small highlights, and attractive effects can be created by the WAX RESIST method.

Finally, even a badly overworked watercolour can often be saved by turning it into a MIXED MEDIA painting, so consider whether you might be able to redeem it by using pastel, acrylic or opaque gouache on top of the watercolour.

Audrey Macleod, Red Roses in a Flowerbed, APPROX. 38.1 X 27.9 CM (15 X 11 IN), WATERCOLOUR WITH ADDED GOUACHE

One of Macleod's primary concerns, whether she is painting flowers or portraits, is the overall design of her paintings. Here she has used the different characteristics of the plants to create a strong pattern in which soft, round shapes are contrasted with spikier, more angular ones. Parts of the paper have been left bare to stand as highlights, but the tiny clusters of leaves on the right have been lightly touched in with opaque paint.

Single specimens

The most obvious example of flowers and plants treated singly rather than as part of a group are botanical paintings. Botanical studies have been made since pre-Renaissance times and are still an important branch of specialized illustration. Many of the best of these drawings and paintings are fine works of art, but their primary aim is to record precise information about a particular species. For the botanical illustrator. pictorial charms are secondary bonuses, but artists, who are more concerned with these than with scientific accuracy. can exploit them in a freer, more painterly way.

However, this is an area where careful drawing and observation is needed. You may be able to get away with imprecise drawing for a broad impression of a flower group, but a subject that is to stand on its own must be convincingly rendered. Looking at illustrated books and photographs can help you to acquire background knowledge of flower and leaf shapes, but it goes without saying that you will also need to draw from life - constantly.

Most flowers can be simplified into basic shapes, such as circles or bells. These, like everything else, are affected by perspective, so that a circle turned away from you becomes an ellipse. It is much easier to draw flowers if you establish these main shapes before you begin to describe each petal or stamen.

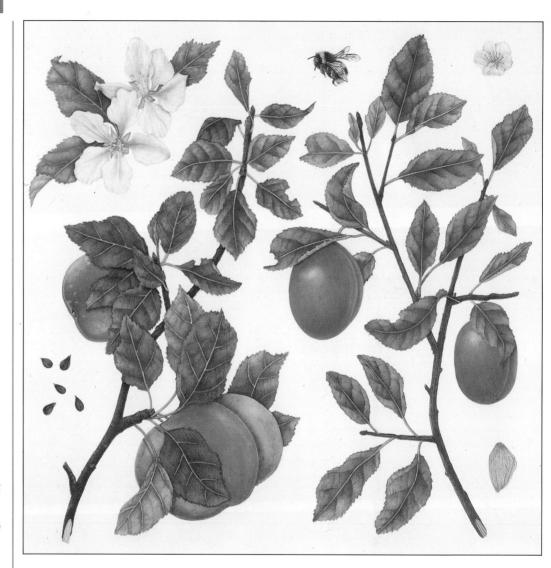

Sharon Beeden, Apples and Plums, 25.8 x 25.8 cm (10 x 10 IN), WATERCOLOUR

This artist is a professional botanical illustrator and the painting was one of a series for a book. Its subject was the introduction of fruit, vegetables and herbs to Britain through the centuries, and before she could begin her work, Beeden had to carry out time-consuming research to find old varieties from various periods of history. Each of these specimens was

drawn from life, with the blossoms redrawn from sketchbook studies done earlier in the year. The composition was worked out on tracing paper and then transferred to the working paper.

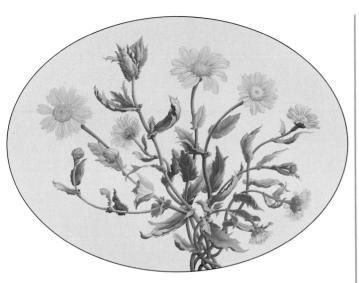

Jean Canter SGFA,

Corn Marigolds

24.1 x 33 CM (9½ x 13 IN),

OVAL, WATERCOLOUR WITH A LITTLE

WHITE GOUACHE

The oval format chosen for this delightful study gives it a rather Victorian flavour. The artist has created a strong feeling of life and movement, with the sinuously curving stems and leaves seeming to grow outward towards the boundary of the frame.

Jenny Matthews, Crown Imperial, WATERCOLOUR

The shapes, structures and colours of some flowers are so fascinating that they seem to demand the right to shine out proud and alone, without

the need for background, foreground, or other diversions. This is certainly the case here, and the artist has made the most of her chosen specimen by her sensitive but tough use of linear brushmarks over delicate washes.

Indoor arrangements

The great advantage of painting cut flowers indoors is that you can control the set-up and work more or less at your leisure – at any rate until the blooms fade and die. The main problem is that flowers can look over-arranged, destroying the natural, living quality that is the subject's greatest charm. Always try to make them look as natural as possible, allowing some to overlap others, and placing them at different heights, with some of the heads turned away from and others towards you, as they would appear when growing in a flowerbed.

Give equally careful thought to the overall colour scheme of the flowers themselves, the vase you put them in and the background. Too great a mixture of colours can lead to a muddled painting that has no sense of unity because each hue is fighting for attention with its neighbour. The best flower paintings are often those with one predominant colour, such as white, blue or yellow, with those in the background and foreground orchestrated to provide just the right element of contrast.

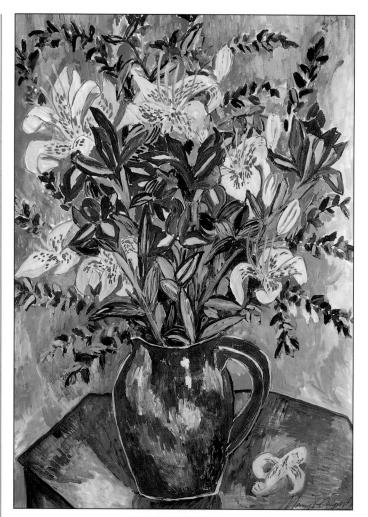

Mary Tempest, *Tiger Lilies*, 50.8 x 40.6 cm (20 x 16 IN), GOUACHE

The marvellously vivid colour scheme of this painting has been planned with great care, with the bright yellows and violets repeated throughout. These two colours are complementaries, colours that enhance one another when used together. Tempest has also brought in the other two main complementaries, red and green, so that the whole painting positively vibrates. Although she has placed the vase of flowers centrally, she has avoided a static look by first arranging the flowers so that they reach up on the left, following the curve of the jug, and second by choosing an irregular shape in the foreground.

Muriel Pemberton,

Bright Garden Bouquet

45.7 x 62.9 cm (18 x 24¾ IN),

WATERCOLOUR, BODY COLOUR, INK

AND PASTEL

Here the off-centre placing of the vase and the way the flowers lean to the left give a rhythm to the composition. Pemberton makes no preliminary drawing and works on the background and flowers at the same time, building up texture and depth of colour with layers of paint, pastel and ink. In some places, she applies thin washes over thick, while in others, transparent watercolour is allowed to show through opaque paint.

Shirley Felts, Chrysanthemums with Chinese Vase, 73.7 X 53.3 CM (29 X 21 IN), WATERCOLOUR

One of the considerations in arranging a flower group must be the characteristics of the flowers themselves. A bloom with strong and dramatic shapes, such as a lily, could look exciting by itself or in a small group, but multi-flowered chrysanthemums are best treated as a mass, as here, because that is how they grow. This group is nevertheless very carefully arranged, with a slight asymmetry and the leaves trailed over the vase on the left to add foreground interest. The little touches of red in the smaller group provide the perfect contrast to the delicate white and green colour scheme.

Composition

A group of flowers tastefully arranged in an attractive vase always looks enticing - that, after all, is the point of putting them there - but it may not make a painting in itself. Placing a vase of flowers in the centre of the picture, with no background or foreground interest, is not usually the best way to make the most of the subject - though there are some notable exceptions to this rule. So you will have to think about what other elements you might include to make the composition more interesting without detracting from the main subject.

One of the most-used compositional devices is that of placing the vase asymmetrically and painting from an angle so that the back of the tabletop forms a diagonal instead of horizontal line. Diagonals are a powerful weapon in the artist's armoury, as they help to lead the eve in to the centre of the picture, while horizontal lines do the opposite.

One of the difficulties with flower groups is that the vase leaves a blank space at the bottom of the picture area. This can sometimes be dealt with by using a cast shadow across part of the composition, or you can scatter one or two blooms or petals beneath or to one side of the vase. thus creating a relationship between foreground and focal point.

Ronald Jestv. Sweet Peas in a Tumbler. 30.5 X 20.3 CM (12 X 8 IN), WATERCOLOUR

Jesty's compositions are always bold, and often surprising, as this one is. We are so conditioned by the idea of 'correct' settings for flower pieces and still lifes that the idea of placing a vase of flowers on a newspaper seems almost heretical. But it works perfectly, with the newspaper images providing just the right combination of geometric shapes and dark tones to balance the forms and colours of the sweet peas.

Geraldine Girvan. Studio Mantelpiece. 57 X 66 CM (223/8 X 26 IN), GOUACHE

Girvan has used a combination of diagonals and verticals to lead the eye into and around the picture. Our eye follows the line of the mantelpiece, but instead of going out of the frame on the left, it is led upward by the side of the picture frame and then downward through the tall flowers to the glowing heart of the picture - the daffodils. She has avoided isolating this area of bright yellow by using a slightly muted version of it in the reflection behind and has further unified the composition by repeating the reds from one area to another.

Carolyne Moran, Hydrangeas in a Blue and White Jug, 26.7 X 26.7 CM $(10^{1/2} \text{ X } 10^{1/2} \text{ IN})$, GOUACHE

Here the flowers occupy an uncompromisingly central position, with the rounded shapes of the blooms and vase dominating the picture, but counterpointed by the rectangles formed by the background window frame. Interestingly, we do not immediately perceive this

painting as square because the verticals give it an upward thrust. The artist has made cunning use of intersecting diagonals in the foreground to break up the predominantly geometric grid, and has linked the flowers to the background by using the same blue under the windowsill. There is considerable overpainting on the flower heads, as they kept changing colour while the artist worked - one of the flower painter's occupational hazards.

Lucy Willis, Magnolia and Window 38.1 X 27.9 CM (15 X 11 IN), WATERCOLOUR

This lovely painting, quiet but strong, shows how a simple composition can be as effective, or even more so, as a complex one. Willis, who works directly from life whenever she can and claims to paint no more than what she sees, nevertheless has a highly selective eye and has chosen the perfect background for the sensuous forms of the magnolia. She likes a fairly limited palette and here has used only a small range of colours to produce a perfectly balanced and unified composition.

Mary Tempest, Anemones 76.2 X 55.9 CM (30 X 22 IN), GOUACHE

This bold, highly patterned composition, with the emphasis on carefully distributed areas of bright colour, is somewhat reminiscent of French painter Henri Matisse (1869-1954). Although the painting is predominantly twodimensional, there is a considerable degree of modelling in the fruit, jug and flowers, which guarantees their place as the focal point of the painting. Tempest uses gouache almost like oil paint, and for this painting she has mixed it with an impasto medium (Aquapasto) in order to build it up thickly.

Natural habitat

Oddly, the term 'flower painting' makes us think of cut flowers rather than growing ones, perhaps because most of the paintings of this genre that we see in art galleries are of arranged rather than outdoor subjects. Flowers. however, are at their best in their natural surroundings, and painting them outdoors, whether they are wild specimens in woods, fields or city wastelands or cultivated blooms in the back garden, is both rewarding and enjoyable.

It can, however, present more problems than painting arranged groups indoors, because you cannot control the background or the lighting, and you may have to adopt a ruthlessly selective approach to achieve a satisfactory composition.

You will also have a changing light source to contend with. As the sun moves across the sky, the colours and tones can change dramatically, and a leaf or flower head that was previously obscured by shadow will suddenly be spotlit so that you can no longer Ignore Its presence. The best way to deal with this problem, if you think a painting may take more than a few hours to complete, is to work in two or three separate sessions at the same time of day or to make several quick studies that you can then combine into a painting in the studio.

▲ Norma Jameson RBA, ROI, Waterlilies, 30.5 x 40.6 cM (12 x 16 IN), GOUACHE AND WATERCOLOUR ON CARTRIDGE PAPER

Jameson works partly from life and partly from slides and says that the former gives the necessary element of spontaneity to her work while the photographic studies provide the equally necessary time for consideration. For specific flower forms, she takes numerous slides, from different angles and positions and in close-up, using the camera like a sketchbook and then distilling those that interest her most.

Juliette Palmer, Pink Roses, White Phlox, 38.1 X 27.9 CM (15 X 11 IN), WATERCOLOUR

This is the artist's own back garden and a spell of good weather gave her the unusual luxury of painting on the spot for as long as she liked. Like Macleod, whose painting is shown opposite, Palmer has a strong sense of design and composition and says that as she observes a subject, various elements will fall into place to form a satisfactory whole. She is not interested in dramatic effects but, as she puts it, 'elegance of line and the delight of the particular bound in gentle relationships of colour and tone'.

 Audrey Macleod, Rhododendrons in Dulwich Park. APPROX 76.2 X 101.6 CM (11 x 16 IN), WATERCOLOUR

Macleod has created a composition with a strong twodimensional pattern quality. To express the delicacy of the subject, she has exploited the LINE AND WASH technique to set up an effective hard/soft contrast and retained the transparency of the paint by touching in the colour lightly to the edges of the forms. She has also washed down some areas to soften the colour, an effect that can be seen behind and below the central bloom. The delicate pen lines, made with watered-down mauve and grey inks, stand out crisply.

Landscape

Whatever the medium used, landscape is among the most popular of all painting subjects. One of the reasons for this is the common belief that it is easier than other subjects. Many who would never attempt a figure painting or flower study turn with relief to country scenes, feeling them to be less exacting and thus more enjoyable. However, a painting will certainly be marred by poor composition or mishandled colours – these things always matter, whatever the subject. The best landscapes are painted by artists who have chosen to paint the land because they love it, and use the full range of their skills to express their responses to it, not by those who choose it as an easy option.

Direct observation

Another factor that separates the really good from the adequate is knowledge, not of painting methods – though this is necessary, too – but of the subject itself. This is why most landscape painters work outdoors whenever they can. Sometimes they only make preliminary sketches, but often they will complete whole paintings on the spot. Even if you only jot down some rapid colour impressions, it is still the best way to get the feel of a landscape.

If you use photographs as a starting point — and many professional artists do take photos as a back-up to sketches — restrict yourself to a part of the countryside you know well and have perhaps walked through at different times of the year so that you have absorbed its atmosphere. Nature's effects are transient and cannot be captured adequately by the camera.

Composition

Nor should you attempt to copy nature itself: painting is about finding pictorial equivalents for the real world. This means that you have to make choices and decide how much to put in or leave out and think about whether you might exaggerate a certain feature in the interests of art. For instance you might emphasize the feeling of space in a wide expanse of countryside by putting in some small figures in the middle distance, or convey the impression of misty light by suppressing detail and treating the whole scene in broad washes.

The medium

The fluidity and translucency of watercolour are perfectly suited to creating impressions of light and atmosphere. Light and portable, it has always been popular for outdoor work, but until you have gained some practice, it can be tricky to handle as a sketching medium. There is always the temptation to make changes in order to keep up with the changing light, and if there is too much overworking, the colours lose their freshness. There are ways of dealing with this, however. One is to work on a small scale, using the paint with a minimum of water so that you cut down the time spent waiting for each layer to dry, and another is to work rapidly wet-in-wet, concentrating on putting down impressions rather than literal descriptions. Gouache can be used thinly, just like watercolour, but dries much more quickly and can be built up in opaque layers for the later stages.

If you intend to complete a whole painting on location rather than just making sketches, it is a good idea, if the subject is at all complex, to make the preparatory drawing the day before.

Charles Knight RWS, ROI, Tall Tree and Buildings, 27.9 x 38.1 CM (11 x 15 IN), WATERCOLOUR

Knight's atmospheric landscapes are marked by the economy with which he describes his shapes, forms and textures. He never uses two brushstrokes when one will suffice. Here he has painted freely but decisively in a combination of WET-IN-WET, WET-ON-DRY and DRY BRUSH, leaving little specks of the paper showing through the paint in places to hint at texture.

Trees and foliage

Trees are among the most enticing of all landscape features. Unfortunately, they are not the easiest of subjects to paint, particularly when foliage obscures their basic structure and makes its own complex patterns of light and shade.

To paint a leafy tree successfully, it is usually necessary to simplify it to some extent. Start by establishing the broad shape of the tree, noting its dominant characteristics, such as the width of the trunk in relation to the height and spread of the branches. Avoid becoming bogged down in detail. If you try to give equal weight and importance to every separate clump of foliage you will create a jumpy, fragmented effect. Look at the subject with your eyes half closed and you will see that some parts of the tree, those in shadow or further away from you, will read as one broad colour area, while the sunlit parts and those nearer to you will show sharp contrasts of tone and colour.

A useful technique for highlighting areas where you want to avoid hard lines is that of LIFTING OUT, while SPONGE PAINTING is a good way of suggesting the lively brokencolour effect of foliage. DRY BRUSH is another favoured technique, well suited to winter trees with their delicate, hazy patterns created by clusters of tiny twigs.

Juliette Palmer, *Fell and River*, 35.6 x 35.6 cm (14 x 14 IN), WATERCOLOUR

It is interesting to compare this painting with the other on this page, since both artists work wet-on-dry, but with very different results. Palmer uses countless tiny brushstrokes to build up a variety of textures, giving her paintings an almost embroidered quality. She reserves HIGHLIGHTS with great skill and care. For example, the blades of grass and lightagainst-dark leaves in the right foreground were achieved by painstakingly painting around each shape. The painting was done in the studio from an on-the-spot sketch, as the fading evening light did not allow enough time to complete it there and then.

Ronald Jesty RBA, *Torteval, Guernsey,* 33 x 15.2 cm (13 x 6 IN), WATERCOLOUR

Jesty also paints WET-ON-DRY, but individual brushstrokes are only visible in the foreground. He has set up an exciting contrast by using very flat paint for the large, strong shapes in the background and delicate BRUSH DRAWING for the slender, spiky grasses. The unusual tall, thin format stresses the vertical emphasis of the composition.

Charles Knight RWS, ROI, Rickmansworth Canal, 27.9 X 38.1 CM (11 X 15 IN), WATERCOLOUR AND PENCIL ON TINTED PAPER

Knight's expressive landscapes are reminiscent of English eighteenth-century watercolourists, and, like them, he owes his deceptively simple-looking effects to a thorough knowledge of the

medium and a willingness to experiment with it. He has used a variety of techniques, including DRY BRUSH, BRUSH DRAWING and WAX RESIST on the trees, but these technical 'tricks' are never allowed to dominate the painting. The overall colour key is influenced by the use of the TONED GROUND. which is left uncovered in large parts of the composition.

Moira Clinch, Lakeland Tree, 33 x 45.7 CM (13 x 18 IN), WATERCOLOUR

In this painting, Clinch has used a combination of WET-IN-WET and WET-ON-DRY, which gives excitement and variety to her paint surface. She has also suggested texture on the large tree trunk by exploiting the granular effect caused by overlaying washes (see WASH TEXTURE). She has cleverly prevented the eye from being taken out of the picture with the swing of the large branch on the right by blurring the paint, so that we focus on the crisply delineated area in the centre.

Carolyne Moran, The Apple Tree Seen Through My Bedroom Window, 25.4 x 22.9 cm (10 x 9 IN),

25.4 X 22.9 CM (10 X 9 IN).
WATERCOLOUR WITH ZINC WHITE
GOUACHE

Both the paintings on this page have bare branches as their theme, and both artists were interested in the patterns they make, but where Palmer's painting is delicate and gentle, Moran's is tough and strong, with an energetic, linear quality. Notice how she has paid particular attention to the perspective of the branches, with some crossing others and coming toward the viewer one of the most common mistakes in painting trees is to make them all go in the same direction, so that the tree lacks solidity. Both Sponging and SPATTERING have been used to give texture and softness to the trees in the background.

Juliette Palmer, *Wood Edge*, APPROX 25.4 x 50.8 CM (10 x 20 IN), WATERCOLOUR

This atmospheric but highly detailed painting was done directly from nature. The artist painted from her car, a practical alternative to wet feet and useless, frozen fingers on a winter day. Many artists would have used LIQUID MASK fluid for the pattern of pale, bare twigs, one of the most attractive features of winter woodlands, but Palmer, who is particularly fond of such effects, creates them entirely by reserving (painting around the lights).

Martin Taylor, Woodland Bank, 35 x 41.5 CM (14 x 16 IN), WATERCOLOUR AND ACRYLIC

Taylor's method of working is unusual among watercolourists. Having fully absorbed the atmosphere of

his chosen scene, he begins to paint from top to bottom, starting with the sky and then working from left to right across the distance. He finishes a complete section before moving on to the next until he reaches the bottom

right corner. He points out that British painter Stanley Spencer (1891-1959) worked in this way. He achieves both his fine detail and his remarkable depth of colour by painting over darks with acrylic lights, and then sometimes

repeating the process in a version of the GLAZING technique. To attain the right effect of aerial perspective in distances, he will occasionally lay a thin whitewash over the whole area.

Fields and hills

Hills always make dramatic subjects, but quieter country flat or with gentle contours can easily become dull and featureless in a painting. It is seldom enough just to paint what you see, so you may have to think of ways of enhancing a subject by exaggerating certain features, stepping up the colours or tonal contrasts, introducing textural interest or using your brushwork more inventively. Interestingly, there have been artists throughout the course of history who have believed that they have been painting exactly what they have seen. but they never really were consciously or unconsciously improving on nature is part of the process of picture-making.

Part of the problem with this kind of landscape is that, although it is often beautiful and atmospheric, much of its appeal comes from the way it surrounds and envelops you. Once you begin to home in on the one small part of it you can fit onto a piece of paper, vou often wonder what you found so exciting. So take a leaf from the photographer's book and use a viewfinder a rectangle cut in a piece of cardboard is all you need. With this, you can isolate various parts of the scene and choose the best. If it is still less interesting than you hoped, add some elements from another area, such as a clump of trees, and consider emphasizing something in the foreground.

Robert Dodd, Amberley and Kithurst Hill, Sussex, 52 X 71.1 CM (20½ X 28 IN), GOUACHE

Dodd has given drama to his quiet subject by the use of bold tonal contrasts and inventive exploitation of TEXTURE. He has used his gouache quite thickly, building up areas such as the ploughed field in the foreground by MASKING and sponging (see SPONGE PAINTING). The more flatly applied paint used for the background and sky allows the textures to stand out strongly by contrast.

► Martin Taylor, Castello-in-Chianti, 26 x 35 CM (10¹/₄ x 13³/₄ IN), WATERCOLOUR AND ACRYLIC

Like many painters before him, Taylor has been excited by the strong Italian light, and this makes itself felt in every area of the painting, from the pale sky and hazy distance to the deep shadows and bright colours of the foreground. Using acrylic white to give body to his watercolour, he builds up his colours and textures gradually, using tiny brushstrokes that create a lovely, shimmering quality, and working on one part of a painting at a time.

■ Donald Pass, Frosty Morning, Autumn, 67.3 x 85 cm (26½ x 33½ N), WATERCOLOUR

Pass has an unusual watercolour style, using his paints almost like a drawing medium. He makes no preparatory drawing, and begins by laying broad washes of light colour. He then builds up each area with a succession of separate, directional or linear brushmarks. It is easy to imagine how this subject might have become dull, but the brushwork, as well as being effective in terms of pure description, creates a marvellous sense of movement: we can almost feel the light wind bending the grass and sending the clouds scudding across the sky.

Rocks and mountains

Mountains are a gift to the painter – they form marvellously exciting shapes, their colours are constantly changing and, best of all, unless you happen to be sitting on one, they are far enough away to be seen as broad shapes without too much worrying detail.

Distant mountains can be depicted using flat or semi-flat washes with details such as individual outcrops lightly indicated on those nearer to hand. For atmospheric effects, such as mist lying between one mountain and another or light cloud blending sky and mountain tops together, try working WET-IN-WET or mixing watercolour with opaque white.

Nearby rocks and cliffs call for a rather different approach, since their most exciting qualities are their hard, sharp edges and their textures even the rounded, seaweathered boulders seen on some seashores are pitted and uneven in surface and are far from soft to the touch. One of the best techniques for creating edge qualities is the WET-ON-DRY method, where successive small washes are laid over one another (if you become tired of waiting for them to dry, use a hairdryer to speed up the process). Texture can be built up in a number of ways. The wax resist, scumbling, or salt spatter methods (see TEXTURE) are all excellent.

Ronald Jesty RBA, Portland Lighthouse 25.4 x 25.4 CM (10 x 10 IN), WATERCOLOUR

Jesty has worked wet-on-dry, using flat washes of varying slzes to describe the crisp, hard-edged quality of the rocks. He has created TEXTURE on some of the foreground surfaces by 'drawing' with an upright brush to produce dots and other small marks, and has cleverly unified the painting by echoing the small cloud shapes in the light patches on the foreground

rock. This was painted in the studio from a pen sketch. Advance planning is a prerequisite for Jesty's very deliberate way of painting, and he works out his compositions and the distribution of lights and darks carefully.

Charles Knight RWS, ROI,

Across the Valley,

27.9 x 38.1 cm (11 x 15 IN),

WATERCOLOUR WITH PENCIL AND WAX

Knight has used the shapes and colours of the distant mountains as a dramatic backdrop to the trees and has avoided any details that might bring them forward into competition with the foreground. Nevertheless, they are not painted completely flat: darker and lighter tones have been blended WET-IN-WET within the crisp, clear outlines, and the lighter grey in the

centre suggests a touch of mist in the valley. The effect of the sunlight on the trees has been achieved by the WAX RESIST technique, and a few branches and tree trunks have been drawn with pencil and fine brushmarks over loose washes.

Juliette Palmer, St Jean de Buège APPROX 40.6 X 40.6 CM (16 X 16 IN), WATERCOLOUR

As is often the case in southern climates, the light was clear and bright, picking out the contours of the mountains and the small trees with pin-sharp clarity. The artist has made the most of this, building up the forms and textures of both mountains and foreground rocks with small, delicate brushstrokes to give a highly patterned but realistic effect. The painting, although begun with a detailed drawing made on the spot, was completed in the studio. As time on location was limited, the drawing was backed up by written notes.

■ David Curtis ROI, RSMA, The Pass of Ryvoan 58.4 x 76.2 cm (23 x 30 IN), WATERCOLOUR

Although this is an unusually large watercolour, it is only partially a studio painting; the first stages were done on location (in Scotland). Contending with sharply sloping ground and squalls of cold rain, the artist made his preliminary drawing, applied liquid mask (see MASKING) to certain small areas such as the path on the left, the dead tree and the patches of snow, and laid the first washes. Having established the general design and the distribution of the whites, he was then able to complete the painting in more comfortable conditions.

► Michael Chaplin RE, Welsh Cliffs, 45.7 x 53.3 CM (18 x 21 IN), WATERCOLOUR WITH SOME BODY COLOUR

Very light pen lines accentuate the directional brushstrokes used for the sharp verticals of the cliff face, and texture has been suggested in place by sandpapering washes, a technique that works particularly well on the rough paper the artist has used. The addition of BODY COLOUR (opaque white) to the paint has produced subtle colours and given a suitably chalky appearance to the cliffs.

Recession

All painting can be seen as a series of optical tricks. The perceived world is three-dimensional, but the painter must translate space and form in a way that makes sense on the flat surface of a piece of paper. The landscape artist does well to realize this, since one of the most attractive qualities of a good landscape painting is the feeling of space it conveys.

Linear perspective makes objects appear smaller the further away they are, while parallel lines, such as furrows in a ploughed field, will appear to converge in the distance. Using linear perspective is one way of suggesting recession, but many landscapes have no parallel lines and few objects, and this is where aerial perspective comes in.

The tiny particles of dust and moisture in the air affect the way we see colours, so that they become paler and paler towards the horizon, with the tonal contrasts minimal or imperceptible. Colours also become cooler, with a higher proportion of blue in them. Sometimes a shaft of sunlight catching the side of a faraway mountain can look quite bright, but in fact, it will be infinitely less vivid than a similarly sunlit area directly in front of you, and it will also be very close in tone to the blues or greys surrounding it.

The easiest way to work is from the back to the front of the picture, beginning with flat washes of pale blues and greys and gradually progressing to brighter, warmer colours and stronger light and dark contrasts.

Martin Taylor, *Spring*, 32 x 48 cm (13 x 19 IN), WATERCOLOUR

Recession is created in this painting by a combination of linear and aerial perspective, but mainly the former. The curving lines of path and field converge as they recede, while the line of trees slope sharply down to the horizon, diminishing in size and depth of tone. Taylor has heightened the effect of space by the detailed treatment of the foreground, which effectively 'pulls' it towards the viewer.

► Robert Dodd, Tillingbourne Valley, Winter, 52 x 72.4 CM (20½ x 28½ IN), GOUACHE

Dodd has observed the effects of aerial perspective carefully, controlling his tones and colours with great skill so that the middle ground merges gently into the far distance. The tonal contrasts in the foreground are quite strong, while the far-off hills are only just darker than the sky. His painting creates a strong feeling of place and atmosphere as well as of space and recession.

■ Ronald Jesty RBA, Poole Harbour from Arne, 24.8 x 43.2 cm (9³/₄ x 17 IN), WATERCOLOUR

Like the other two paintings shown here, this one makes use of a strong foreground to create depth, but Jesty has also defined the middle distance and linked it to the background by including the flock of birds and the posts in the river. The side of the brush was used to indicate the clumps of bending reeds, with the paint used fairly dry, and the light-against-dark birds on the right were achieved by SCRAPING BACK.

Weather and the seasons

The British landscape painter John Constable (1776–1837) once said that '... the sky is the source of light and governs everything'. Sky is, of course, the mirror of the weather, and it is part and parcel of all landscape, transforming it – sometimes in a matter of minutes - from a peaceful, sunny scene to a dark and brooding one. This kind of rapid transition takes place all the time, often far more subtly. Even sunlight varies widely: the colours of both sky and land on a hot summer's day are quite unlike those seen in winter, while the light cast by a grey sky can be strong or very weak depending on the amount of cloud cover and the strength and position of the sun above the clouds.

A landscape painting – even one with no visible sky should always give the viewer a feeling of the weather conditions under which it is seen, and the best way to experience these is at first hand. Another great British painter, J.M.W. Turner (1775–1851), who was fascinated by the subject. made endless outdoor studies of landscapes under different skies and at different times of the year. This was in spite of the fact that he had a near-perfect visual memory and was able to re-create the effects of a thunderstorm in the Alps years after seeing it.

► Ronald Jesty RBA, Winter, Sedge Moor 40.6 x 22.9 CM (16 x 9 IN), WATERCOLOUR

In this bold composition, the dark tree and low, red sun counterpoint the brilliance of the white snow – the paper left uncovered. The brooding purple-grey sky often seen on a late winter afternoon has been exaggerated, both to make a more powerful statement and to provide warm/cool contrast. The simplification of the tree into broad shapes accentuates the drama of the scene.

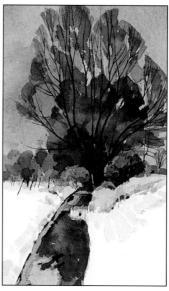

▼ Charles Knight RWS, ROI, *Evening*,

76.2 X 101.6 CM ($9^{3}/_{4}$ X 1 $3^{1}/_{4}$ IN), WATERCOLOUR WITH WAX AND PENCIL

The mist has been beautifully described by means of wet washes of pale colours. In the central tree area, the overlaying of washes has created lines, providing touches of definition. The effect of the setting sun behind the trees has been achieved by lightly sponging the area while lightly scribbled lines of wax crayon (see wax RESIST) suggest ripples and highlights on the water.

Michael Chaplin RE, Grove Green Farm 33 X 45.7 CM (13 X 18 IN), WATERCOLOUR

We tend to think of snow as always being white, whatever the weather conditions, but the land always reflects colour from the sky, and since white surfaces are more reflective than dark ones, snow is a direct mirror of the prevailing light. In this well-observed painting (done on the spot, wearing three pairs of socks) there are no whites, only pale and darker greys, emphasized by the warm red-browns of the buildings and trees. The impression of cold is palpable.

Martin Taylor, Castello di Tocchi, Tuscany 37 x 30 cm (14½ x 14¼ IN), WATERCOLOUR

If you were to take only one small section of the foreground of this painting and mask out the rest, you would recognize the clear, bright light of a Mediterranean country. As in all his paintings,

Taylor has built up strong contrasts of tone and depth of colour by means of considerable overpainting with small, careful brushstrokes. Because he mixes watercolour and acrylic, he is able to lay light colours over dark and vice versa, working for long periods on one area of a painting until he achieves the right effect.

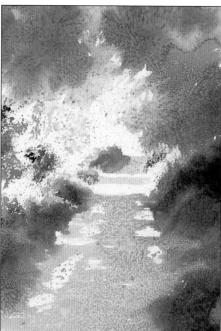

Using a No. 10 brush, sap green and lemon yellow is dabbed onto the brightest areas of foliage. A wash of sap green is taken over the rest of the leaf canopy and hedges, and an olive green wash is applied to the path. The two greens are allowed to bleed into each other. While the paint is still wet, the artist scatters salt onto it to create texture.

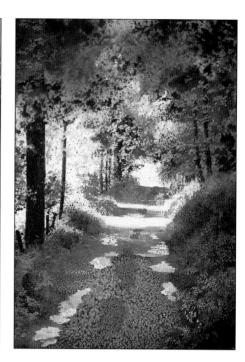

Leaves, ivy, ferns and brambles are again masked out with liquid mask. When dry, the tree trunks, fence posts and branches are painted in dark olive green. Sap green is applied randomly, and more olive green is flooded onto the path and again sprinkled with salt while wet.

Using a large, fairly dry brush, bands of very dark olive green are painted across the path for the shadows. When all the paint is dry, the liquid mask is gently rubbed off to reveal the reserved highlights. To finish, the artist works in a little extra detail where necessary - for example, on the tree trunks and brushes sap green into the reflections of the puddles.

Naomi Tydeman, Sunlight Through Trees WATERCOLOUR

Skies

It may seem odd to devote a whole section to skies - they are, after all, an integral part of landscape - but, from the painter's point of view. they are a major subject in themselves. They demand close observation and a degree of technical know-how, partly because of their infinite variety and partly because they are not subject to the same rules that govern the solid earth below. A mountain, cliff or tree will change in appearance under different lighting conditions. but its structure will remain stable, while clouds, seemingly solid but in fact composed of nothing but air and moisture, are constantly on the move, forming and re-forming in ways that can only partially be predicted and are never the same twice. Most important of all, the sky is the light source without which the landscape could not exist, and weather conditions above relate directly to the colours, tones and prevailing mood of the land below. Thus, the surest way to spoil a landscape is by failing to analyze or express this interdependent relationship.

Clear skies

We tend to think of cloudless skies as simply blue, but in fact they vary widely according to the season and climate. A midsummer's sky in a hot country will be a warm blue, sometimes tending to violet and often surprisingly dark in tone, while a winter sky in a temperate zone is a paler and cooler blue. Nor is a clear sky the same colour all over. A frequent mistake is to paint blue skies in one uniform wash, but there are always variations – sometimes slight, but often quite marked. As a general rule, skies are darker and warmer in colour at the top and paler and

cooler on the horizon, following the same rules of aerial perspective as the land (see LANDSCAPE, RECESSION on page 144). There is, however, an important exception to this. Sky directly over the sea will absorb particles of moisture, giving a darker band of colour at the horizon, and a similar effect can often be seen in cities, where the dark band is caused by smoke, dust or other pollution.

'Learning' clouds

There are few people, whether they paint or not, who can fail to be enthralled by cloud effects – great dark thunderheads, delicate 'mackerel' skies or the magical effects created by a low evening sun breaking through after a day's rain. Sadly, these effects are fleeting, so the landscape painter needs to be in constant readiness to watch, memorize and sketch.

The British painter John Constable (1776–1837)

Christopher Baker, Bosham Estuary, 45 X 22.5 CM (6 X 9 IN), WATERCOLOUR AND CONTÉ CRAYON The scudding clouds are painted lightly and deftly, with definition restricted to the few lines of crayon that formed the preliminary drawing.

was fascinated by skies and well understood their leading role in landscape painting. He made endless oil sketches of nothing but skies. Often these were done in a few minutes, but provided him with a storehouse of information that he drew on for his finished paintings. Such quick studies provide the ideal means of recording

these transient effects: even a rapid pencil sketch of cloud shapes with written notes of the colours will act as an *aide-mémoire* and help you to observe constructively. Photographs are also useful in this context, as long as you use them as part of a learning process and not as models to copy for a painting.

Methods

For novice watercolour painters, skies, particularly those with complex cloud formations, are a daunting subject. You

aim at a soft impression and find you have unwanted hard edges, or you try to build up some really dramatic tonal contrast for a stormy sky and overwork the paint, completely ruining the effect. But really, clouds are not so very difficult. The trick is to understand the medium well enough to develop your own tricks of the trade. Always be ready to use the element of

happy accident. Unintentional BACKRUNS and spreading paint may suggest the perfect way of painting rain clouds, while experiments with the LIFTING OUT technique will quickly show you how to paint wind clouds or achieve soft, fluffy white edges without having to go through the more laborious process of reserving highlights.

Robert Tilling RI, Winter Sky, 40.6 x 58.4 cm (16 x 23 IN), WATERCOLOUR

Working on a light stretched paper with a Not surface, and with his board well tilted, the artist uses large brushes to lay very wet washes, later adding further ones WET-ON-DRY.

Clouds in composition

The possibilities of using clouds as an integral part of a composition are often ignored. which seems strange in view of the fact that skies are often the dominant element in a landscape. But the landscape painter must tackle this problem: clouds form exciting shapes in themselves, and these can be manipulated or exaggerated to add extra movement and drama to a subject. Shapes in the sky can also be planned to provide a balance for those in the foreground or middle distance. such as clumps of trees or rounded hills, and if colours as well as shapes are repeated from sky to land, the two parts of the painting will come together to form a satisfying whole. Since the sky is reflected to some extent in the land below, you will often see touches of blue or violet from the undersides of clouds occurring again in shadows or distant hills.

Not all paintings, of course. need this kind of sky interest. A mountain scene, for instance, or winter trees in stark silhouette, will be more successful if the sky is allowed to take second place, but a flat landscape can often be saved from dullness by an eventful sky, so keep a special sketchbook for recording cloud effects so that you can use them in landscapes painted indoors. Skies are very difficult to recreate from memory alone, so in addition to sketches, you could also use photographs of skies.

Charles Knight RWS, ROI, Sunset, South Downs, 27.9 x 38.1 cM (11 x 15 IN), WATERCOLOUR AND PENCIL

In this painting, the sky is virtually the whole composition, with the hills and fields serving as an anchor to the movement above. Much of the sky and foreground has been painted WET-IN-WET, and in the central area the orange

and grey washes have been allowed to flood together, giving a realistically soft effect. But the artist has not overdone the technique: below the orange patch there are clearer, harder edges, which are echoed by the crisp pencil lines defining the hills below, and the small clouds toward the top have been worked WET-ON-DRY.

Ronald Jesty RBA, Cloud Study 17.8 X 22.9 CM (7 X 9 IN), WATERCOLOUR

This dramatic painting, although giving the appearance of a planned and studio-composed piece, was in fact a study sketch made on the spot after a storm - which iust goes to show that nature will do at least some of the composing if you are receptive enough to her suggestions. The painting is quite small and was done quickly, of necessity, with superimposed washes and the dark clouds at the top painted wet-in-wet. Wet paint was lifted out in places (see LIFTING OUT) and the white cow parsley was suggested by STIPPLING around the shapes with the point of a brush.

Donald Pass, Spring Shower, 53.3 X 45.7 CM (21 X 18 IN), WATERCOLOUR

This is the perfect example of clouds used as an integral part of a composition. The painting is full of movement, and our eve is encouraged to travel around it as we follow the direction of the dramatic. curving cloud - up to the

right, around to the left and then downward through the bright patches of blue to the sunlit trees. The artist has tied the sky to the land both by using the same kind of brushwork throughout the picture and by echoing shapes: the vertical cloud seems a logical extension of the central group of tall trees.

Cloud formations

Clouds are always on the move - gathering, dispersing, forming and re-forming - but they do not behave in a random way. There are different types of cloud, each with its own individual structure and characteristics. It is not necessary to know the name of each type, but to paint clouds convincingly you need to recognize the differences. It is also helpful to realize that they form on different levels, because this affects their tones and colours.

Cirrus clouds, high in the sky, are fine and vaporous, forming delicate, feathery plumes where they are blown by the wind. The two types of cloud that form on the lowest level are cumulus clouds, with horizontal bases and cauliflower-like tops, and storm clouds (or thunderclouds) great, heavy masses that rise up vertically, often resembling mountains or towers. Both these low-level clouds show strong contrasts of light and dark. A storm cloud will sometimes look almost black against a blue sky, and cumulus clouds are extremely bright where the sun strikes them and surprisingly dark on their shadowed undersides. Between these two extremes of high and low, there is often an intermediate level of cloud with gentler contrasts than the low layer, so a single sky with a mixture of all these types of clouds can present a fascinating ready-made composition of varied shapes and colours.

Christopher Baker, Bosham Clouds 47.8 x 25.4 cm (7 x 10 IN), WATERCOLOUR AND CONTÉ CRAYON

The light conté-crayon drawing made to establish the main shapes has been deliberately used as part of the painting. Working on rag paper, which gives a pleasing texture to the picture surface, Baker has worked swiftly, with almost no overpainting. The subtle warm greys of the clouds were achieved by mixtures of ultramarine and light red, with some viridian and raw sienna in places.

Ronald Jesty RBA, *Out of Oban*, 33 x 33 CM (13 x 13 IN), WATERCOLOUR

This dramatic cloud study was painted in the studio from a pen sketch. Built up entirely by means of superimposed washes painted WET-ON-DRY, the colours are nevertheless fresh and clear. Although many watercolourists avoid overlaying washes for subjects

such as these, which are easily spoiled by too great a build-up of paint, Jesty succeeds because he takes care to make his first washes as positive as possible. Notice the granulated paint in the clouds caused by laying a wet wash over a previous dry one (see WASH: TEXTURES), an effect often used to add extra surface interest.

Moira Clinch, *Mountain Retreat*, 39.4 \times 48.3 CM (15 $\frac{1}{2}$ \times 19 IN), WATERCOLOUR

There is often quite sharp definition as well as strong contrasts of tone in the low level of cloud (that nearest to us). Clinch has given form to the clouds by using a combination of WET-IN-WET, which creates soft, diffused shapes, and WET-ON-DRY, which forms crisp edges where one wash overlaps another. The effect of the rain has been achieved by careful LIFTING OUT.

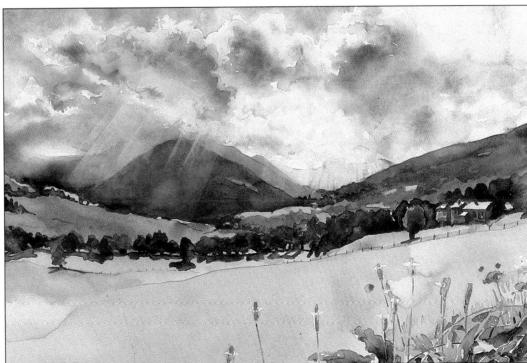

Clouds present a kaleidoscope of colours, but these are far from accidental. They are caused by the position of the sun and by the reflections of surrounding colours.

At noon, when the sun is high, clouds are largely robbed of colour - this is when you see the 'fleece balls' that amateur painters often depict - but the low sun of early morning or evening presents a different picture. At such times, there is a panorama of hues - yellows, warm pinks, browns and violets, with the edges of clouds a glowing gold where they reflect the sun. A cloud high in the sky will be blue-grey or violet on the underside because it takes on some of the blue from the sky, while a similar cloud lower on the horizon will be browner because it reflects less of the blue.

It is useful to know these general rules, particularly when you are painting indoors from notes and sketches. An everchanging sky can be a headache, however, if you are working on the spot. Each new effect and set of colours will seem to be better than the last, and you will find it difficult not to make changes. This could lead to disaster, as pushing the paint around too much is the surest way to destroy the airy evanescence of a sky. The best way to work is fast, keeping your colour mixtures simple and your brushwork free and unfussy. The same applies to a studio painting, so to avoid overworking the paint, plan which colours you will use, and put them on with assurance.

John Martin's cloud study, painted in gouache on a toned ground, shows careful observation of the colours seen in an early evening sky. If gouache is used too thickly from the outset, later layers will stir up and muddy the earlier ones, so he begins by using it as watercolour, blocking in the main shapes lightly.

2 He continues to build up the forms and colours of the clouds, thickening the paint only marginally in most areas, but introducing some opaque white at top left. **3** The final step (below) is to overpaint a touch of bright, deep blue at the top of the sky, separating the main cloud masses, and to add a few touches of light-toned, thick paint to the foreground. These link it to the sky by suggesting patches of sunlight, but no attempt is made at precise definition of the fields and hills, since this would steal attention from the real subject of the painting.

▶ This detail shows the dry, cream-coloured paint scrubbed over a darker mauve-grey. This SCUMBLING technique is well suited to skies, because it allows one colour to shine through another to give a shimmering, vaporous effect.

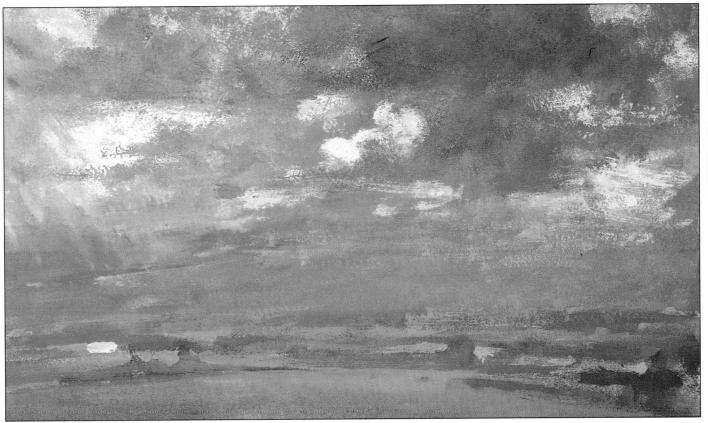

John Martin, Cloud Study, APPROX 22.9 X 35.6 CM (9 X 14 IN), GOUACHE ON TONED PAPER

Rain and mist

Watercolour is particularly well suited to capturing soft, pale, misty skies, wet-looking rainclouds, and delicate shafts of light, but such effects can easily look drab unless you introduce variety.

An overcast sky is seldom a completely flat grev. The most fascinating wet-weather effects are created by blue sky or a weak sun reflecting back through the fine layers of clouds to suggest other colours. In misty conditions. these colours are always gentle and subdued, so control your palette carefully. using the minimum of tonal contrast. This applies equally to the landscape (or seascape) beneath the sky, because a bright colour accent or overdark tone introduced into a muted colour scheme will destroy the atmosphere.

A painting like this can be almost monochromatic, but it will not be dull if you provide some extra interest, such as varied brushwork or the surface texture provided by working on rough paper. Directional brushwork creates an impression of movement, while squalls of rain can be described by dragging wet paint down the paper with a stiff bristle brush. BACKRUNS can be exploited to give interest to soft, wet clouds, while techniques such as SPATTERING and Spunge PAINTING can be used to enliven a too-flat area of colour.

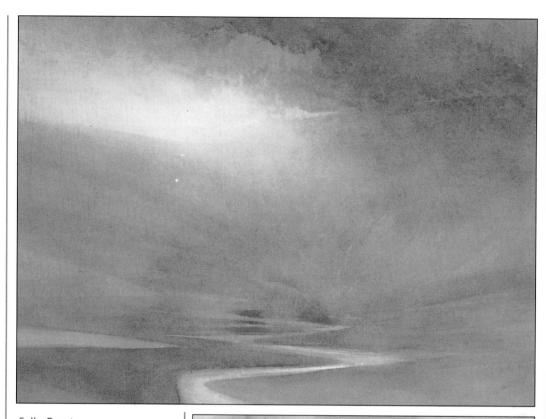

Colin Paynton, Welsh Elements I, 76.2 x 101.6 cm (19 $\frac{1}{2}$ x 26 $\frac{1}{2}$ IN), WATERCOLOUR

At first glance, this atmospheric painting looks almost monochromatic, but there are subtle touches of green-grey towards the horizon, which are echoed in the sky. The control of tones is skilful, as is the use of paint: notice the long. sweeping brushstrokes radiating upward from the centre of the horizon and the deliberate BACKRUN at the top of the sky. The artist has used a certain amount of washing out (see LIFTING OUT) to achieve his soft effects.

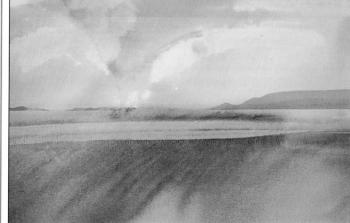

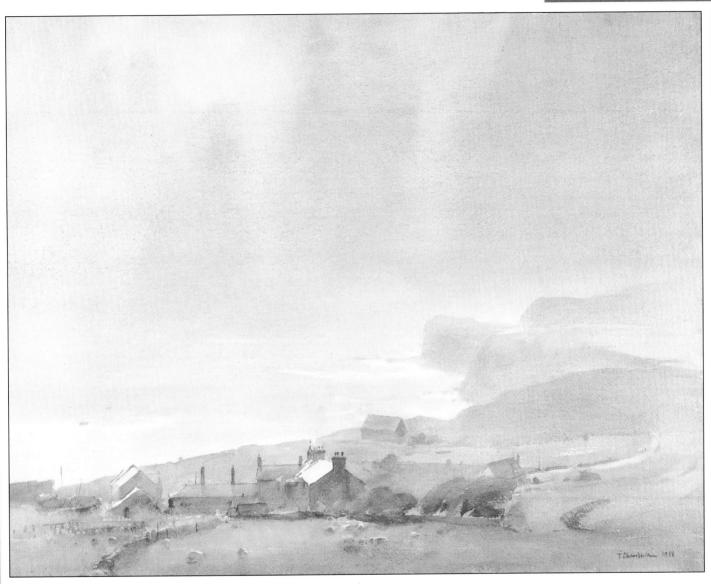

■ Robert Tilling RI, Winter Headland, WATERCOLOUR

Tilling is fascinated by dramatic light effects, and most of his watercolours are devoted to exploring the interaction of sky, sea and land. He works very wet, using large brushes, but controls his paint carefully. Here, for instance, he has held the dark grey-purple wash away from the headland to create an eloquent line of light above it. ▲ Trevor Chamberlain, Hazy Sun and Damp Mist, Boulby Down, 51.4 x 73 CM (20½ x 28⅓ IN), WATERCOLOUR

This lovely evocation almost makes us feel the damp but warm atmosphere with the sun about to break through. The artist has worked WET-IN-WET, controlling the tones and colours with the precision demanded by such a subject.

Still life

There was a time when drawing objects such as plaster casts, bottles and bowls of fruit was regarded as the first step in the training of art students. Only after a year or two spent perfecting their drawing technique would they be allowed to move on to using actual paint, while the really 'difficult' subjects such as the human figure were reserved for the final year. This now seems an arid approach, almost designed to stifle any personal ideas and talent, but like many of the teaching methods of the past, it contained a grain or two of sense - drawing and painting 'captive' subjects is undeniably a valuable exercise in learning to understand form and manipulate paint. But still-life painting can be very much more than this. It is enormously enjoyable, and presents almost unlimited possibilities for experimenting with shapes, colours and composition as well as technique.

The great beauty of still life lies in its controllability. You, as artist, are entirely in charge: you decide which objects you want to paint, arrange a set-up that shows them off to advantage, and orchestrate the colour scheme, lighting and background. Best of all, particularly for those who dislike being rushed, you can take more or less as long as you like over the painting. If you choose fruit and vegetables, they will, of course, shrivel or rot in time, but at least they will not move. This degree of choice allows you to express your own ideas in an individual manner, whereas in a portrait or landscape painting, you are more tied to a specific subject.

The still-life tradition

Almost all artists have at some time turned their hands to still life, and long before it became an art form in its own right, lovely little still lifes often appeared among the incidental detail in portraits and religious paintings. The first pure still-life paintings were those with an allegorical significance that became popular in the sixteenth century. Typical of these paintings, known as vanitas, were subjects such as flowers set beside a skull, signifying the inevitable triumph of death. It was the Flemish and Dutch painters of the seventeenth and eighteenth centuries, though. who really put still-life and flower painting on the map, with their marvellously lavish arrangements of exotic fruit and flowers, rich fabrics and fine china and glass. The vanitas still lifes reminded their religious patrons of the transience of life, but these exuberant and unashamedly materialistic works, painted for the wealthy merchant classes, were celebrations of its many sensual pleasures.

Still-life painting has remained popular with artists ever since, and, although it was regarded as an inferior art form by the French Academy, who favoured paintings with grand historical or mythological themes, it gained respectability when the Impressionists altered the course of painting forever. The still-life paintings of Edouard Manet (1832–83), Paul Cézanne (1839–1906), and Vincent Van Gogh (1853–90) rank among the finest works of any kind ever produced, the everyday subject matter being transcended in such a way that paintings became personal and passionate artistic statements.

Cherryl Fountain, Still Life with Pheasant and Hyacinth, 50.8 x 33 CM (20 x 13 IN), WATERCOLOUR

This artist also paints landscapes, in the same highly detailed style, but she likes still life particularly because she can control her set-up in a way that allows her to express her love of both pattern and texture.

'Found' groups

A still-life painting can be of more or less anything – the only thing common to all paintings in this genre, naturally, is that the subjects do not move.

Many still-life paintings are the result of carefully planned arrangements. Paul Cézanne (1839-1905) reputedly spent days setting up his groups of fruit and vegetables before so much as lifting his brush. Sometimes, though, you may just happen to see a subject, such as plates and cups on a table or a few vegetables lying on a piece of newspaper, that seems perfect in itself, or needs only small adjustments to make it so. These 'found' groups have a particular charm of their own, hinting at impermanence and the routines of everyday life.

Found groups obviously have to be painted more quickly than arranged ones, but this is in some ways an advantage, since you want to achieve a spontaneous, unposed effect. So make your technique express this also and paint freely, putting down broad impressions of shapes, colour and light.

Alternatively, you can use the idea of the found group as the basis for a more deliberate set-up, placing the objects in a more convenient place for painting or one where they have better light. Be careful, however, not to destroy the essence of the subject by overplanning and including too many extra elements.

Carolyne Moran, Kitchen Table with Basket and Vegetables, 36.8 x 54.6 cm ($14\frac{1}{2}$ x $21\frac{1}{2}$ IN), GOUACHE

This painting gives a powerful impression of spontaneity and immediacy, partly through the sense of movement created by the spilling vegetables, but equally through the manner of painting. Although the drawing is accurate – chairs, basket and vegetables all make sense in terms of structure and

proportion – there is no unnecessary detail. The light coming through the cane of the basket is described deftly but with no niggling, and the brushwork throughout the painting is vigorous and expressive. On the left-hand wall, the artist has allowed her brush to follow the sweeping lines of the upright chair struts, and on the table she has smeared still-wet paint with her fingers to simulate the grain of the wood.

John Lidzey FRSA, Oil Lamp, 15.2 X 24.1 CM (91/2 X 6 IN), WATERCOLOUR

This is a page from the artist's sketchbook. Heavily sized paper, such as the cartridge paper used for sketchbooks, has a non-absorbent surface that causes the paint to mix

freely but unevenly. Using plenty of water, he allowed the paint to flood onto the paper, controlling it with damp absorbent cotton wool. He used only three colours, ultramarine, yellow ochre and burnt sienna, but encouraged them to run into one another and mix, treating the paper almost like a palette.

Martin Taylor, Still Life with Pumpkin, 23 X 33 CM (9 X 13 IN), WATERCOLOUR

We are not all fortunate enough to have such a perfect still-life setting as this old stone building. But neither does Martin Taylor - he happened on this arrangement of fruit and vegetables quite by chance during a trip to Italy, and promptly settled down to paint it. The picture's most striking feature is the way he has built up the rough textures of the stone and contrasted them with the smooth ones of the fruit and vegetables, which glow out like beacons from their neutral-coloured surroundings.

Themes

A successful still life is seldom. if ever, a random collection of objects - there should always be some kind of theme. One of the most popular types of still life is the culinary one, where fruit, vegetables and kitchen equipment are grouped together. Attractive in themselves, they also are related in subject, so that the viewer is not worried by the discordant notes of objects that seem not to belong. Another kind of theme is the 'literary' one. Some still lifes tell a story about the personal interests of the artist. The best-known examples of such still lifes are those of Vincent Van Gogh (1853-90), whose paintings of his room in Arles and his moving portrayals of his own work-soiled boots are almost a form of pictorial biography, telling us as much about the artist and his way of life as about the objects themselves. This approach to painting makes a lot of sense most people possess some objects that have particular value because they evoke memories, so what better than to make them the starting point for a personal still life.

You can also take colours and shapes as the theme, choosing objects that seem to be linked visually or setting up exciting contrasts. Visual themes need very careful handling at the painting stage—if the objects are widely dissimilar in kind you may have to treat them in a semi-abstract way, allowing them to hide their identity behind their general forms or outlines.

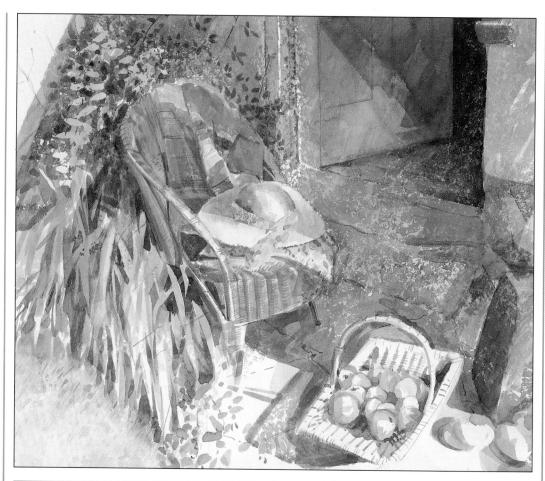

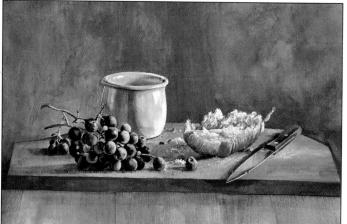

■ Martin Taylor,Grapes and Bread,23 X 33 CM (9 X 13 IN),WATERCOLOUR AND ACRYLIC

Food has always been a popular still-life theme, and this lovely, simple little group is very much in the Dutch tradition of minute observation and truth to the realities of everyday life. Painted in Italy at the end of a holiday, it had an extra significance for the artist, the grapes (wine) and bread symbolizing the Italian way of life.

■ Michael Emmett,

By the Cottage Door,

76.2 x 101.6 cm (14½ x 16½ IN),

WATERCOLOUR

This delightful outdoor group is an example of a still life with a narrative content: we can see that someone. perhaps the painter's wife, has been sitting in the sun preparing fruit and vegetables, but has now abandoned her task. This adds an extra dimension to the picture. inviting us to participate in the domestic scene, but the implied story plays only a secondary role; once drawn in, we can admire the carefully planned composition and the artist's technical skill. He has painted mainly wet-on-dry, building up subtle but varied colours by means of successive overlapping washes, and the effect of dappled sunlight by the door has been cleverly suggested by the SPATTERING technique.

Moira Huntly RI, RSMA, Still Life with African Artefact, 49.5 x 35.5 cm (19½ x 14 IN), WATERCOLOUR AND GOUACHE

Here the main theme is colour and shape; if you look at the painting through half-closed eyes, you can see an abstract pattern, perfectly balanced and carefully controlled. One of the surest ways to tie all the elements in a still life together is to repeat colours and shapes from one area to another, and there could be few better examples than this painting and its subtly echoing patterns.

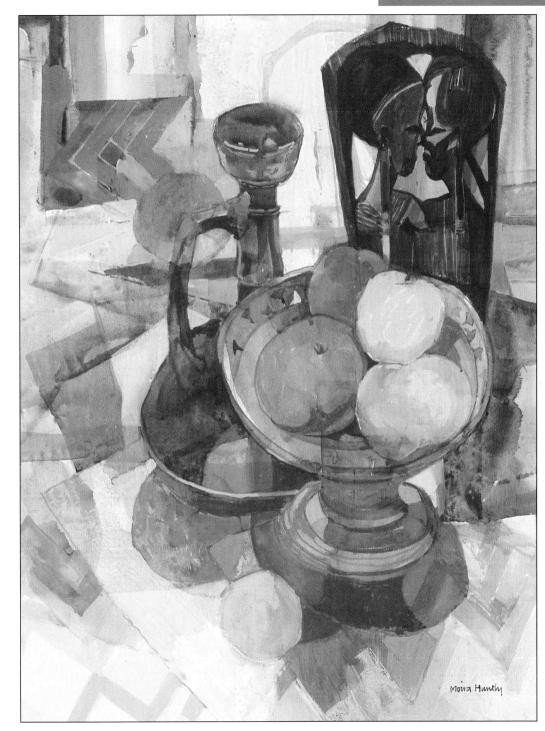

Arranging the group

Planning the disposition of objects in a still-life group so that they provide a satisfactory balance of shapes and colours is as important as painting it.

A good still life, like any other painting, should have movement and dynamism, so that your eye is drawn into the picture and led around it from one object to another. It is wise to avoid the parallel horizontals formed by the back and front of a tabletop: the eye naturally travels along straight lines and these will lead out of the painting instead of into it. A device often used to break up such horizontals is to arrange a piece of drapery so that it hangs over the front of the table and forms a rhythmic curve around the objects. An alternative is to place the table at an angle so that it provides diagonal lines that will lead in toward the centre of the picture.

Never arrange all the objects in a regimented row with equal spaces between them, as this will look static and uninteresting. Try to relate them to one another in pictorial terms by letting some overlap others, and give a sense of depth to the painting by placing them on different spatial planes, with some near the front of the table and others towards the back. Finally, make sure that the spaces between objects form pleasing shapes - these 'negative shapes' are often overlooked, but they play an important part in composition.

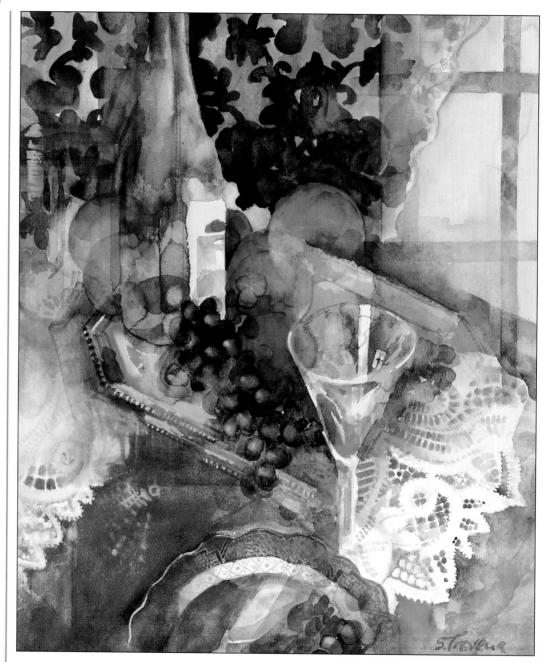

■ Shirley Trevena,

Black Grapes and Wine,

50.8 x 40.6 cm (20 x 16 IN),

WATERCOLOUR AND GOUACHE

Trevena works straight from her arranged group with no sketching, and composes as she paints. She likes to vary the texture of her paint, using thin watercolour washes in places and thickly built up layers of gouache in others. The lace is the original white paper left untouched. Her work has a lyrical, quality: the objects are all recognizable, but we are drawn to the painting by the fluid shapes and colours.

Geraldine Girvan, Winter Oranges, 32.4 x 36.8 CM (123/4 x 131/2 IN), GOUACHE

This arrangement relies for its effect on simplicity, but it is carefully planned. Notice how the artist has made use of strong tonal contrasts and diagonal lines to lead the eye into the centre of the picture, and how she has used blues to counterpoint the marvellous, glowing oranges. Girvan's main interest is colour, and she favours gouache because it allows her to build up the strong, vibrant harmonies she loves.

Edward Piper, Nude in a Mauve Negligée, 45.7 x 61 cm (18 x 24 ln), WATERCOLOUR AND LINE

In a way, this painting breaks the rules of still life because it includes a human figure. But because the treatment is not naturalistic, it blends perfectly with the other components of the group, looking at first glance rather like one of the plaster casts that appear frequently in Cézanne's still-life paintings. Piper uses colour to establish broad areas that relate to, but do not describe, the forms, and adds crisp but free definition by means of drawn lines - a bold use of the LINE AND WASH technique. Notice how the group of flowers on the left, with its strong contrast of tone, draws the eye into the bright area of red, pink and purple at the centre.

Backgrounds

One of the most common mistakes in still-life painting is to treat the background as unimportant. It is easy to feel that only the objects really matter and that the spaces behind and between them are areas that just need to be filled in somehow. All the elements in a painting should work together, however, and backgrounds, although they may play a secondary role, require as much consideration as the placing of the objects.

The kind of background you choose for an arranged group will depend entirely on the kind of picture you plan. A plain white or off-white wall could provide a good foil for a group of elegantly shaped objects, such as glass bottles or tall vases, because the dominant theme in this case would be shape rather than colour, but a group you have chosen because it allows you to exploit colour and pattern would be better served by a bright background, perhaps with some pattern itself.

The most important thing to remember is that the background colour or colours must be in tune with the overall colour key of the painting. You can stress the relationship of foreground to background when you begin to paint, tying the two areas of the picture together by repeating colours from one to another. For example, if your group has a predominance of browns and blues, try to introduce one of these colours into the background also. It is usually better in any case not to paint it completely flat.

 Geraldine Girvan. Victoria Day. 48.3 x 53 CM (19 X 20 1/8 IN), GOUACHE

Here the background is as busy and eventful as the foreground, as befits a painting in which colour and pattern are the dominant themes. Notice how the artist has echoed the shapes of the blue fish (bottom right) in the patterned wallpaper above.

Shirley Felts, Still Life with Apples, 40.6 x 30.5 CM (16 x 12 IN), WATERCOLOUR

For this painting, the artist has chosen a plain brown background that picks up the colour of the tabletop. But she has not painted it flat: there are several different colours and tones in the 'brown', including a deep blue, and she has given movement and drama to it by the use of brushstrokes that follow the direction of the spiky leaves.

Ronald Jesty RBA. Plums in a Dish 28 x 29.9 CM (11 X 9 IN), WATERCOLOUR

This artist likes to exploit unusual viewpoints in his stilllife paintings, and in this example he has chosen to paint his subject from above. This not only neatly solves the problem of a separate background and foreground, it also allows him to make the most of the elegant shape of the metal platter.

Settings

The majority of still lifes are done indoors for the very simple reason that it is more convenient from the painting point of view, as well as giving you greater control over the set-up and lighting. There is, however, a wide range of indoor settings: you can paint in the corner of a room with your group lit by artificial light, you can arrange your objects on a windowsill with natural light behind them, you can even paint in a garage or greenhouse. There is no reason why you should not paint outside - a picture of a group of garden tools and a wheelbarrow is just as valid a still-life subject as a collection of bottles on a table.

Always consider the possibilities of more unusual settings, but never choose them randomly – the objects should look as though they belong to the place not as though they have been unwillingly transplanted.

Whether you decide on an outdoor subject or one lit by daylight coming through a window, you will, of course, have to cope with the problem of a changing light source.

Daylight indoors can create exciting shadow patterns that you can use as an element in the composition, but they will not remain the same for long, so you will either have to work fast or in two or more separate sessions at the same time of day.

Carolyne Moran, Time for Tea, 26.7 x 27.3 cm ($10\frac{1}{2}$ x $12\frac{3}{4}$ IN), GOUACHE ON BOCKINGFORD PAPER

It is surprising how few still lifes are painted outdoors, but it seems like the obvious setting for a group like this, and provides an interesting and natural-looking background. A changing light source can be a problem, but here the artist has avoided any dramatic light and shade effects to concentrate on the shapes and colours of the objects set against the dark background of pots and foliage.

Cherryl Fountain, January Windowsill, 55.2 x 76.3 CM $(21^{3}/_{4} \times 30 \text{ IN})$, WATERCOLOUR

Here the artist has chosen to group her objects so that they are lit by the cold winter light coming in from outside, which partially silhouettes the cactus and the tail of the bird, as well as dictating the colour key for the painting. An additional advantage of this setting is that the window frame provides a stabilizing set of verticals and horizontals that act as a counterpoint to the curving shapes of the leaves and the pots.

Paul Dawson, The Pink Umbrella. 33 x 45.7 CM (13 x 18 IN), GOUACHE AND ACRYLIC

We tend to think of still life as a group of objects arranged against a background, but here the whole painting is the still life - the chair and parasol, the hat on the table, the floor with its pattern of shadows and the wooden wall and shuttered window. Everything is treated with the same loving attention to detail. Dawson uses a variety of techniques to obtain his meticulously realistic effects. The floorboards, table and walls were painted by DRY BRUSH over a preliminary wash,

with the leaves added in thick gouache on top. The procedure for the chair was more complex. First an overall wash was laid, then the cane was defined with waterproof white ink and a fine brush, and finally thin glazes of

acrylic were used to give the chair its colour and form. Altogether, this is an exercise in technical ingenuity.

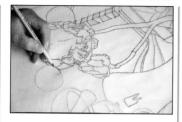

1 Ronald Jesty is an artist who works almost exclusively WET-ON-DRY. This painting is built up in a series of separate stages. Here he is transferring a full-scale drawing to the watercolour paper by drawing over a tracing.

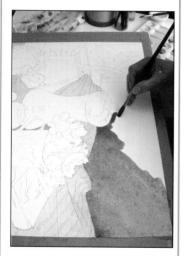

2 He begins with several small, neutral-coloured washes and then paints the golden-brown background. Notice that he has turned the board sideways to make it easier to take the paint around the edges of the bottle.

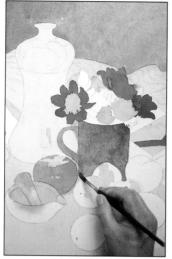

3 It is important to establish the colour key early, so once the background is complete, he puts down a pale pinkish grey for the tabletop and areas of vivid red for the petals of the anemones. Without the background, it would have been difficult to assess the strength of colour needed for these. The next stages are the persimmon and the mug that holds the flowers, close in tone and colour but with clearly perceptible differences. None of these areas of colour is completely flat: the modelling on the persimmon and the jug begins immediately, with darker, cooler colours in the shadow areas. which are linked to the bluegrey of the pestle and mortar.

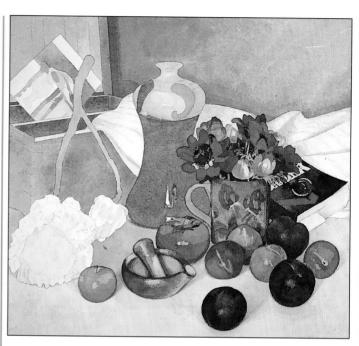

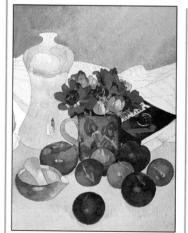

The flowers and fruit are now virtually complete, with the dark, rich colours built up in a series of small, overlapping washes to leave HIGHLIGHTS of varying intensity. The light blue-grey of the vase on the left represents the colour and tone to be reserved for highlights.

The box on the left is painted in a colour that picks up that of the persimmons and yellow plums. Although the painting is vivid and colourful, the colours are deliberately orchestrated to give an overall strength and unity to the composition. A further wash is laid on the blue vase to provide the mid-toned highlights when the darkest tones have been added.

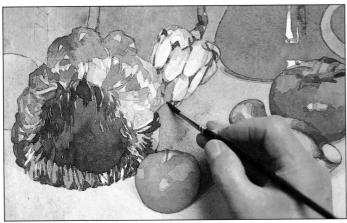

6 I The complex forms of the artichoke head are described with delicate but accurate brushstrokes. Again, the colours used are versions of those elsewhere in the painting – there are no blacks or dead browns even in the darkest outlines.

7 With the deep blues and purples of the jug complete, the painting has a definite focal point. Although the whole picture is eventful and there are some delightful touches, such as the book title we cannot quite read and the sketch on the extreme left (which probably has some significance for the artist), our attention is drawn to the centre by the strong, dark tones and glowing colours. It is not easy to achieve this intensity in watercolour without muddying the paint by overworking, and this is why Jesty plans so thoroughly. He overlays washes to a considerable extent, but avoids overworking by using barely diluted paint from the outset where the tones are to be dark.

Ronald Jesty, Persimmons and Plums, 40.6 x 50.8 CM (16 x 20 IN), WATERCOLOUR ON STRETCHED BOCKINGFORD PAPER

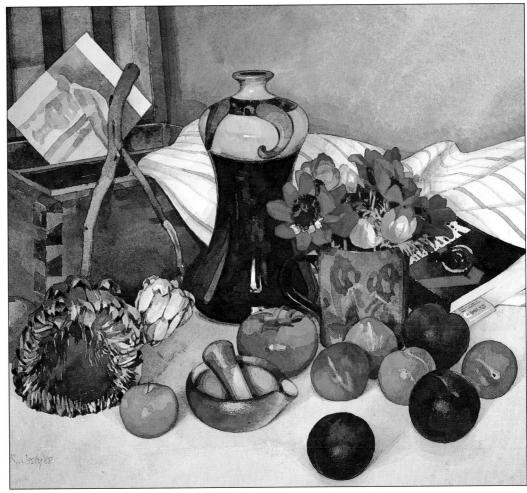

Water

For the artist, water is one of the most appealing and challenging of all subjects. Like the sky, it presents a multitude of different faces – from wild, wind-tossed waves or turbulent waterfalls to the glassy surface of a still pond. Also, like the sky, it is elusive and insubstantial.

Observe and simplify

Perhaps more than any other subject, water requires very close observation. The shapes and colours of trees or hills can, to some extent, be re-created from memory, but water has no permanent shape or presence of its own. A completely still lake will present a mirror image of the sky, but one tiny breeze can transform the water surface into a steely grey, solid-looking mass. A fast-running stream seen from a certain distance away may provide a reassuringly simple surface and an even colour, but as soon as you sit down beside it, the real paradox of water becomes apparent. It is undeniably there, but at the same time it is a transparent and ethereal presence through which you can clearly see the sand and rocks below.

To paint water successfully, it is necessary to simplify what you see, but you cannot hope to distill the essence of a subject until you are familiar with its complexities. So be prepared to spend time watching water – it is a pleasing pastime in itself. If you sit quietly by a river or on the seashore, you will begin to see that the movements of water, like its changing colours, follow certain patterns. Understanding, for instance, the way the sea swells to become a wave, before breaking into foam will enable you to paint it with assurance and freedom.

Painting methods

As soon as you begin to labour the paint, the effect of movement and fluidity will be destroyed. There are several techniques that are particularly suited to the subject; some are shown in the examples on the following pages, but, as a general rule, any method that involves much overlaying of paint should be avoided. Broad, flat or broken washes are ideal for still lakes or calm sea, and a DRY BRUSH dragged across rough white paper is a wonderfully economical means of suggesting lines or patches of wind-ruffled water in the distance. Ripples and reflections can be described in a kind of shorthand by calligraphic brushmarks and squiggles, while the WET-IN-WET method is marvellous for creating a soft, diffused impression. Everyone has their own way of painting, however, and ultimately the only way to find the best approach is by trial and error.

■ Robert Tilling,

Low Tide Textures,

50.8 x 71.1 CM (20 x 28 IN),

WATERCOLOUR, GOUACHE AND COLLAGE

Robert Tilling lives in the Channel Islands, and most of his watercolours are based on what he calls the 'edge of the sea'. As can be seen in this painting, he is fascinated by the abstract qualities of such seascapes. He usually works in pure watercolour, used in

broad, wet washes, but here he has used a collage technique, involving gluing torn (stretched) paper to the working surface and then applying washes on top. Some colour was then scraped off with a piece of stiff cardboard, more washes applied, and some gouache lines added as a final stage.

Ronald Jesty, Loch Etive at Taynuilt, 19 X 27.9 CM $(7\frac{1}{2} X 11 IN)$, WATERCOLOUR

Jesty has set up such a strong contrast of darks and lights that the patch of white water reflected from the bright area of sky seems almost to be illuminated from behind. The combination of deep-toned, hard-edged washes and the slightly granular texture of the paper is particularly striking.

Light on water

The effects of light on water are almost irresistible, particularly the more dramatic and fleeting ones caused by a changeable sky. Obviously they can seldom be painted on the spot; a shaft of sunlight suddenly breaking through cloud to spotlight an area of water could disappear before you lay out your colours. But you can recapture such effects in the studio as long as you have observed them closely.

When you begin to paint, remember that the effect you want to convey is one of transience, so try to make your technique express this quality. This does not mean splashing on the paint with no forethought – this is unlikely to be successful. One of the paradoxes of watercolour painting is that the most seemingly spontaneous effects are in fact the result of careful planning.

Work out the colours and tones in advance so that you do not have to correct them by overlaying wash over wash. It can be helpful to make a series of small preparatory colour sketches to try out various techniques and colour combinations. Knowing exactly what you intend to do enables you to paint freely and without hesitation. If you decide to paint wet-IN-WET, first practise controlling the paint by tilting the board. If you prefer to work wet-on-dry, establish exactly where your highlights are to be and then leave them strictly alone or, alternatively. put them in last with opaque white used drily.

Francis Bowyer, *It's Freezing!*, 38.1 x 53.3 cm (15 x 21 in), WATERCOLOUR AND BODY COLOUR (GOUACHE WHITE)

The effect of the low sun on the choppy water has been beautifully observed and painted rapidly and decisively, with each brushstroke of vivid colour put down and then left alone. In places, such as the more distant waves, the paint is thin enough for the paper to be visible, while in the foreground the shapes of the brushmarks have been exploited to give a feeling of movement to the wavelets breaking on the beach.

■ Robert Tilling RI, Winter Tide, 40.6 x 58.4 CM (16 X 23 IN), WATERCOLOUR

Tilling begins his watercolours by laying very wet, broad washes with large brushes

(No. 12 up). Here he has also used stiff-bristled housepainting brushes to create the striated effect of the wet beach, combining this with SCRAPING BACK (using cardboard scraps) to build up a lively and descriptive paint surface.

Shirley Felts, The River Guadalupe, 53.3 x 73.7 cm (21 x 29 IN), WATERCOLOUR

This lovely painting shows a breathtakingly skilful use of reserved HIGHLIGHTS. Each pale reflection, tiny sunlit twig and

point of light has been achieved by painting around the area. This can result in tired, overworked paint, but here nothing of the luminosity of the watercolour has been sacrificed, and it remains fresh and sparkling.

Moving water

Most people have experienced the disappointment of finding that a photograph of a waterfall or rushing stream has completely failed to capture the movement and excitement of the subject. This is because the camera freezes movement by its insistence on including every tiny detail, and this provides an important lesson for the painter. You can never hope to paint moving water unless you simplify it.

Rippling water under a strong light shows distinct contrasts of tone and colour, often with hard edges between the sunlit tops and the shadows caused by broken reflections. Working WET-ON-DRY is the best way of describing this quality, but avoid too much overlaying of washes. because this can quickly muddy the colours and destroy the crispness. LIQUID MASK is useful here, because you can block out small highlights on the tops of wavelets while you work freely on the darker tones.

The wax resist method is tailor-made for suggesting the ruffled effect of windblown water or the broken spray on the tops of breakers, while the delicate, lacelike patterns formed when a wave draws back from the beach can be very accurately 'painted' by SCRAPING BACK.

Whatever technique or combinations of techniques you decide on, use as few brushstrokes as possible – the more paint you put on, the less wet the water will look.

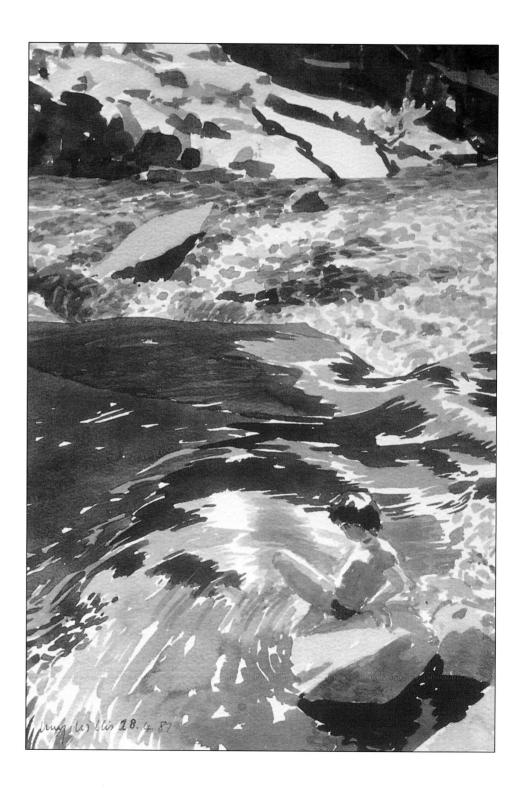

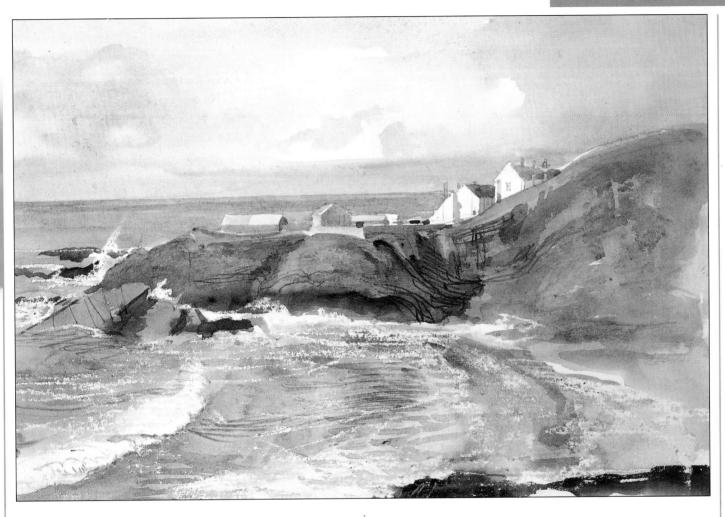

■ Lucy Willis, Pinhao Rapids, 38.1 x 27.9 CM (15 X 11 IN), WATERCOLOUR

The artist says that what attracted her about this subject was the contrast between the smooth, glassy water in the foreground, sliding towards the rapids and the turbulence beyond. She found that the effect of the water's flow could be described entirely through the

pattern of dark and light reflections, which, as she observed, remained more or less the same even though the water itself was in fast movement. Willis has expressed the hard-edged quality of the water, with its abrupt transitions from light to very dark, by working WET-ON-DRY, with a very precise use of differently shaped brushstrokes.

Charles Knight RWS, ROI, Headland,

27.3 X 37.5 CM ($10^{3}/_{4}$ X $14^{3}/_{4}$ IN), WATERCOLOUR, PENCIL AND WAX

Knight is a committed landand seascape painter, and a master of the watercolour medium. This wonderfully atmospheric painting provides the perfect illustration of the secondary role played by technique in art. He has made excellent use of WAX RESIST for the waves and given a lovely feeling of movement and drama to the headland with crisp, dark pencil lines, but his techniques, although fascinating to analyze, remain 'in their place' as no more than vehicles that allow him to express his ideas.

Still water

There are few sights more tempting to the painter than the tranquil, mirror-like surface of a lake on a still day or a calm, unruffled sea at dawn or dusk. But although it would be reasonable to believe still water to be an easy subject, particularly in a medium that has such an obvious affinity with it, it is surprising how often such paintings go wrong.

The most frequent reason for failure is simply poor observation. A calm expanse of water is seldom exactly the same colour and tone all over. because it is a reflective surface. Even if there are no objects such as boats, rocks or cliffs to provide clearly defined reflections, the water is still mirroring the sky and will show similar variations. These shifts in colour and tone often subtle - are also affected by the angle of viewing. Water looks darker in the foreground because it is closer to you and thus reflects less light.

It is also important to remember that a lake or area of sea is a horizontal plane. This sounds obvious, but has powerful implications for painting. A horizontal plane painted in an unvaried tone will instantly assume the properties of a vertical one because no recession is implied. It can sometimes be necessary to stress flatness and recession by exaggerating a darker tone or even inventing a ripple or two to bring the foreground forward.

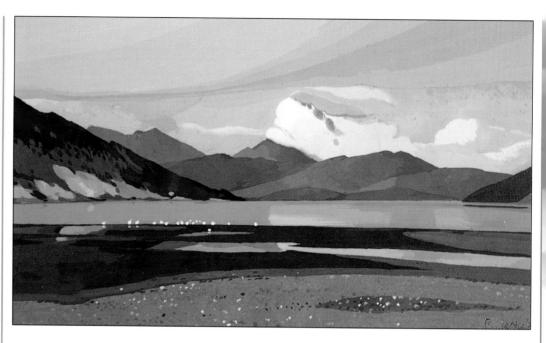

Ronald Jesty RBA, The White Cloud, Loch Etive 16.5 x 27.9 cm ($6\frac{1}{2}$ x 11 IN), GOUACHE

It is interesting to compare this painting with the one opposite, by the same artist. The majority of his paintings are in pure watercolour, but here he uses gouache applied in broad areas of very flat colour to give an almost printlike effect, in which the juxtaposition of shapes and colours are all-important. He has produced an exciting composition by echoing the sweeping curve of the cloud in the light area of foreground. while the reflections in the water serve to break up the central area of blue-grey.

Robert Tilling RI, Noirmont Evening, Jersey, 40.6 x 58.4 cm (16 x 23 IN), WATERCOLOUR

The magical effects of still water under a setting sun have been achieved by a skilful use of the WET-IN-WET technique. Tilling works on paper with a Not surface, stretched on large blockboard supports. He mixes paint in considerable quantities and applies it with large brushes, tilting his board at an angle of 60° or sometimes even more to allow the paint to run. This method can easily get out of control. so he watches carefully, ready to lessen the angle of the board if necessary to halt the flow of the colours. The dark wash for the headland was painted when the first wet-inwet stage had dried.

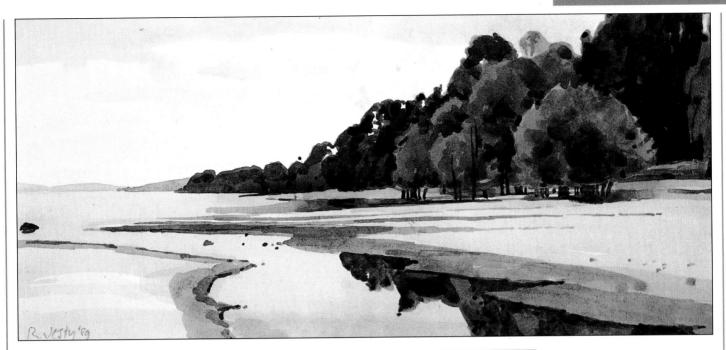

▲ Ronald Jesty RBA, Loch Rannoch, Low Water 15.2 x 34.3 CM (6 x 13½ IN), WATERCOLOUR

The artist has cleverly enhanced the bright surface of the water and its pale, sandy banks by setting up strong contrasts of tone while keeping the colours muted. The crisply painted reflections of the dark trees on the right and the little lines of shadow on the left define the river with perfect accuracy. The water surface is not painted completely flat: a sense of space and recession is created by the slightly darker patch of colour directly in the foreground as well as by the linear perspective that narrows the river banks as the river flows towards the lake.

Reflections

Reflections are one of the many bonuses of water provided free of charge to the painter. Not only do they form lovely patterns in themselves, they can also be used as a powerful element in a composition, allowing you to balance solid shapes with their watery images and to repeat colours in one area of a painting in another.

The most exciting effects are seen when small movements of water cause ripples or swells that break up the reflections into separate shapes, with jagged or wavering outlines.

Water can, of course, be so still that it becomes literally a mirror, but this does not necessarily make a good painting subject because it loses much of its identity.

As in all water subjects, try to simplify reflections and keep the paint fresh and crisp. Let your brush describe the shapes by drawing with it in a calligraphic way (see BRUSH DRAWING) and never put on more paint than you need. The amount of detail you put into a reflection will depend on how near the front of the picture it is. A distant one will be more generalized because the ripples will decrease in size as they recede from you, so avoid using the same size of brushmark for both near and far reflections, or the water will appear to be flowing uphill. You could emphasize foreground reflections by painting WET-ON-DRY, and give a softer, more diffused, quality to those in the background by using the WET-IN-WET OR LIFTING OUT methods.

■ Michael Cadman RI, ARCA, Cornish Harbour, Low Tide, 45.7 x 33 CM (18 x 13 IN), ACRYLIC ON TONED PAPER

Here the artist has exploited the potential of acrylic to the full, using brushmarks as an integral part of the painting, so that water, buildings, and sky are all broken up into small areas of colour. The reflections are hinted at rather than literally described. Because we cannot be quite sure where the water ends and the steps and harbour wall begin, the two parts of the picture seem to flow into one another to create a sense of complete unity, reinforced by the overall golden colour key. To help him achieve this, Cadman has painted on a TONED GROUND (ovster-coloured Canson Mi-Teintes paper) and in places has used his paint guite thinly so that the paper stands as a colour in its own right. Although in the main, this is a fairly direct painting, in some areas, notably the light on the main building, a dark underpainting of burnt sienna and violet was used and allowed to show through successive coats of overpainted impasto. These were then glazed (see GLAZING) in places.

▲ John Tookey, *Snape*, 76.2 x 101.6 cm (13½ x 20¼ IN), WATERCOLOUR AND PEN

This painting aptly illustrates the idea of 'making less say more'. The main area of water consists of only two washes, with the initial pale one left to show through the subsequent slightly darker one in the foreground. These pale patches hint at soft ripples, which have then been defined more precisely with a few shapes of darker blue-grey. There is no hesitant niggling and the reflections have been painted similarly freely, with calligraphic brushmarks, broken lines and squiggles suggesting the way they are broken up by the gentle movement of the water.

► Ronald Jesty RBA, Old Harry Rocks 48.3 x 30.5 cm (19 x 12 IN), WATERCOLOUR

In this bold composition, the reflection, rather than being an incidental detail, forms part of the painting's focal point. The treatment is stylized to some extent, but nevertheless extremely accurate. There is no unnecessary detail, but there is enough variation in the reflection to suggest both the structure of the rock above and the slightly broken surface of the water. The artist has painted wet-on-dry, his preferred method, and has made clever use of the shape and direction of his brushmarks to lead the eye into the centre of the picture.

Boats

Many of us avoid painting urban scenes because of the clutter of cars and feel outraged when a brash new motor vehicle spoils our view of a pretty village. But the relationship of water and boats is a time-hallowed one. and they have always been among the most popular of painting subjects. With their swelling curves and exciting colours and textures, boats (particularly old ones) are exciting in themselves, and they also provide an opportunity to make use of reflections in a composition. Their forms, however, are more complex than one might think. and practice is essential if you are to learn to draw them convincingly. Work from life whenever possible and try to learn the basic structure and the way it is affected by perspective.

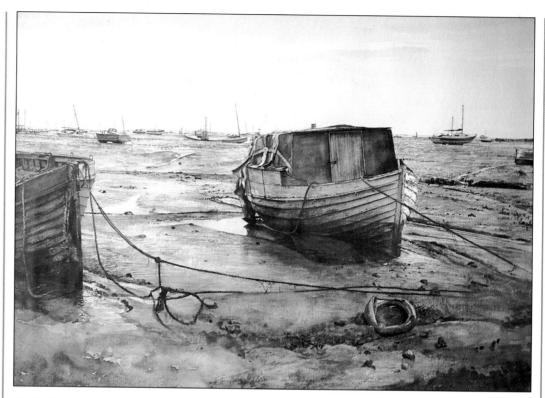

Martin Taylor, Morning, Leigh-on-Sea. 54 X 72 CM (211/4 X 283/8 IN). WATERCOLOUR AND BODY COLOUR

This quiet, atmospheric painting is a visual essay in light and texture. Taylor always works from top to bottom in his landscapes, establishing the colour and shades of the sky and middle distance to set the key for the rest of the painting. He mixes white gouache with watercolour blues for skies, and often works on them for hours. dabbing with a sponge or tissue paper and working into and over preliminary washes.

TEXTURE is obtained in a number of ways, sometimes

simply by allowing the grain of the paper to show through and sometimes by working with a DRY BRUSH over earlier washes. On the boats, the blade of a craft knife has been used to scuff the paper, a method the artist uses guite frequently, often painting over the scraped area and then repeating the process until he is satisfied with the result.

Once he has covered all the white paper, he goes back over the whole painting, tying it all together to achieve the right quality of light. He finds this final stage the most exciting of all - the final 'expression' after the hard work has been done.

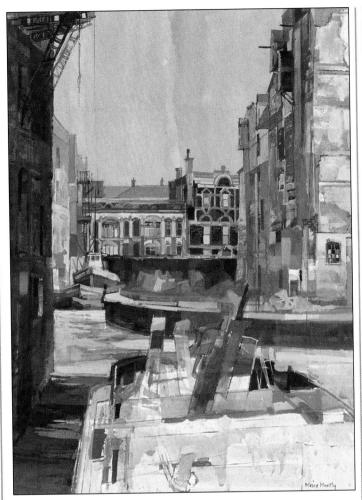

Moira Huntly RI, RSMA, Charlie's Live Bait Stand, Campbell River 30 X 27 CM (113/4 X 143/2 IN), WATERCOLOUR AND GOUACHE

Huntly's paintings, whether landscape or still life, have a strong abstract quality, and here she has used the shapes of the boats to create a pattern of intersecting curves and verticals. Nevertheless, the boats are carefully drawn and perfectly convincing in terms of actuality, and the colour scheme of greens, blue-greys and muted reds gives a strong feeling of place and atmosphere.

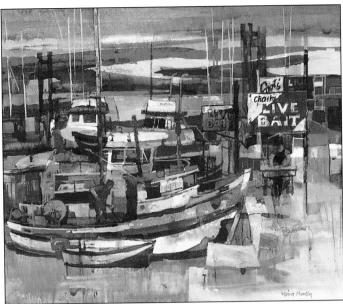

Moira Huntly RI, RSMA, Butler's Wharf, London 39.5 x 149.5 cm (15½ x 19½ IN), WATERCOLOUR AND GOUACHE

This painting, like that on the left by the same artist, stresses the relationship of shapes, and the barges have been simplified into a series of blocks of colour. Warm washes of transparent watercolour have been overlaid with gouache in places and textural effects were achieved by a simple printing technique. This, demonstrated on page 102, involves brushing watercolour onto a small piece of thick paper and pressing it onto the working surface before the paint dries.

1 Kate Gwynn is an inventive artist who seldom restricts herself to one technique, and here she uses various methods, improvising as she works. First she establishes the main composition, overlaying washes in the water area to create hard edges

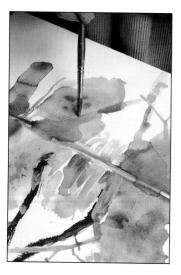

Having laid further washes, she now works WET-IN-WET with the point of the brush to suggest the effect of the reflected foliage.

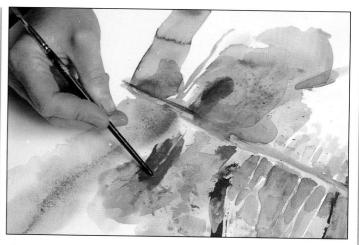

The brushmarks made in the last stage have now been overlaid with loose, wet washes to achieve a soft, diffused effect. The pale tree trunks seen on the right in this picture have been reserved in the traditional

manner (see HIGHLIGHTS), but here the handle of the brush is used to draw into paint slightly thickened with BODY COLOUR, providing an effective contrast to the loose wash on the right.

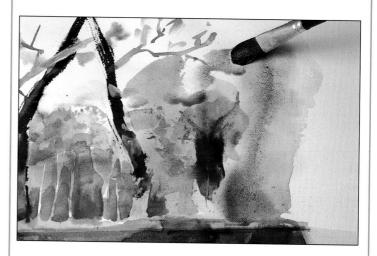

Sky is suggested with a wet brushstroke of blue, which is allowed to run into the yellow wash below.

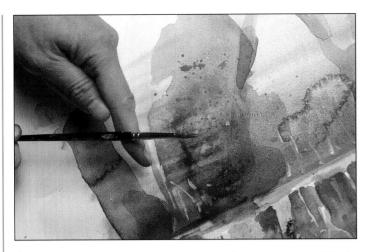

5 The SPATTERING technique is used to build up the impression of texture. Again, the paint has been slightly thickened with opaque white. Notice the deliberate use of the BACKRUN to accentuate the aqueous effect and the horizontal brushmarks suggesting slight ripples.

The soft, undefined impression has been maintained throughout the painting, with no attempt at precise description. The intersecting diagonals of the central trees provide a focal point, and the crisp, dark strokes of rather dry paint contrast with the paler, more fluid reflections below.

Kate Gwynn, Trees and Water, 40.6 x 50.8 cm (16 x 20 IN), WATERCOLOUR WITH SOME BODY COLOUR ON STRETCHED BOCKINGFORD PAPER

INDEX

Page numbers in italic refer to illustrations and captions

Α

abstract patterns: blots 13 acetate: squaring up 52, 52-3 acrylic 65, 76, 97, 100 blending 12 broken colour 16 brush drawing 18 dry brush 28 glazing 30, 30 mixed media 42, 42, 44-5, 81, 87, 89, 94, 95, 97, 101, 108, 117, 118, 139, 164, 171 scraping back 46 scumbling 48 surface texture 57 toned grounds 59 underpainting 60 washes 61 wet-in-wet 68 wet-on-dry 70 aerial perspective 137, 144, 144-5, alizarin crimson 12, 14, 16 anatomy 74 animals 74-84, 75-85 birds 75, 76, 76-7, 84 domestic and farm 80, 80-1 dry brush 28 movement 78, 78-9 textures 84, 84-5 wild animals 82, 82-3 Aquapasto 127 Arches papers 26, 60 architecture see buildings artificial light 92 asymmetry 124 atmosphere: landscapes 140

В backgrounds: animal paintings 80 figure paintings 104, 110, 110-13 flower paintings 122, 122 groups of figures 114 portraits 71 still-life paintings 168, 168-9 backlighting 94 backruns 10, 10-11, 78-9, 151, 158, 158 Baker, Christopher: Bosham Clouds 154 Bosham Estuary 150 Ely Cathedral 92

C

Cadman, Michael:

Cornish Harbour, Low Tide 182-3

Gloucester Catherdral III 94

A Memory of Whitby 95

Beedon, Sharon: Apples and Plums binders 31 birds 75, 76, 76-7, 84 black: tones 48 blending 12, 12 blots 13, 13 blotting paper 26 lifting out 36 boards: watercolour 109 boats 184, 184-5 Bockingford papers 36, 170, 173, body colour 14, 14-15, 54, 89, 109, 111, 115, 122, 143, 176, 184, 187 botanical paintings 118, 120, 120 Bowyer, Francis: Changing for a Swim 115 It's Freezina! 176 Bowyer, William: The Artist's Mother 108 Boys, David: Chia-Chia 83 Sketchbook Studies 77 bristle brushes 48, 49 broken colour 16, 16-17, 28, 44, 48 brush drawing 18, 18-19, 76, 134 brushmarks 20, 20-1 fur and feathers 84, 85 landscape 134, 139 rain and mist 158 texture 57 water 174, 182 brushes: for brush drawing 18 Chinese 105 dry brush 28 scumbling 48 spattering 49 stippling 54 wet-on-dry 70 bubble wrap 7 building up 22, 22-4 buildings 86-100, 87-103 detalls 90, 90-1 interiors 92, 92-3 in landscapes 98, 98-9 lighting 94, 94-5 masking 40 pattern and texture 100, 100-3 towns and cityscapes 88, 88-9 underdrawing 27 viewpoint 96, 96-7

calligraphic brushmarks 174, 182 candles: wax resist 66, 66 Canson Mi-Teintes paper 182-3 Canter, Jean: Corn Marigolds 121 cartridge paper 163 cats 80 'cauliflowers' see backruns Cézanne, Paul 160, 162, 167 Chamberlain, Trevor: Armchair Gardener 111 The Flower Seller, Bow Church 91 Hazy Sun and Damp Mist, Boulby Down 159 Marine Blacksmith 112 Old Wharf at Rotherhithe 95 changing colours 25, 25 Chaplin, Michael: Grove Green Farm 147 Welsh Cliffs 143 charcoal: mixed media 44-5, 106 China: brush drawing 18 Chinese brushes 105 Chinese white 14, 34 cityscapes 88, 88-9, 150 Clinch, Moira: Lakeland Tree 135 Mountain Retreat 155 clouds 150 colours 152, 156, 156-7 in composition 152, 152-3 edges 32 formations 154, 154-5 lifting out 36, 36 rain and mist 158, 158-9 wet-in-wet 12 collage: mixed media 174-5 colours: aerial perspective 144 backgrounds 168 blending 12, 12 broken 16, 16-17, 28, 44, 48 building up 22, 22-4 clouds 152, 156, 156-7 colour changes 25, 25 complementary 122 diffusing 36 flower paintings 118, 122, 122 gradated washes 63, 63-4 lifting out 26, 36 light and 94, 94, 176 overlaying 48 permanency 26 rain and mist 158 reviving 31 scumbling 48 skies 150 spattering 49

cadmium lemon 16

cadmium red 25

still life 164, 165 still water 180 stippling 54 toned grounds 59 underpainting 60, 60 variegated washes 63, 63-4 wet-in-wet 68, 68-9 wet-on-dry 70, 70-1 complementary colours 122 composition: clouds 152, 152-3 figure drawing 104 flower paintings 124, 124-7 landscapes 132 still-life paintings 166, 166-7 Constable, John 80, 146, 150-1 Conté crayons: mixed media 45. 105, 113, 150, 154 Corot, Jean-Baptiste Camille 96 corrections 26, 26, 36, 50 corrugated cardboard 58 Cotman papers 36 cotton buds 26, 34, 36 cracking 31 craft knives 46 cravons 78 Conté 45, 105, 113, 150, 154 watercolour 44, 78, 106 wax 66, 146 Curtis, David: Bandstand, St James's Park 116-17 The Pass of Ryvoan 143 Ruined Barracks, Scotland 99 D

Dawson, Paul: The Pink Umbrella 171 Snowy Owl 76 deer 82 Degas, Edgar 74, 110 details: buildings 90, 90-1 diagonals 124, 125, 166, 167 Dodd, Robert: Amberley and Kithurst Hill. Sussex 138 Tillingbourne Valley, Winter 145 dogs 78-9, 80 domestic animals 80, 80-1 dragged washes 16, 32 drapery: still life 166 drawing 27, 27, 104 brush 18, 18-19, 76, 134 pen 38, 38 dry brush 12, 20, 28, 28-9, 48, 84, 88, 133, 134, 174 drying paint 70 Dutch school 118, 160

E	French Academy 160	Н	Sweet Peas in a Tumbler 124
edges:	fruit 160, 164	hairdryers 70	Torteval, Guernsey 134
hard and soft 12, 32, 32-3	blending 12	hard edges 12, 32, 32-3	The White Cloud, Loch Etive 180
lifting out 36	fur 76, 80, 84	hares 82, 84	Winter, Sedge Moor 146
softening 12, 26	/ 0, 00, 04	hatching 113	
Emmett, Michael: By the Cottage	G	herbals 118	K
Door 164-5	gelatine 31	highlights 14, 17, 22, 34, 34-5	kneadable putty erasers 27
enlarging: squaring up 52, 52-3	gesso grounds 30	corrections 26	Knight, Charles:
erasers 27	Girvan, Geraldine:	foliage 134	Across the Valley 141
elaseis 2/	Flowers in the Hearth 72	lifting out 31, 36, 134	Evening 146
F	Studio Mantelpiece 125	masking 34, 34, 40, 148	Headland 179
faces <i>see</i> portraits	Victoria Day 168-9	reserving 27, 34, 34, 40, 57, 60,	Rickmansworth Canal 135
farm animals 80, 80-1	Winter Oranges 167	136, 177, 186	Sunset, South Downs 152
feathers 76, 76, 84, 84, 85	glass: colours 90	scraping back 46, 47	Tall Tree and Buildings 133
	glazing 30, 30, 60, 100, 137	stippling 54	knives:
felt-tipped pen: mixed media 44,	gloss media 30	on water 29, 176, 178	corrections with 26, 26
94 Felts, Shirley:	glycerine 31	hills 138, <i>138-9</i>	painting with 57
Chrysanthemums with Chinese	gouache:	Hockney, David 30	scraping back 46, 46
	animals 76, 79, 82	horizon 150	Scraping back 40, 40
Vase 123 The River Guadalupe 177	blending 12	horizontal planes 180	L
Still Life with Apples 169	body colour 14, 14, 15	horses 74, 79, 81	landscapes 132-46, 133-49
Fenton, Greta: Mother and Child	broken colour 16	Hot Pressed boards 109	buildings in 98, 98-9
	corrections 26	Hot Pressed paper 92	dry brush 28
105 fields 138, 138-9	dry brush 28	Huntly, Moira:	fields and hills 138, 138-9
figures 104-14, 105-17	flowers 125, 127	Butler's Wharf, London 185	mixed media 42
0 1 1 2 7	highlights 34	Charlie's Live Bait Stand,	recession 144, 144-5
brush drawing 16-17 in context 110, 110-13	landscapes 132, <i>138</i> , <i>145</i>	Campbell River 185	rocks and mountains 140, 140-3
groups 114, 114-17	mixed media 42, 42-3, 44, 75,	Still Life with African Artefact 165	skies 150-8, 150-9
line and wash 38	76, 83, 92, 102-3, 108-9, 112,	Venice 102-3	sponge painting 50
portraits 108, 108-9	115, 118, 119, 121, 130-1, 136,	Termee 102 y	trees and foliage 134, 134-7
studies 106, 106-7	167, 171, 174-5, 185	1 I	underdrawing 27
fingers: scumbling 48	scraping back 46	imitative texture 57	underpainting 60
Flemish school 118, 160	scumbling 48	impasto 30, 82, 127	weather and seasons 14, 146,
flowers 118-28, 119-31	still life 162, 169, 170	Impressionists 16, 160, 174	146-9
backruns 10, 10-11	toned grounds 59	Indian ink: wash-offs 65	Large, George:
blots 13, 13	underpainting 60	ink:	Finches 114-15
composition 124, 124-7	wash-offs 65	brush drawing 18	Hedgecutters 112
indoor arrangements 122, 122-3	washes 61	mixed media 87, 97, 115, 122,	lemon yellow 117
line and wash 38	water 180	130-1	Lidzey, John 8
masking 40-1	wet on dry 70	wash-offs 64, 65, 65	Figure in a Cornfield 8
natural habitat 128, 128-9	gradated washes 63, 63-4	interiors 92, 92-3	Girl on Stool 113
single specimens 120, 120-1	granulation 155	figure paintings 110	Interior with Desk and Chair 93
wet-in-wet 68-9, 130-1	green: colour changes 25	still-life paintings 170	Oil Lamp 163
foliage 134, 134-7	green-gold 16	Italy 118	St Paul's at Night 89
blots 13	grids: squaring up 52, 52-3	_	lifting out 26, 26, 31, 36, 36-7,
brushmarks 20	grounds:		134, 153, 155, 182
dry brush 28	glazing 30	Jameson, Norma: Waterlilies 128	light:
masking 40	toned 14, 59, 59, 182-3	Japan: brush drawing 18	aerial perspective 144
foregrounds 114, 168, 180	groups of figures 114, 114-17	Jesty, Ronald:	artificial 92
forms:	gum arabic 31, 31, 36, 42	Cloud Study 153	buildings 94, <i>94-5</i>
figure drawing 104	gum water 31	Loch Etive at Taynuilt 175	clouds 154
sponge painting 50	gummed strip 56	Loch Rannoch, Low Water 181	flower paintings 128
'found groups': still life 162,	Gurney, Julia:	Old Harry Rocks 183	interiors 92, 92-3
162-3	From Peter Jones 97	Out of Oban 155	landscapes 146
Fountain, Cherryl:	Studio View 87	Persimmon and Plums 172-3	skies 150
January Windowsill 171	Gwynn, Kate: Trees and Water	Plums in a Dish 168-9	still-life paintings 170
Still Life with Pheasant and	186-7	Poole harbour from Arne 145	on water 176, 176-7
Hyacinth 161		Portland Lighthouse 140	line and wash 38, 38-9, 42, 76,
France 118		Shandie 80	90, 99, 106, 118, 129

Interest prespective 144, 144 Interest spattering 49 mouthains 140, 140-3, 152 mouth diffusers: spattering 49 mouthains 140, 140-3, 152	vocation	10000	1000	
lines: drawing straight 86 liquid mask 8, 31,00, 40-17,6, 84, 483, 31,00, 40-17,6, 84, 483, 31,00, 40-17,6, 84, 483, 31,00, 40-17,6, 84, 483, 31,00, 40-17,6, 84, 483, 31,00, 40-17,6, 84, 483, 31,00, 40-17,6, 84, 483, 31,00, 40-17,6, 84, 483, 31,00, 40-17,6, 84, 483, 31,00, 40-17,6, 84, 483, 31,00, 40-17,6, 84, 483, 31,00, 40-17,6, 84, 483, 31,00, 40-17,6, 84, 483, 31,00, 40-17,6, 84, 483, 31,00, 40-17,6, 84, 483, 41,00, 40-17,10, 41,00, 41	linear perspective 144, 144	mountains 140, 140-3, 152	Paynton Colin: Welsh Flements I	Pembrandt 28 80
Mediumask 8, 31, 40, 40-1, 76, 84, 143 Mediumask 8, 31, 40, 40-1, 72, 76, 94, 143, 143 Mediumask 8, 31, 40, 40-1, 72, 76, 94, 143, 143 Mediumask 8, 31, 40, 40-1, 72, 78, 99 Mushinde, Sally king 16 de lemar 8, 150, 161 Spatial state 127 Martin, John: Cloud Study 56-7 Planda Cottage 9, 37 Planda Cottage 9, 38, 152 Mattins, John: Cloud Study 56-7 Planda Cottage 9, 38, 152 Planda Cottage 9, 38, 153 Plan		mouth diffusers: spattering 40		
Mode McGuinness, Michael: Bruce 209 Macleod, Audrey: Portrait of Stephen Ebbett 109 Macleod, Audrey: Portrait of Stephen Ebbett 409 Macleod, Audrey: Portrait of Stephen Ebbett 409 Macleod, Audrey: Not papers 40, 151 Morapers 4				
McGuinness, Michael:		animals 74, 78, 78-9		reserving highlights as az az
McGeuinness, Michael:				16561VIIIg IIIgIIIIgIIIS 22, 27, 34,
McGuinness, Michael: Bruce 109 Sally 107 Madeled, Audrey: Portrait of Stephen Ebbett 109 Portrait of Stephen Ebbett 109 Portrait of Stephen Ebbett 109 Rad Roses in a Flowerbed 119 Rhododendrans in Dulwich Park 128 Mante, Edouard 160 Mante, Edouard 160 Mante, Edouard 160 Martin, John: Cloud Study 156-7 Pinda Cottage 23 masking 34, ab., 40-41, 112, 148 flower paintings 118 meter deal 42 painting water 178 spattering 49 masking 1ape 40 Matthews, Jenny: Crown Imperial 121 Medieval paintings 118 methylated spirits 17 Michel, Sally: Ring-failed Lemur 83 Millichip, Paul: Berber 110 Scorched Door 90 miniatures 54 Mirza, Ill. The Old Village of Kardomili, Felipopmese 120 Scorched Door 90 miniatures 54 Mirza, Ill. The Old Village of Kardomili, Felipopmese 120 Scorched Door 90 miniatures 54 Mirza, Ill. The Old Village of Kardomili, Felipopmese 120 Scorched Door 90 miniatures 54 Mora, 181 The Polit Pire See Enthrough My Bedroom Window 136 Hydrangeats in Blue and White July 125 Mora, Landen 174 Morther See Seen Through My Bedroom Window 136 Hydrangeats in Blue and White July 125 Kitchen Table with Basket and Vegetables 162 Time for Iree Seen Through My Bedroom Window 136 Hydrangeats in Blue and White July 125 Jacks Sponder See Job (2010) 130 Time for Iree Seen Through My Bedroom Window 136 Hydrangeats in Blue and White July 125 Jacks Sponder See Job (2010) 130 Time for Iree Seen Through My Bedroom Window 136 Hydrangeats in Blue and White July 125 Jacks Bedroom Window 136 Hydrangeats in Blue and White July 125 Jacks Bedroom Window 136 Hydrangeats in Blue and White July 125 Jacks Bedroom Window 136 Hydrangeats in Blue and White July 125 Jacks Bedroom Window 136 Hydrangeats in Blue and White July 125 Jacks Bedroom Window 136 Hydrangeats in Blue and White July 125 Jacks Bedroom Window 136 Hydrangeats in Blue and White July 125 Jacks Bedroom Window 136 Hydrangeats in Blue Bedroom Window 136 Hydr	M			
Solly 107 Maclead, Audrey: Maclead, Audr	McGuinness, Michael:	mayorage, Lauweara 74		
Sally 197 Macleed, Audrey: Portrati of Stephen Ebbett 199 Portrati of Stephen Ebbett 199 Red Roses in Flowerbed 191 Rhododendrons in Dulwich Park 128-9 Manet, Edouard 160 manganese blue 16 marbling 57 Martin, John: Cloud Study 156-7 Pinda Cortage 93 masking 34, 40, 40-11, 121, 148 flower paintings 118 highlights 34 painting water 178 spattering 49 Mattiews, Jenny: Crown Imperial 121 Medieval paintings 118 methylated spirits 17 Medieval paintings 118 methylated spirits 19 Mirch, Sally: Rimy-calied Lemur 87 Millichip, Paul: Berber 100 Scorched Door op miniatures 54 Mirca, Ill: The Old Village of Kardamili, Peloponnese 100 Poth with Sand Pile, Cycladic Series 97 mixed media 42, 42-5, 44, 75, 76, 76, 36, 38, 89, 90, 29, 49-5, 101, 154, 104, 104, 107-13, 179, 118, 110, 190-11, 130, 114, 150, 154, 104, 107, 174-5, 179, 185 Monet, Claude 174 monorchome 60, 92, 106, 158 More, Henny 66 Mora, Carolyne: Mora, Carolyne: Marin John Carolyne in a Blue and Mylte Julg 125 Manet Mirca and Wilte Julg 125 Marin The Doll Will Basket and Vegetables 862 Time for lea 179 Matter Bask and White Julg 125 Matter Secondary of the Marin Secondary of the M		N	1.5	
Madeod, Audrey: Portatiot of Stephen Ebbett 109 Red Roses in a Flowerbed 119 Red Roses in a Flowerbed 199 Red Rodead foo manganese blue 16 figure paintings 108 underpainting 60 oil pastels: mixed media 44 resist 66 figure paintings 108 flower paintings 118 flower paintings 120 linear 144, 144 pett 89 landscapes 132, 138 moving water 178 portraits 108 salvating up 52, 52 phthalocyanine green 17 Piper, Edward Mellein, Malta 99 Nade In Manue Negligée 167 pathesis not de la de 194 moncheme 60, 92, 106, 158 Moore, Henry 66 Moran, Carolyne: The Apple free Seen Through My Bedroom Window 136 Hydrangese in a Blue and White Jug 125 Kitchen Table with Basket and Vegetables 162 Time for fee Ree Seen Through My Bedroom Window 136 Hydrangese in a Blue and White Jug 125 mixed media 44, 45, 122, 130-1 pat				
Portrait of Siephene Ebbett 109 Red Roses for a Flowerbed 199 Rhododendrons in Dulwich Park 128-9 Manet, Edouard 160 observation 132, 174, 180 oil plants: broken colour 16 figure paintings 104 glazing 30 masking 34, 40, 40-1;12, 148 oil plants: broken colour 16 figure paintings 104 glazing 30 sumbling 48 underpainting 60 oil pastes: mixed media 44 resist 66 opaque paints see body colour pastering 49 masking tape 40 Matthews, henri 127 Matthews, lenny: Crown Imperiol 121 methylated spirits 17 methylated spirits 17 methylated spirits 17 methylated spirits 18 methylated spirits 17 he Old Village of Kardomili, Peloponnese 100 Scorched Door 90 miniatures \$4 Mirza, Illi: Fell and River 138 Sillichip, Paut: Berber 110 Scorched Door 90 miniatures \$4 Mirza, Illi: Fell and River 139 Silli-19, 113, 11-13, 11-13, 11-13, 11-13, 11-13, 11-13, 11-13, 11-13, 11-13, 11-13, 11-13, 11-13, 11-14, 15-15, 15		'negative' shapes 8 104 166		
Red Roses in a Flowerbed 119 Rhododandrons in Dulwich Park 128-9 Maret, Edouard 160 manganese blue 16 fligure paintings 108 glazing 30 scumbling 48 masking 34, 40, 40-1, 112, 148 flower paintings 118 methylated spirits 17 Matthews, Jenny. Crown Imperial 121 Medieval paintings 118 methylated spirits 17 Michel, Sally: Ring-falled Lemur 83 Millichip, Paul: Berber 110 Scorched Door 90 miniatures 54 Milra, Jili. The Old Village of Kardamili, Peloponnese 100 Path with Sand Pile, Cycladic Sories 97 mist 20, 158, 158-9 mixed media 42, 42-5, 44, 75, 76, 76, 83, 87, 89, 93, 94-5, 101-3, 166, 177-9, 177, 177, 185 More, Lenute 174 monochrome 60, 92, 106, 158 Moore, Henry 66 Moran, Carolyne: Martin 192 Passes parting 30 Moran, Carolyne: Mire Apple Tree Seen Through My Bedroom Window 136 Hydrangeas in a Blue and White Jug 128 Kitchen Toble with Basket and Vegetables 162 Time for leta 170 Not pages 40, 151 Mort Lettipped 44, ilen and sush 38 pen and link 44 pespective 84 aerial 1377, 144, 144-5, 150 biblidings 98 figures 115 flower paintings 120 linear 144, 144 pespective 84 aerial 1377, 144, 144-5, 150 biblidings 120 linear 144, 144 pespective 84 aerial 1377, 144, 144-5 pespective 84 aerial 1377, 144, 144-5 pespective 84 aerial 137, 144, 144-9 pontatis 130 Mort Salver 176, 78 flower paintings 120 linear 144, 144 pest 178 potralis 130 potralis 130 sand: with acrylic 57 sand with acrylic 57 see also vater lifting out 37 masking 34, 46, 169 see a				
Rhododendrons in Dulwich Park 128-9 Manet, Edouard 160 magnanese blue 16 marbling 5.7 Martin, John: Cloud Study 156-7 Pinda Cottage 33 masking 34, 40, 40-1, 112, 148 flower paintings 118 flower paintings 104 glazing 30 masking tape 40 Maltise, Henri 127 Matthews, Jenny: Crown Imperial 121 Medieval paintings 118 methylated Spirits 17 Medieval paintings 118 methylated Spirits 17 Berber 110 Scorched Door 90 miniatures 54 Milchel, Sally: Ring-daled Lemur 83 Millichip, Paul: Berber 110 Scorched Door 90 miniatures 54 Milchel, Sally: Ring-daled Lemur 83 Millichip, Paul: Berber 110 Scorched Door 90 miniatures 54 Palme, Lileitte: Berber 110 Scorched Door 90 miniatures 54 Palme (Lileitte: Berber 110 Scorched Door 90 miniatures 54 Palme (Lileitte: Berber 110 Scorched Door 90 miniatures 54 Palme (Samuel: The Magic Apple The Pathway to Molière Cavallico, Cévennes 98 Palme, Lileitte: Fell and River 134 The Pathway to Molière Cavallico, Cévennes 98 Palme, Lileitte: Fell and River 134 The Pathway to Molière Cavallico, Cévennes 98 Palme, Lileitte: Fell and River 134 The Pathway to Molière Cavallico, Cévennes 98 Palme, Lileitte: Fell and River 134 The Pathway to Molière Cavallico, Cévennes 98 Palme, Lileitte: Fell and River 134 The Pathway to Molière Cavallico, Cévennes 98 Palme, Lileitte: Fell and River 134 The Pathway to Molière Cavallico, Cévennes 98 Palme, Lileitte: Fell and River 134 The Pathway to Molière Cavallico, Cévennes 98 Palme, Lileitte: Fell and River 134 The Pathway to Molière Cavallico, Cévennes 98 Palme, Lileitte: Fell and River 134 The Pathway to Molière Cavallico, Cévennes 98 Palme, Lileitte: Fell and River 134 The Pathway to Molière Cavallico, Cévennes 98 Palme, Lileitte Songe 137, 174, 1745, 179, 185 Monet, Church 175, 179, 185 Monet				
Josephane Ledouard 160 manganese blue 16 marbling 5 7 Martin, John: Cloud Study 156-7 Pinda Cottage 93 masking 34, 40, 40-1, 112, 148 flower paintings 118 highlights 34 painting water 178 spattering 49 masking 149, 40, 40-1, 112, 148 Matisse, Henri 127 Matthews, Jenny: Crown Imperial 121 Medieval paintings 118 methylated spirits 17 Milchel, Sally: Ring-tolled Lemur 83 Milchel, Sally: Ring-tolled Lemur 84 Milchel, Sally: Ring-tolled Lemur 83 Milchel, Sally: Ring-tolled Lemur 84 Milchel, Sally: Ring-tolled Lemur 84 Milchel, Sally: Ring-tolled Lemur 84 Milchel, Sally: Ring-tolled Lemur 85 Milchel, Sally: Ring-tolled Lemur 84 Milchel, Sally: Ring-tolled Lemur 84 Milchel, Sally: Ring-tolled Lemur 85 Milchel, Sally: Ring-tolled Lemur 84 Milchel, Sally: Ring-tolled Lemur 85 Milchel, Sally: Ring-tolled Lemur 84 Milchel, Sally: Ring-tolled Lemur 84 Milchel, Sally: Ring-tolled Lemur 84 Milchel, Sally: Ring-tolled Lemur 85 Milchel, Sally: Ring-tolled Lemur 84 Milchel, Sally: Ring-tolled Lemur 85 Milchel, Sally: Ring-tolled Lemur 84 Milchel, Sally: Ring-tolled Lemur 85 Milchel, Sally: Ring-tolled Lemur 85 Milchel, S		110t papers 40, 151	line and wash as	
Manel, Edouard 160 marganese blue 16 marganese blue 16 marbling 5.7 marbling 5.7 Martin, John: Cloud Study 156-7 Pinda Cottage 93 masking 34, 40, 40-1, 112, 148 nother paintings 118 nightights 34 painting water 178 spattering 49 masking tape 40 Matisse, Henry Crown Imperial 121 Matthews, Jenny: Crown Imperial 121 Medieval paintings 118 medieval apaintings 118 medieval paintings 118 medie	128-9	0		
manganese blue 16 marbling 5 7 Martin, John: Cloud Study 16-7 Pinda Cottage 93 masking 34, 40, 40-1, 112, 148 flower paintings 118 highlights 34 painting water 178 spattering 49 masking ape 40 Matisse, Henri 127 Martin, Inphase 40 Matisse, Henri 127 Medieval paintings 118 methylated spirits 17 Medieval paintings 118 methylated spirits 17 Millchip, Paul: Berber 10 Scorched Door 90 miniatures 54 Mirza, Ill: The Old Village of Kardamili, Peloponnese 100 Path with Sand Pile, Cycladic Series 97 mist 20, 158, 158-9 mist 20, 158, 158-9 mist 20, 158, 159-9 mist 20, 158, 159-9 mist 20, 158, 159-9 mist and 42, 42-5, 44, 75, 76, 76, 83, 87, 89, 92, 94-5, 101-3, 116, 107-9, 112, 117, 118, 119, 130-1, 136, 139, 141, 150, 154, 164, 167, 174, 179, 159 More, Claude 174 Medieval paintings 10 Series 97 More, Claude 174 More, Claude 174 More, Claude 174 More, Claude 174 Medieval painting 50 Spring Shower 153 More, Henry 66 Moran, Carolyne: The Apple free Seen Through My Bedroom Window 136 Hydrangeas in a Blue and White July 135 Kitchen Table with Basket and Vegetables 168 Medreval paintings 100 pall mistress 4 mist and mist 185 mathylage 159 mist to pall the see 110 Spring Shower 153 More, Laude 174 Medieval paintings 118 methylated spirits 17 pall thinner: resist techniques 57 palettes: acrylics 82 palettes: acrylics 82 flower paintings 120 linear 144, 144 pets 80 flower paintings 120				
marbling 57 Martin, John: Cloud Study 156-7 Pinda Cottage 93 masking 34, 40, 40-1, 112, 148 flower paintings 118 highlights 34 painting water 178 spattering 49 masking tape 40 Matisse, Henri 127 Matthews, Jenny: Crown Imperial 121 Medieval paintings 118 methylated spirits 17 Millichip, Paul: Berber 120 Scorched Door 90 Scorched Door 90 Scorched Door 90 Path with Sand Pile, Cycladic Series 97 mist 20, 158, 158-9 mist 40, 158, 158-9 mist 40, 158, 158-9 mist 70, 158, 158-9 mist 70, 158, 158-9 mixed media 42, 22-5, 44, 75, 76, 76, 83, 87, 89, 92, 94-5, 101-3, 116, 107-9, 117-17, 117, 119, 130-1, 136, 139, 141, 150, 154, 164, 167, 174, 179, 159 Berbor 100 Share Dear 110 Share The Old Village of Kardamili, Peloponnese 100 Path with Sand Pile, Cycladic Series 97 mist 20, 158, 158-9 mixed media 42, 22-5, 44, 75, 76, 76, 83, 87, 89, 92, 94-5, 101-3, 116, 107-9, 117-17, 117, 119, 130-1-13, 156, 177, 178 Share The Old Village of Kardamili, Peloponnese 100 Path with Sand Pile, Cycladic Series 97 mixed media 42, 22-5, 44, 75, 76, 76, 83, 87, 89, 92, 94-5, 101-3, 116, 107-9, 117-17, 117, 119, 130-1-13, 156, 174-17, 179, 179 Share The Pathway to Molière Cavaillac, Series 97 mixed media 42, 22-5, 44, 75, 76, 76, 83, 87, 89, 92, 94-5, 101-3, 116, 107-9, 117-17, 117, 118, 115, 115, 116, 110 Share The Pathway to Molière Cavaillac, Series 97 mixed media 42, 22-5, 44, 75, 76, 76, 76, 83, 87, 89, 92, 94-5, 101-3, 116, 107-9, 117-17, 117, 117, 117-17, 118-67, 118-67 Marchal 121 Marchal 122 Marchal 122 Marchal 123 Marchal 124 Marchal 125 Nathery are paintings 10, 41, 50, 50, 50 Salt 17, 67, 78 salt 17, 77, 78, 51 salt 17, 77, 78,				A CONTRACTOR OF THE CONTRACTOR
Martin, John: Cloud Study 156-7 Pinda Cottage 93 Pinda P			buildings 86	
Cloud Study 156-7 Pinda Cottage 93 masking 34, 40, 40-1, 112, 148 flower paintings 118 highlights 34 painting water 178 spattering 49 masking tape 40 Matisse, Henri 227 Matthews, Jenny: Crown Imperial 121 Medieval paintings 118 methylated spirits 17 Michel, Sally: Ring-tailed Lemur 83 Millichip, Paul: Berber 120 Scorched Door 90 miniatures 5-4 Mirza, Illi: The Old Village of Kardamili, Peloponnese 100 Path with Sand Pile, Cycladic Series 97 mist 20, 158, 158-9 mist 20, 158, 158-9 mist 20, 158, 158-9 mist 20, 158, 158-9 mist 40, 167, 174, 179, 189, 19, 130-1, 136, 139, 141, 150, 154, 164, 167, 174, 179, 179, 179, 177, 178, 179, 179, 179, 177, 178, 179, 179, 179, 179, 177, 178, 179, 170, 170, 170, 170, 170, 170, 170, 170				· ·
Scumbling A8 underpainting 60 oil pastels: mixed media 44 pets 80				
masking 34, 40, 40-1, 112, 148 flower paintings 118 highlights 34 painting water 178 spattering 49 masking tape 40 maksiking tape 40 Matisse, Henri 127 Matthews, Jenny: Crown Imperial 121 Medieval paintings 118 methylated spirits 17 Michel, Sally: Ring-railed Lemur 83 Milichip, Paul: Berber 110 Scorched Door 90 miniatures 54 Mirza, Ill: The Old Village of Kardamili, Peloponnese 100 Path with Sand Pile, Cycladic Series 97 mixed media 42, 42-5, 44, 75, 76, 6, 8, 37, 88, 99, 29, 45, 101-3, 106, 107, 174-5, 179, 185, 101-3, 136, 139, 141, 150, 154, 164, 167, 174-5, 179, 179, 179, 179, 179, 179, 179, 179	Pinda Cottage 93		1	
flower paintings 118 highlights 34 painting water 178 spattering 49 masking tape 40 Matisse, Henri 127 paque white 34, 46, 84 Oram, Ann: Sunflowers 130-1 to Sborne, Doreen: Durrell's Alexandria 115 overpainting 22 proportions 121 meters buildings 108 methylated spirits 17 Millichip, Paul: Berber 110 Scorched Door 90 miniatures 54 Millichip, Paul: The Pathway to Molière Cavaillac, Cévennes 98 Palmer, Jamel: The Pathway to Molière Cavaillac, Cévennes 98 Palmer, Jamel: The Pathway to Molière Cavaillac, Cévennes 98 Palmer, Jamel: The Magic Apple mixed media 42, 42-5, 44, 75, 76, 83, 87, 89, 92, 94-5, 101-3, 106, 107-9, 112, 117, 118, 119, 130-1, 136, 139, 141, 150, 154, 164, 167, 174-5, 179, 185 Monet, Claude 174 monochrome 60, 92, 106, 158 Moran, Carolyne: The Apple Tree Seen Through My Bedroom Window 136 Hydrangeas in a Blue and White Jug 25 Kitchen Table with Basket and Vegetables 162 Time for Tea 170		0 ,		rough papers 40, 57
mixed media 44 resist 66 paque painting water 178 spattering 49 masking tape 40 Matisse, Henri 27 Matthews, Jenny: Crown Imperial 121 Medieval paintings 118 methylated spirits 17 Michel, Sally: Ring-tailed Lemur 83 Millichip, Paul: Berber 110 Scorched Door 90 miniatures 54 Mirza, Jill: The Old Village of Kardamili, Peloponnese 100 Path with Sand Pile. Cycladic Series 97 mist 20, 158, 158-9 mist 20, 158, 158-9 mist 20, 158, 158-9 mist 20, 158, 158-9 mist 130, 154, 159, 150, 154, 164, 167, 174-5, 179, 178 Monet, Claude 174 monochrome 60, 92, 106, 158 Moran, Carolyne: The Apple Tree Seen Through My Bedroom Window 136 Hydrangeas in a Blue and White Jug 25 Kitchen Table with Basket and Vegetables 162 Time for Tea 170 mixed media 44 resist 66 opaque paints see body colour opaque white 34, 46, 84 opaque paints see body colour opaque white 34, 46, 84 resist 66 opaque paints see body colour opaque white 34, 46, 84 opaque paints see body colour opaque white 34, 46, 84 ranimals 74, 76, 78 clouds 151, 152 sandsaper 178 sandsaper 47, 143 sap green 26, 36 Saunders 98 sandwith acrylic 57 sandpaper 47, 143 sap green 26, 36 Saunders 98 sandwith acrylic 57 sandpaper 47, 143 sap green 26, 36 Saunders 98 sandwust: with acrylic 57 sandpaper 47, 143 sap green 26, 36 Saunders 98 sandwith acrylic 57 sandpaper 47, 143 sap green 26, 36 Saunders 98 sandwith acrylic 57 sandpaper 47, 143 sap green 26, 36 Saunders 98 sandwith acrylic 57 sandpaper 47, 143 sap green 26, 36 Saunders 98 saw dust: with acrylic 57 sandpaper 47, 143 sap green 26, 36 Saunders 98 saw dust: with acrylic 57 sandpaper 47, 143 sap green 26, 36 Saunders 98 saw dust: with acrylic 57 sandpaper 177 piper, Edward: Medileha, Malta 99 Nude in a Mauw Negligée 167 plants see flowers portraits 28, 104, 108, 108-9 backgrounds, 71 paters: 30, 158, 158-9 proportion: lifting out 37 making 40 patriats 108 skies 151 squaring up 52, 52 phthalocyanine green 117 piper, Edward: Medileha, Malta 99 Nude in a Mauw Negligée 167 plants 29, 52-32 underdrawing 27 seel-portraits 108 squaring up 5		, ,	1 1	C
painting water 178 spattering 49 masking tape 40 Matisse, Henri 127 Matthews, lenny: Crown Imperial 121 Medieval paintings 118 methylated spirits 17 Michel, Sally: Ring-tailed Lemur 83 Millichip, Paul: Berber 110 Scorched Door 90 miniatures 54 Mirza, Illi: Pelpoponnese 100 Path with Sand Pile, Cycladic Series 97 mist 20, 158, 158-9 mixed media 42, 42-5, 44, 75, 76, 76, 83, 87, 89, 99, 29, 45-5, 101-3, 130-1, 136, 139, 141, 150, 154, 164, 167, 174-5, 179, 185 Monet, Claude 174 monochrome 60, 92, 106, 158 Moore, Henry 66 Moran, Carolyne: The Apple Fire Seen Through My Bedroom Window 136 Mydrangeas in a Blue and White 1yg 25 Kitchen Table with Basket and Vegetables 162 Time for Tea 170 resist 60 opaque paints see body colour opaque white 34, 46, 84 Oram, Ann: Sunflowers 130-1 Osborne, Doren: Durrell'S Alexandria 115 overpainting 22 paint thinner: resist techniques 57 palettes: acrylics 82 Palmer, Juliette: Fell and River 134 The Pathway to Molière Cavaillac, Cévennes 98 Pink Roses, White Phlox 129 St lean de Buâge 142 Wood Edge 136 Palmer, Samuel: The Magic Apple Tiree 56 Palmer samuel: The Magic Apple Tiree 57 palettes: acrylics 82 Palmer, Juliette: Fell and River 134 The Pathway to Molière Cavaillac, Cévennes 98 Pink Roses, White Phlox 129 St lean de Buâge 142 Wood Edge 136 Palmer, Juliette: Fell and River 134 The Pathway to Molière Cavaillac, Cévennes 98 Pink Roses, White Phlox 129 Steas 157 Squaring up 52, 52-3 underdrawing 27 seelf-portraits 108 self-portraits 108 sperim type 6 figures 104 Pathway to Molière Cavaillac, Cévennes 98 Pink Roses White 14, 166-9 Seedheads: blots 13 Self-portraits 108 self-portraits 108 sperim type 14 Self-port				
spattering 49 masking tape 40 Malisse, Henri 127 Matthews, Jenny: Crown Imperial 121 Medieval paintings 118 methylated spirits 17 Michel, Sally: Ring-tailed Lemur 83 Millichip, Paul: Medieval paintings 118 methylated spirits 17 Michel, Sally: Ring-tailed Lemur 83 Millichip, Paul: Millichip, Allatur acyllic 57 Scandpiap 47, 143 Sandpaper 47, 143 Sapgrea 26, 36 Saudust: with acyllic 57 Scraping back 46, 46, 46, 46, 46, 46, 46, 46, 46, 46,				
Matisse, Henri 127 Matthews, Jenny: Crown Imperial 121 Matthews, Jenny: Crown Imperial 121 Millichip, Paul: Berber 110 Scorched Door 90 miniatures 54 Millic III: The Old Village of Kardamili, Pelaponnese 100 Path with Sand Pile, Cycladic Series 97 mist 20, 158, 158-9 mist 20, 158, 158-9 mixed media 42, 42-5, 44, 75, 76, 76, 83, 87, 89, 92, 94-5, 101-3, 130-1, 136, 139, 141, 150, 154, 164, 167, 174-5, 179, 118, 119, 130-1, 136, 139, 141, 150, 154, Monet, Claude 174 monochrome 60, 92, 106, 158 Moore, Henry 66 Moran, Carolyne: The Apple Tree Seen Through My Bedroom Window 136 Hydrangeas in a Blue and White Jake 145, 122, 130-1 171me for Tea 170 Matthews, Jenny: Crown Imperial 20 Oram, Ann: Sunflowers 130-1 05borne, Doreen: Durrell's Alexandria 115				
Mattsse, Henri 127 Matthews, Jenny: Crown Imperial 121 Medieval paintings 118 methylated spirits 17 Michel, Sally: Ring-tailed Lemur 83 Millichip, Paul: Berber 110 Scorched Door 90 miniatures 5 4 Mirza, Jill: The Old Village of Kardamili, Peloponnese 100 Path with Sand Pile, Cycladic Series 97 mist 20, 158, 158-9 mixed media 42, 42-5, 44, 75, 76, 67, 68, 83, 87, 89, 92, 94-5, 101-3, 106, 107-9, 112, 117, 118, 119, 130-1, 136, 119, 141, 150, 154, 164, 167, 174-5, 179, 185 Monet, Claude 174 monochrome 60, 92, 106, 158 More, Henry 66 Moran, Carolyne: The Apple Tree Seen Through My Bedroom Window 136 Hydrangeas in a Blue and White 139 Film Rosel is 19 Spring Shower 130-10 Sborne, Doreen: Durrell's Alexandria 155 overpainting 22 Dram, Ann: Sunflowers 130-1 Soborne, Doreen: Durrell's Alexandria 155 overpainting 12 paint thinner: resist techniques 57 palettes: acrylics 82 palmer, Juliette. Fell and River 134 The Pathway to Molière Cavaillac, Cévennes 98 Pink Roses, White Phlox 129 St Jean de Buège 142 Wood Edge 136 Palmer, Samuel: The Magic Apple Tree 6 paper towels 57 lifting out 37 masking 40 rain and mist 198 sponge painting 50 squaring up 52, 52-3 underdrawing 27 seascapes 174, 174-5 see also water lifting out 37 masking 40 rain and mist 198 sponge painting 50 squaring up 52, 52-3 underdrawing 27 sescapes 174, 174-5 see also water lifting out 37 masking 40 rain and mist 198 sponge painting 50 squaring up 52, 52-3 underdrawing 27 sescapes 174, 174-5 see also water lifting out 37 masking 40 rain and mist 198 sponge painting 50 squaring up 52, 52-3 underdrawing 27 wet-on-dry 70-1 pretinting 59 lifting out 37 mestile paintings 10, 110-13 still-life paintings 170-1 Securating 60 settings 100, 100-1 Reform Window 136 Hydrangeas in a Blue and White July 125 Kitchen Table with Basket and Vegetables 162 pastel specific N. 30 setting 102, 46-7, 68, 48, 8, 104, 108, 108-9 potratis 28, 104, 108, 108-9 potratis 28, 104, 108, 108-9 potratis 20, 182 potratic 103 scumbling 419 potratic 20 potratic 20 potratic 20 potratic 20 po				
Mathews, Jenny: Crown Imperial 121 121 Medieval paintings 118 methylated spirits 17 Michel, Sally: Ring-tailed Lemur 83 Millichip, Paul: Berber 110 Scorched Door 90 miniatures 54 Mirza, Illi: Peloponnese 100 Path with Sand Pile, Cycladic Series 97 mist 20, 158, 158-9 mixed media 42, 42-5, 44, 75, 76, 76, 83, 87, 89, 92, 94-5, 101-3, 106, 107-9, 112, 117, 118, 119, 130-1, 136, 139, 141, 150, 154, 164, 167, 174-5, 179, 185 Moran, Carolyne: The Alpha free Seen Through My Bedroom Window 136 Hydrangaes in a Blue and White Jug 125 Kitchen Table with Basket and Vegetables 162 Time for Tea 170 Medieval paintings 118 Methylated spirits 17 Medieval paintings 118 Alexandria 115 overpainting 22 postpainting 22 postpainting 22 phihalocyanine piene 117 piper, Edward: Mellieha, Malta 99 Nude in a Mauve Negligée 167 plants see flowers portraits 28, 104, 108, 108-9 backgrounds 71 self-portraits 108 sawdust: with acrylic 57 scraping back 46, 46-7, 84, 88, 145, 177, 178 scausdust: with acrylic 57 scraping back 46, 46-7, 84, 88, 145, 177, 178 scumbling 48, 48, 100, 157 sea salt 57 sea alst 57 sea salt 57 sea sal				
Medieval paintings 118 methylated spirits 17 Michel, Sally: Ring-tailed Lemur 83 Millichip, Paul: Berber 110 Scorched Door 90 miniatures 54 Mirza, Iill: The Old Village of Kardamili, Peloponnese 100 Path with Sand Pile, Cycladic Series 97 mist 20, 158, 158-9 mixed media 42, 42-5, 44, 75, 76, 76, 83, 88, 93, 94, 94-5, 101-3, 106, 107-9, 112, 117, 118, 119, 130-1, 136, 139, 141, 150, 154, 164, 167, 174-5, 179, 185 Moner, Claude 174 monochrome 60, 92, 106, 158 Moore, Henry 66 Moran, Carolyne: The Apple Tree Seen Through My Bedroom Window 136 Hydrangeas in a Blue and White Jug 125 Kitchen Table with Basket and Vegetables 162 Kitchen Table with Basket and Vegetables 162 Kitchen Table with Basket and Vegetables 162 Time for Tea 170 Alexandria 115 overpainting 22 Alexandria 115 overpainting 22 Skies 151 Squaring up 52, 52 phthalocyvanine blue 36 phthalocyvanine green 117 Piper, Edward: Mellieha, Malta 99 Nude in a Mauve Negligée 167 plants see flowers portraits 28, 104, 108, 108-9 backgrounds 71 self-portraits 108 sponge painting 50 sea alts 57 sea salt 57 seascapes 174, 174-7-5 sea salt 57 seascapes 174, 174-7-5 sea salt 57 sea salt 57 seascapes 174, 174-5 sea salt 57 seas				
Medieval paintings 118 methylated spirits 17 Michel, Sally: Ring-tailed Lemur 83 Milichip, Paul: Berber 110 Scorched Door 90 miniatures 54 Mirza, jill: The Old Village of Kardamili, Pelopomnese 100 Path with Sand Pile, Cycladic Series 97 mist 20, 158, 158-9 mised media 42, 42-5, 44, 75, 76, 76, 83, 87, 89, 92, 94-5, 101-3, 106, 107-9, 117, 117, 118, 119, 130-1, 136, 139, 141, 150, 154, 164, 167, 174-5, 179, 185 Monet, Claude 174 monochrome 60, 92, 106, 158 Moore, Henry 66 Moran, Carolyne: The Apple Tree Seen Through My Bedroom Window 136 Hydrangeas in a Blue and White Jug 125 Kitchen Table with Basket and Vegetables 162 Time for Tea 170 Mellicha, Malta 99 Nuda in a Mauve Negligée 167 plants see flowers portraits 28, 104, 108, 108-9 backgrounds 71 self-portraits 108 sponge painting 50 squaring up 52, 52 phthalocyanine green 117 Piper, Edward: Mellieha, Malta 99 Nuda in a Mauve Negligée 167 plants see flowers portraits 28, 104, 108, 108-9 backgrounds 71 self-portraits 108 sponge painting 50 squaring up 52, 52 phthalocyanine blue 36 phthalocyanine green 117 Piper, Edward: Mellieha, Malta 99 Nuda in a Mauve Negligée 167 plants see flowers portraits 28, 104, 108, 108-9 backgrounds 71 self-portraits 28, 104, 108, 108-9 real with 54 sponge painting 50 rini and mist 158 sponge 17 plants see flowers portraits 28, 104, 108, 108-9 rea		The second secon		sawdust: with acrylic 57
methylated spirits 17 Michel, Sally: Ring-tailed Lemur 83 Michel, Sally: Ring-tailed Lemur 83 Millichip, Paul: Berber 110 Scorched Door 90 miniatures 54 Mirza, Jill: The Old Village of Kardamili, Peloponnese 100 Path with Sand Pile, Cycladic Series 97 mist 20, 158, 158-9 figure sold Flower Land and White Jug 125 Kitchen Table with Basket and Vegetables 162 Time for Tea 170 Mellieha, Malta 99 huhalocyanine green 117 piet, Edward: Mellieha, Malta 99 Nude in a Maute Negligée 167 plants see flowers portraits 28, 104, 108, 108-9 backgrounds 71 self-potraits 108 sponge painting 50 squaring up 52 5, 25-3 underdrawing 27 wet-on-dry 70-1 petinting 59 proportion: buildings 86 figures 104 Prussian blue 14 putty erasers 27 pastel pencils: mixed media 102-3 pastels 78 mixed media 44, 45, 122, 130-1 patterns: buildings 100, 100-1 patterns: a Mulei na Maute Negligée 167 plants see flowers portraits 28, 104, 108, 108, 108-9 backgrounds 71 self-potraits 108 sponge painting 50 squaring up 52, 52-3 underdrawing 27 wet-on-dry 70-1 petinting 59 figure painting 50 still-life paintings 110, 110-13 still-life paintings 10, 110-13 still-life paintings 10 scumbling 48, 48, 100, 157				
Millichip, Paul: Berber 110 Scorched Door 90 miniatures 54 Mirza, Jill: The Old Village of Kardamili, Peloponnese 100 Path with Sand Pile, Cycladic Series 97 mist 20, 158, 158-9 mixed media 42, 42-5, 44, 75, 76, 76, 83, 87, 89, 92, 94-5, 101-3, 136, 139, 141, 150, 154, 164, 167, 174-5, 179, 185 Monet, Claude 174 monochrome 60, 92, 106, 158 Moore, Henry 66 Moran, Carolyne: The Apple Tree Seen Through My Bedroom Window 136 Hydrangeas in a Blue and White Jug 125 Kitchen Table with Basket and Vegetables 162 Kitchen Table with Basket and Vegetables 162 Time for Tea 170 Panint thinner: resist techniques 57 palettes: acrylics 82 palmet, Juliette: Palmet, Saucary Milliche, Malta 99 Nude in a Mauve Negligée 167 plants see flowers plant sit 39 seasajes 174, 174-5 sea salt 57 seascapes 174, 174-5 see also water lifting out 37 masking 40 rain and mist 158 sponge painting 50 squaring up 52, 52-3 underdrawing 27 welf-portraits 108 self-portraits 108 self-portraits 108 self-portraits 108 self-portraits 108 self-portraits 28 self-portraits 108 self-portraits 28 self-portraits 108 self-portraits		Overpainting 22		145, 177, 178
Millichip, Paul: Berber 110 Scorched Door 90 miniatures 54 Mirza, Jill: The Old Village of Kardamili, Peloponnese 100 Path with Sand Pile, Cycladic Series 97 mist 20, 158, 158-9 mist 20, 158, 158-9 mist ed media 42, 42-5, 44, 75, 76, 76, 83, 87, 89, 92, 94-5, 101-3, 106, 107-9, 117, 118, 119, 130-1, 136, 139, 141, 150, 154, 164, 167, 174-5, 179, 185 Monet, Claude 174 monochrome 60, 92, 106, 158 Moran, Carolyne: The Apple Tree Seen Through My Bedroom Window 136 Hydrangeas in a Blue and White Jug 125 Kitchen Table with Basket and Vegetables 162 Kitchen Table with Basket and Vegetables 162 Kitchen Table with Basket and Vegetables 162 Time for Tea 170 paint thinner: resist techniques 57 palettes: acrylics 82 palmer, Luliette: Fell and River 134 The Pathway to Molière Cavaillac, Cévennes 98 Palmer, Sumell: 7 Piper, Edward: Mellieha, Malta 99 Nellicha, Malta 99 Diper, Edward: Mellieha, Malta 99 Nellicha, Malta 99 Diper, Edward: Mellieha, Malta 99 Nellicha, Malta 99 Diper, Edward: Mellieha, Malta 99 Diper, Edward: Mellieha, Malta 99 Nellicha, Malta 99 Diper, Edward: Mellieha, Malta 99 Diper, Gward: Mellieha, Malta 99 Diper, Seascapes 174, 174-5 Seascapes 174, 176 Daishing ut 39 Diplor in lifting out 36 Sponge painting 50 Squaring up 52, 52-		P		
Berber 110 Scorched Door 90 miniatures 54 Mirza, Jill: The Old Village of Kardamili, Peloponnese 100 Path with Sand Pile, Cycladic Series 97 mist 20, 158, 158-9 mixed media 42, 42-5, 44, 75, 76, 76, 83, 87, 89, 92, 94-5, 101-3, 106, 107-9, 112, 117, 118, 119, 139-1, 136, 139, 141, 150, 154, 164, 167, 174-5, 179, 185 Monet, Claude 174 monochrome 60, 92, 106, 158 Moore, Henry 66 Moran, Carolyne: The Apple Tree Seen Through My Bedroom Window 136 Hydrangeas in a Blue and White Jug 125 Kitchen Table with Basket and Vegetables 162 Kitchen Table with Basket and Vegetables 162 Time for Tea 170 palettes: acrylics 82 Palmer, Juliette: Palmar Nilette: Pell and River 134 The Pathway to Molière Cavaillac, Cévennes 98 Palmer, Juliette: Pell and River 134 The Pathway to Molière Cavaillac, Cévennes 98 Pink Roses, White Phlox 129 St Jean de Buège 142 Wood Edge 136 Palmer, Samuel: The Magic Apple Tree 6 Paper towels 57 lifting out 37 masking 40 rain and mist 158 sponge painting 50 underdrawing 27 see flowers portraits 28, 104, 108, 108-9 backgrounds 71 self-portraits 108 sponge painting 50 underdrawing 27 wet-on-dry 70-1 pretinting 59 proportion: buildings 86 figures 104 Prussian blue 14 putty erasers 27 shadows: attaching object to surface 12, 35 buildings 94, 94 clouds 154 figures 18 flower paintings 12 still-life paint		naint thinner, resist techniques 57		
Scorched Door 90 miniatures 54 Mirza, Jill: The Old Village of Kardamili, Peloponnese 100 Path with Sand Pile, Cycladic Series 97 mist 20, 158, 158-9 mixed media 42, 42-5, 44, 75, 76, 76, 83, 87, 89, 92, 94-5, 101-3, 106, 107-9, 112, 117, 118, 119, 130-1, 136, 139, 141, 150, 154, 164, 167, 174-5, 179, 185 Monet, Claude 174 monochrome 60, 92, 106, 158 Moore, Henry 66 Moran, Carolyne: The Apple Tree Seen Through My Bedroom Window 136 Hydrangeas in a Blue and White Jug 125 Kitchen Table with Basket and Vegetables 162 Time for Tea 170 Palmer, Juliette: Fell and River 134 The Pathway to Molière Cavaillac, Cévennes 98 Pink Roses, White Phlox 129 St Jean de Buège 142 Wood Edge 136 Palmer, Juliette: Fell and River 134 The Pathway to Molière Cavaillac, Cévennes 98 Pink Roses, White Phlox 129 St Jean de Buège 142 Wood Edge 136 Palmer, Samuel: The Magic Apple Tree 6 Palmer, Juliette: Fell and River 134 The Pathway to Molière Cavaillac, Cévennes 98 Pink Roses, White Phlox 129 St Jean de Buège 142 Wood Edge 136 Palmer, Samuel: The Magic Apple Tree 6 Palmer, Juliette: Fell and River 134 The Pathway to Molière Cavaillac, Cévennes 98 Pink Roses, White Phlox 129 St Jean de Buège 142 Wood Edge 136 Palmer, Samuel: The Magic Apple Tree 6 Palmer, Samuel: The Old Nichon 19 Soponis Sponge painting 50 squaring up 52, 52-3 underdrawing 27 wet-on-dry 70-1 pretining 59 proportion: buildings 86 figure paintings 10, 110-13 still-life paintings 110, 110-13 Still-life paintings 110, 110-13 Still-life paintings 124 still-life paintings 125 stippling 54, 54-5 tr				
miniatures 54 Mirza, Jill: The Old Village of Kardamili, Peloponnese 100 Path with Sand Pile, Cycladic Series 97 mist 20, 158, 158-9 mixed media 42, 42-5, 44, 75, 76, 76, 83, 87, 89, 92, 94-5, 101-3, 106, 107-9, 112, 117, 118, 119, 139-1, 136-1, 139, 141, 150, 154, 164, 167, 174-5, 179, 185 Monet, Claude 174 monochrome 60, 92, 106, 158 Moore, Henry 66 Moran, Carolyne: The Apple Tree Seen Through My Bedroom Window 136 Hydrangeas in a Blue and White Jug 125 Kitchen Table with Basket and Vegetables 162 Kitchen Table with Basket and Vegetables 162 minist 20, 158, 158-9 mixed media 44, 45, 122, 130-1 patterns: buildings 100, 100-1 Fell and River 134 The Pathway to Molière Cavaillac, Cévennes 98 Plants see flowers portraits 28, 104, 108, 108, 108, 108, 108, 108, 108, 108			Nudo in a Marria Naclináa (-	
Mirza, Jill: The Pathway to Molière Cavaillac, Cévennes 98 Pink Roses, White Phlox 129 St Jean de Buège 142 Wood Edge 136 Palmer, Samuel: The Magic Apple mixed media 42, 42-5, 44, 75, 76, 76, 83, 87, 89, 92, 94-5, 101-3, 136, 139, 141, 150, 154, 164, 167, 174-5, 179, 185 Monet, Claude 174 monochrome 60, 92, 106, 158 Moran, Carolyne: The Apple Tree Seen Through My Bedroom Window 136 Hydrangeas in a Blue and White Jug 125 Kitchen Table with Basket and Vegetables 162 Kitchen Table with Basket and Vegetables 162 Time for Tea 170 The Pathway to Molière Cavaillac, Cévennes 98 Pink Roses, White Phlox 129 St Jean de Buège 142 Wood Edge 136 Palmer, Samuel: The Magic Apple Tree 6 Paper towels 57 Prussian blue 14 Prussian blue				
The Old Village of Kardamili, Peloponnese 100 Path with Sand Pile, Cycladic Series 97 mist 20, 158, 158-9 mixed media 42, 42-5, 44, 75, 76, 76, 83, 87, 89, 92, 94-5, 101-3, 106, 107-9, 112, 117, 118, 119, 130-1, 136, 139, 141, 150, 154, 164, 167, 174-5, 179, 185 Monet, Claude 174 monochrome 60, 92, 106, 158 Moore, Henry 66 Moran, Carolyne: The Apple Tree Seen Through My Bedroom Window 136 Hydrangeas in a Blue and White Jug 125 Kitchen Table with Basket and Vegetables 162 Kitchen Table with Basket and Vegetables 162 Time for Tea 170 Time for Tea				
Peloponnese 100 Path with Sand Pile, Cycladic Series 97 mist 20, 158, 158-9 mixed media 42, 42-5, 44, 75, 76, 76, 83, 87, 89, 92, 94-5, 101-3, 106, 107-9, 117, 118, 119, 130-1, 136, 139, 141, 150, 154, 164, 167, 174-5, 179, 185 Monet, Claude 174 monochrome 60, 92, 106, 158 Moore, Henry 66 Moran, Carolyne: The Apple Tree Seen Through My Bedroom Window 136 Hydrangeas in a Blue and White Jug 125 Kitchen Table with Basket and Vegetables 162 Kitchen Table with Basket and Vegetables 162 Time for Tea 170 Pink Roses, White Phlox 129 St Jean de Buège 142 Wood Edge 136 Palmer, Samuel: The Magic Apple Tree 8 Palmer, Samuel: The Magic Apple Tree 6 Palmer, Samuel: The Magic Apple Tree 4 Prussian blue 14 Putty erasers 27 Past umber 20 Past underdrawing 27 Seacn				
Path with Sand Pile, Cycladic Series 97 mist 20, 158, 158-9 mixed media 42, 42-5, 44, 75, 76, 76, 83, 87, 89, 92, 94-5, 101-3, 106, 107-9, 112, 112, 118, 119, 130-1, 136, 139, 141, 150, 154, 164, 167, 174-5, 179, 185 Monet, Claude 174 monochrome 60, 92, 106, 158 Moore, Henry 66 Moran, Carolyne: The Apple Tree Seen Through My Bedroom Window 136 Hydrangeas in a Blue and White Jug 125 Kitchen Table with Basket and Vegetables 162 Time for Tea 170 St Jean de Buège 142 Wood Edge 136 Palmer, Samuel: The Magic Apple Tree 6 paper towels 57 lifting out 26-7 scumbling with 48 papers: handmade 57 lifting out colour 36 pretinting 59 proportion: buildings 86 figures 104 prussian blue 14 putty erasers 27 R R rain 20, 158, 158-9 raw umber 20 razor blades 26, 46, 46 recession 144, 144-5, 180, 181 reflections on water 174, 177, 178-9, 182, 182-3, 186-7 seasons: landscapes 146, 146-9 seedheads: blots 13 self-portraits 108 settings: figure paintings 10 squaring up 52, 52-3 underdrawing 27 wet-on-dry 70-1 pretinting 59 proportion: buildings 86 figures 104 prussian blue 14 putty erasers 27 R rain 20, 158, 158-9 raw umber 20 razor blades 26, 46, 46 recession 144, 144-5, 180, 181 reflections on water 174, 177, shapes: 'negative' 8, 104, 166			,	
Series 97 mist 20, 158, 158-9 mist 20, 109-10 mist 20, 109-10 mist 20, 109-10 mist 20,				
mist 20, 158, 158-9 mixed media 42, 42-5, 44, 75, 76, 76, 83, 87, 89, 92, 94-5, 101-3, 106, 107-9, 117, 118, 119, 130-1, 136, 139, 141, 150, 154, 164, 167, 174-5, 179, 185 Monet, Claude 174 monochrome 60, 92, 106, 158 Moore, Henry 66 Moran, Carolyne: The Apple Tree Seen Through My Bedroom Window 136 Hydrangeas in a Blue and White Jug 125 Kitchen Table with Basket and Vegetables 162 Kitchen Table with Basket and Vegetables 162 Time for Tea 170 Palmer, Samuel: The Magic Apple Tree 6 paper towels 57 lifting out 16-7 scumbling with 48 papers: handmade 57 lifting out 16-7 scumbling with 48 papers: handmade 57 lifting out colour 36 pretinting 59 tinted 135 Pass, Donald: Fivsty Morniny, Autumn 139 Spring Shower 153 pastels 78 mixed media 44, 45, 122, 130-1 patterns: buildings 100, 100-1 Palmer, Samuel: The Magic Apple wet-on-dry 70-1 pretinting 59 proportion: buildings 86 figure paintings 110, 110-13 still-life paintings 1/0-1 Seurat, Georges 113 sgraffito 46, 46-7 shadows: attaching object to surface 12, 78 flower paintings 124 stippling 54, 54-5 translucency 27 shapes: 'negative' 8, 104, 166				seasons: landscapes 146, 146-9
mixed media 42, 42-5, 44, 75, 76, 76, 83, 87, 89, 92, 94-5, 101-3, 106, 107-9, 112, 117, 118, 119, 130-1, 136, 139, 141, 150, 154, 164, 167, 174-5, 179, 185 Monet, Claude 174 monochrome 60, 92, 106, 158 Moore, Henry 66 Moran, Carolyne: The Apple Tree Seen Through My Bedroom Window 136 Hydrangeas in a Blue and White Jug 125 Kitchen Table with Basket and Vegetables 162 Time for Tea 170 Tree 6 paper towels 57 lifting out j6-7 scumbling with 48 papers: handmade 57 lifting out colour 36 pretinting 59 proportion: buildings 86 figures 104 Prussian blue 14 putty erasers 27 Patterns: buildings 94, 94 clouds 154 figures 18 flower paintings 110, 110-13 still-life paintings 110, 110-13 still-life paintings 110, 110-13 still-life paintings 170-1 Seurat, Georges 113 sgraffito 46, 46-7 shadows: attaching object to surface 12, 35 buildings 94, 94 clouds 154 figures 18 flower paintings 124 still-life paintings 124 still-life paintings 120, 158, 158-9 raw umber 20 razor blades 26, 46, 46 recession 144, 144-5, 180, 181 reflections on water 174, 177, patterns: buildings 100, 100-1	mist 20, 158, 158-9			
paper towels 57 106, 107-9, 112, 117, 118, 119, 130-1, 136, 139, 141, 150, 154, 164, 167, 174-5, 179, 185 Monet, Claude 174 monochrome 60, 92, 106, 158 Moore, Henry 66 Moran, Carolyne: The Apple Tree Seen Through My Bedroom Window 136 Hydrangeas in a Blue and White Jug 125 Kitchen Table with Basket and Vegetables 162 Time for Tea 170	mixed media 42, 42-5, 44, 75, 76.			•
lifting out 36-7 scumbling with 48 papers: handmade 57 lifting out colour 36 pretinting 59 tinted 135 Hydrangeas in a Blue and White Jug 125 Kitchen Table with Basket and Vegetables 162 Time for Tea 170 lifting out 36-7 scumbling with 48 papers: handmade 57 lifting out colour 36 pretinting 59 tinted 135 R R proportion: buildings 86 figures 104 Prussian blue 14 putty erasers 27 R R R R R R R lifting out 36-7 scumbling with 48 papers: handmade 57 lifting out colour 36 pretinting 59 tinted 135 buildings 94, 94 clouds 154 figures 18 flower paintings 12 still-life paintings 10, 110-13 still-life paintings 10, 110-13 still-life paintings 170-1 Seurat, Georges 113 sgraffito 46, 46-7 shadows: attaching object to surface 12, 35 buildings 94, 94 clouds 154 figures 18 flower paintings 12 still-life paintings 12 still-life paintings 12 still-life paintings 10, 110-13 still-life paintings 10, 110-13 still-life paintings 170-1 seumblings 10, 110-13 still-life paintings 10, 110-13 still-life paintings 10, 110-13 still-life paintings 12 still-life p	76, 83, 87, 89, 92, 94-5, 101-3,	paper towels 57		
scumbling with 48 130-1, 136, 139, 141, 150, 154, 164, 167, 174-5, 179, 185 Monet, Claude 174 monochrome 60, 92, 106, 158 Moore, Henry 66 Moran, Carolyne: The Apple Tree Seen Through My Bedroom Window 136 Hydrangeas in a Blue and White Jug 125 Kitchen Table with Basket and Vegetables 162 Time for Tea 170 Scumbling with 48 papers: handmade 57 lifting out colour 36 pretinting 59 tinted 135 R R R putty erasers 27 Prussian blue 14 putty erasers 27 shadows: attaching object to surface 12, 35 buildings 94, 94 clouds 154 figures 18 flower paintings 12 still-life paintings 12 still-life paintings 12 still-life paintings 54, 54-5 translucency 27 shapes: 'negative' 8, 104, 166				
164, 167, 174-5, 179, 185 Monet, Claude 174 monochrome 60, 92, 106, 158 Moore, Henry 66 Moran, Carolyne: The Apple Tree Seen Through My Bedroom Window 136 Hydrangeas in a Blue and White Jug 125 Kitchen Table with Basket and Vegetables 162 Time for Tea 170 papers: handmade 57 lifting out colour 36 pretinting 59 tinted 135 Pass, Donald: Fivily Morning, Autumn 139 Spring Shower 153 pastel pencils: mixed media 102-3 patterns: buildings 100, 100-1 papers: handmade 57 lifting out colour 36 pretinting 59 tinted 135 R R rain 20, 158, 158-9 raw umber 20 razor blades 26, 46, 46 recession 144, 144-5, 180, 181 reflections on water 174, 177, 178-9, 182, 182-3, 186-7 serdifito 46, 46-7 shadows: attaching object to surface 12, 35 buildings 94, 94 clouds 154 figures 18 flower paintings 12 still-life paintings 12 still-life paintings 12 still-life paintings 54, 54-5 translucency 27 shapes: 'negative' 8, 104, 166				
Monet, Claude 174 monochrome 60, 92, 106, 158 Moore, Henry 66 Moran, Carolyne: The Apple Tree Seen Through My Bedroom Window 136 Hydrangeas in a Blue and White Jug 125 Kitchen Table with Basket and Vegetables 162 Time for Tea 170 handmade 57 lifting out colour 36 pretinting 59 tinted 135 Pass, Donald: Frusty Morning, Autumn 139 Spring Shower 153 pastel pencils: mixed media 102-3 pastels 78 mixed media 44, 45, 122, 130-1 patterns: buildings 100, 100-1 Prussian blue 14 putty erasers 27 R rain 20, 158, 158-9 raw umber 20 razor blades 26, 46, 46 recession 144, 144-5, 180, 181 reflections on water 174, 177, 178-9, 182, 182-3, 186-7 shadows: attaching object to surface 12, stilleling surface 12, shadows: attaching object to surface 12, statching object to surface 12, shadows: attaching object to surface 12, statching object to surface 12, statching object to surface 12, shadows: attaching object to surface 12, statching object to surface 12, statching object to surface 12, shadows: attaching object to surface 12, statching object to surface 12, statching object to surface 12, statching o				
monochrome 60, 92, 106, 158 Moore, Henry 66 Moran, Carolyne: The Apple Tree Seen Through My Bedroom Window 136 Hydrangeas in a Blue and White Jug 125 Kitchen Table with Basket and Vegetables 162 Time for Tea 170 Ilifting out colour 36 pretinting 59 tinted 135 R R rain 20, 158, 158-9 raw sienna 25 raw umber 20 razor blades 26, 46, 46 recession 144, 144-5, 180, 181 reflections on water 174, 177, 178-9, 182, 182-3, 186-7 attaching object to surface 12, 35 buildings 94, 94 clouds 154 figures 18 flower paintings 124 still-life paintings 12 stippling 54, 54-5 translucency 27 shapes: 'negative' 8, 104, 166		1		
Moore, Henry 66 Moran, Carolyne: The Apple Tree Seen Through My Bedroom Window 136 Hydrangeas in a Blue and White Jug 125 Kitchen Table with Basket and Vegetables 162 Time for Tea 170 Pretinting 59 tinted 135 Pass, Donald: Frusty Murniny, Autumn 139 Spring Shower 153 pastel pencils: mixed media 102-3 pastels 78 mixed media 44, 45, 122, 130-1 patterns: buildings 100, 100-1 R rain 20, 158, 158-9 raw sienna 25 raw umber 20 razor blades 26, 46, 46 recession 144, 144-5, 180, 181 reflections on water 174, 177, 178-9, 182, 182-3, 186-7 shapes: 'negative' 8, 104, 166	monochrome 60, 92, 106, 158			
Moran, Carolyne: The Apple Tree Seen Through My Bedroom Window 136 Hydrangeas in a Blue and White Jug 125 Kitchen Table with Basket and Vegetables 162 Time for Tea 170 Time for Tea Seen Through My Basket Through My Fuss, Donald: Frusly Murniny, Autumn 139 Spring Shower 153 pastel mixed media 102-3 pastel s 78 mixed media 44, 45, 122, 130-1 patterns: buildings 100, 100-1 Time for Tea 170 Time for Tea 170 Time for Tea 170 Time for Tea Seen Through My Frusly Murniny, Autumn 139 Spring Shower 153 pastel mixed media 102-3 pastel pencils: mixed media 102			patty crasers 27	
The Apple Tree Seen Through My Bedroom Window 136 Hydrangeas in a Blue and White Jug 125 Kitchen Table with Basket and Vegetables 162 Time for Tea 170 Pass, Donald: Frusly Murniny, Aulumn 139 Spring Shower 153 pastel pencils: mixed media 102-3 pastels 78 mixed media 44, 45, 122, 130-1 patterns: buildings 100, 100-1 Pass, Donald: Frusly Murniny, Aulumn 139 raw sienna 25 raw umber 20 razor blades 26, 46, 46 recession 144, 144-5, 180, 181 reflections on water 174, 177, 178-9, 182, 182-3, 186-7 shapes: 'negative' 8, 104, 166	Moran, Carolyne:		R	
Bedroom Window 136 Hydrangeas in a Blue and White Jug 125 Kitchen Table with Basket and Vegetables 162 Time for Tea 170 Fiosly Morniny, Autumn 139 Spring Shower 153 pastel pencils: mixed media 102-3 pastel s 78 mixed media 44, 45, 122, 130-1 patterns: buildings 100, 100-1 Fiosly Morniny, Autumn 139 raw sienna 25 raw umber 20 razor blades 26, 46, 46 recession 144, 144-5, 180, 181 reflections on water 174, 177, 178-9, 182, 182-3, 186-7 stigures 18 flower paintings 12 stipling 54, 54-5 translucency 27 shapes: 'negative' 8, 104, 166	The Apple Tree Seen Through My	Pass, Donald:		
Hydrangeas in a Blue and White Jug 125 Ritchen Table with Basket and Vegetables 162 Time for Tea 170 Spring Shower 153 pastel pencils: mixed media 102-3 pastels 78 mixed media 44, 45, 122, 130-1 patterns: buildings 100, 100-1 raw umber 20 razor blades 26, 46, 46 recession 144, 144-5, 180, 181 reflections on water 174, 177, 178-9, 182, 182-3, 186-7 shapes: 'negative' 8, 104, 166				
Jug 125 pastel pencils: mixed media 102-3 razor blades 26, 46, 46 still-life paintings 12 Kitchen Table with Basket and Vegetables 162 mixed media 44, 45, 122, 130-1 recession 144, 144-5, 180, 181 stippling 54, 54-5 Time for Tea 170 patterns: buildings 100, 100-1 178-9, 182, 182-3, 186-7 shapes: 'negative' 8, 104, 166			1	
Kitchen Table with Basket and pastels 78 recession 144, 144-5, 180, 181 stippling 54, 54-5 Vegetables 162 mixed media 44, 45, 122, 130-1 reflections on water 174, 177, patterns: buildings 100, 100-1 translucency 27 Shades 26, 40, 40 stippling 54, 54-5 translucency 27 shapes: 'negative' 8, 104, 166	Jug 125			
Vegetables 162 mixed media 44, 45, 122, 130-1 reflections on water 174, 177, translucency 27 Time for Tea 170 patterns: buildings 100, 100-1 178-9, 182, 182-3, 186-7 shapes: 'negative' 8, 104, 166	Kitchen Table with Basket and			
Time for Tea 170 patterns: buildings 100, 100-1 178-9, 182, 182-3, 186-7 shapes: 'negative' 8, 104, 166				
1/0 9, 102, 102 3, 100 / Silapes. Hegative 6, 104, 106		patterns: buildings 100, 100-1		

			TO CONTROL OF THE CON
silhouettes 94, 96	surface texture 57	Trevena, Shirley: Black Grapes and	watercolour inks 18
Simpson, lan: From St Martin's,	Sutton, Jake:	Wine 166-7	wax crayons 66, 146
London 44-5	Circus Cyclist 106	Turner, J.M.W. 146, 174	wax resist 66, 66-7, 90, 100, 118,
sketches:	Down to the Start 79	turpentine: resist techniques 57	141, 178, 179
animal paintings 74	Down to the Start 79	Tydeman, Naomi: Sunlight Through	weather 146, 146-9, 150
	T	Trees 148-9	wet-in-wet 10, 68, 68-9, 90, 91, 112
birds 77 brush drawing 18	Taylor, Martin:		blending 12, 12
clouds 152	Back of the Castello di Tocchi,	U	broken colour 16
figure groups 114	Tuscany 96	ultramarine blue 25, 30	edges 32, 32-3
figure studies 104, 106, 106-7,	Castello di Tocchi, Tuscany 147	underdrawings 27, 27, 38, 66	flower paintings 68-9, 118, 130-1
116	Castello-in-Chianti 139	underpainting 60, 60	highlights 34
flowers 130	Grapes and Bread 164		landscapes 132, 133, 140, 141
landscapes 132	Leigh-on-Sea 184	V	skies 153, 155
line and wash 38	Spring 144	Van Gogh, Vincent 160, 164	stretching paper 56
skies and clouds 151	Still Life with Pumpkin 163	vanishing point 86	water paintings 174, 176, 180-1,
squaring up 52	Up the Garden Path 89	vanitas still lifes 160	182, 186
skies 150-8, <i>150-9</i>	Within the Castle Walls 101	variegated washes 63, 63-4	with wet-on-dry 70
building up 22, 22, 23	Woodland Bank 137	varnish 31	wet-on-dry 70, 70-1, 89
clear 150	Tempest, Mary:	vegetables 160, 164	edges 32
clouds 150-2, 152-3	Anemones 127	viewfinders 138	landscapes 133, 134, 140, 140,
colours 156, 156-7	Tiger Lilies 122	viewpoints 90, 96, 96-7	151
formations 154, 154-5	texture 57, 57-8, 184		painting water 176, 178, 182,
horizon 150	animals 84, 84-5	W	183
lifting out 36, 36	blots 13	Wade, Laura: Macaws 75	skies 155
rain and mist 158, 158-9	brushmarks 20, 20	Walker, Sandra:	still-life paintings 172-3
sponge painting 50	buildings 100, 100-3	Brad Street II 88	white:
variegated washes 63	dragging washes 16	Grand Street 88	highlights 34, 34
weather 146	dry brush 28	wash-offs 65, 65, 84	opaque 14, 34, 46, 84
snow 147	glazing 30	washes 14	wild animals 82, 82-3
soap 57	granulation 155	backruns 10, 10-11, 78-9, 151,	Wilder, John: Brown Hare 82
soft edges 32, 32-3	imitative 57	158, 158	Willis, Lucy:
spattering 13, 17, 48, 49, 79, 84,	scumbling 48	brushmarks 20, 20-1	Boy on a Rock 106
88, 90, 136, 187	spattering 49	building up 22, 22-4	Dog with a Stick III 78-9
Spencer, Stanley 137	sponge painting 50, 51	colour changes 25	Lefteri Milking 80
sponges:	surface 57	dragged 16, 32	Magnolia and Window 126
corrections with 26, 26	washes 135	edges 32, 32	Pinhao Rapids 178-9
gradated washes 63	wax resist 66, 66	flat 61, 61-2	Wills, Richard:
highlights 34	Tilling, Robert:	gradated 63, 63-4	Bess 79
lifting out 36	Low Tide Textures 174-5	granulation 155	Old Man with Bucket 108 Sir Geraint Evans 107
painting with 50, 50-1, 134, 136	Noirmont Evening, Jersey 180-1	line and wash 38, 38-9	White Horse 81
scumbling 48	Winter Headland 159	overlaying 30	windows 90, 92, 93, 96
washes 61	Winter Sky 151	overpainting 22 sponge painting 50	Willdows 90, 92, 93, 90
squaring up 27, 52, 52-3	Winter Tide 177	variegated 63, 63-4	Z
stencilling brushes 48	titanium white 117	wet-in-wet 14, 68, 68-9	zinc white 34
still life 160-70, 161-73	toned grounds 59, 59, 183	wet-on-dry 70, 70-1	Zola, Emile 110
arranging 166, 166-7	tones:	water 174-84, 175-87	zoos 82
backgrounds 168, 168-9	aerial perspective 144, 145	see also seascapes	2003 02
flowers 118	blending 12, 12	boats 184, 184-5	
'found groups' 162, <i>162-3</i>	building up 22, 22-4	brushmarks 20-1	
settings 170, 170-1	stippling 54	edges 32	
themes 164, 164-5	underpainting 60 Tookey, John:	highlights 20	
wet-on-dry 172-3	London Café 92	light on 176, 176-7	
still water 180, 180-1	Snape 183	masking 40	
stippling 20, 54, 54-5	Venetian Backstreet 94	moving 178, 178-9	
straight lines 86	toothbrushes: spattering 49, 49	reflections 10, 174, 177, 178-9,	
stretching paper 56, 56	townscapes 88, 88-9	182, 182-3, 186-7	
studies: figure 106, 106-7	townscapes oo, oo-9	102, 102), 100 /	

townscapes 88, 88-9 trees 134, 134-7, 152

sunlight 94, 94-5, 146, 176 see also light

182, *182-3*, *186-7* still water 180, *180-1*

watercolour crayons 44, 78, 106

Credits

Demonstration paintings by: David Curtis (116-117).

Kate Gwynn (26, 84-85, 186-187).

Moira Huntley (102-103). Ronald Jesty (172-173).

Judy Linnell (10-11, 13, 16-17, 18-19, 28-29, 36-37, 46-47, 65, 68-69).

John Martin (156-157).

Frontispiece

Samuel Palmer, courtesy of the Fitzwilliam Museum, Cambridge,

8 John Lidsey.

72 Geraldine Girvan, courtesy of Chris Beetles Ltd. St James's. London.

75 Laura Wade.

76 Paul Dawson.

77 David Boys.

78 Lucy Willis, courtesy of Chris Beetles Gallery, London.

79(1) Jake Sutton, courtesy of

Francis Kyle Gallery, London. (b) Richard Wills.

80(t) Ronald Jesty. (b) Lucy Willis. courtesy of Chris Beetles Gallery, London.

81 Richard Wills.

82 John Wilder.

83(t) David Boys. (b) Sally Michel.

87 Julia Gurney.

88 Sandra Walker.

89(1) Martin Taylor. (r) John Lidzev.

90 Paul Millichip.

91 Trevor Chamberlain.

92(t) Christopher Baker.

(b) John Tookey.

93(l) John Lidzey (collection of Yvonne Joyce). (r) John Martin.

94(t) John Tookey.

(b) Michael Cadman.

95(t) Michael Cadman.

(b) Trevor Chamberlain. 96 Martin Taylor.

97(l) Julia Gurney. (r) Jill Mirza.

98 Juliette Palmer. 99(t) Edward Piper, courtesy of

Catto Gallery, London.

(b) David Curtis. 100 Iill Mirza.

101 Martin Taylor.

105 Greta Fenton, courtesy of Duncan Campbell Fine Art, London.

106(t) Jake Sutton, courtesy of Francis Kyle Gallery, London.

(b) Lucy Willis.

107(1) Michael McGuinness.

(r) Richard Wills.

108(t) William Bowyer, courtesy of Metrographic Arts, London,

(b) Richard Wills.

109(l) Audrey Macleod.

(r) Michael McGuinness.

110 Paul Millichip.

111(l) Jacqueline Rizvi. (r) Trevor Chamberlain.

112(t) Trevor Chamberlain.

(b) George Large, courtesy of

Duncan Campbell Fine Art, London.

113 John Lidzev.

114 George Large, courtesy of Duncan Campbell Fine Art, London.

115(t) Francis Bowver, courtesy of Metrographic Arts, London,

(b) Doreen Osborne.

119 Audrey Macleod.

120 Sharon Beeden.

121(l) Jean Canter.

(r) Jenny Matthews, courtesy of Royal Botanic Gardens, Edinburgh.

122(t) Mary Tempest, courtesy of

Duncan Campbell Fine Art, London. (b) Muriel Pemberton, courtesy of Catto Gallery, London.

123 Shirley Felts.

124 Ronald Jesty.

125(t) Geraldine Girvan, courtesy of Chris Beetles Ltd, St James's, London. (b) Carolyne Moran.

126 Lucy Willis.

127 Mary Tempest.

128(t) Norma Jameson.

(b) Audrey Macleod.

Ann Oram (130-131).

Mary-Ann Rogers (84-85).

Julia Rowntree (12, 20-21, 22-24, 27, 32-33, 34-35, 49, 61-64, 70-71). Haidee-Jo Summers (14-15, 25, 30, 31, 38-39, 40-41, 42-43, 48, 50-51,

54-55, 57-58, 59, 60, 66-67). Naomi Tydeman (148-149).

129 Juliette Palmer.

133 Charles Knight, courtesy of Chris Beetles Ltd, St James's, London.

134(l) Juliette Palmer.

(r) Ronald Jesty.

135(t) Charles Knight, courtesy of Chris Beetles, St James's, London.

(b) Moira Clinch.

136(t) Juliette Palmer.

(b) Carolyne Moran.

137 Martin Taylor.

138 Robert Dodd.

139(t) Martin Taylor.

(b) Donald Pass.

140 Ronald Jesty.

141 Charles Knight, courtesy of Chris Beetles Ltd, St James's, London.

142 Juliette Palmer.

143(t) David Curtis. (b) Michael Chaplin (collection of lan and Julie Kury).

144 Martin Taylor.

145(t) Robert Dodd.

(b) Ronald Jesty.

146(t) Ronald Jesty. (b) Charles Knight, courtesy of Chris Beetles Ltd, St James's, London.

147(1) Michael Chaplin (collection of Eric and Gill Mitchell).

(r) Martin Taylor.

150 Christopher Baker.

151 Robert Tilling.

152 Charles Knight, courtesy of Chris Beetles Ltd, St James's, London.

153(l) Ronald Jesty. (r) Donald Pass.

154 Christopher Baker.

155(t) Ronald Jesty.

(b) Moira Clinch.

158(t) Colin Paynton.

(b) Robert Tilling.

159 Trevor Chamberlain.

161 Cherryl Fountain.

162 Carolyne Moran.

163(l) John Lidzey. (r) Martin Taylor. 164(b) Michael Emmett, courtesy of

Catto Gallery, London.

(b) Martin Taylor. 165 Moira Huntley.

166 Shirley Trevena (collection

of lo Webb).

167(t) Geraldine Girvan, courtesy of Chris Beetles Ltd, St James's,

London. (b) Edward Piper, courtesy of Catto Gallery, London.

168(t) Geraldine Girvan, courtesy of Chris Beetles Ltd. St James's. London. (b) Ronald Jesty.

169 Shirley Felts.

170 Carolyne Moran.

171(t) Cherryl Fountain. (b) Paul Dawson.

174 Robert Tilling.

175 Ronald Jesty.

176(t) Francis Bowyer, courtesy of Metrographic Arts, London.

(b) Robert Tilling. 178 Lucy Willis.

179 Charles Knight, courtesy of Chris Beetles Ltd. St James's.

London.

180 Ronald Jesty.

181(t) Ronald Jesty.

(b) Robert Tilling.

182 Michael Cadman. 183(t) John Tookey.

(b) Ronald Jesty.

184 Martin Taylor.

185 Moira Huntley.